# Photo No-Nos

# Photo No-Nos

Meditations on What Not to Photograph

Edited by Jason Fulford

*aperture*

avoid
a void
void avoid
void a void
void
a void avoid a
void a
void avoid
void
avoid a
void a void

—Hernán Diaz

# Contents

# Contributors

## What Is a Photo No-No?

Empty stairs is one for me. I've taken hundreds of pictures of stairways to nowhere. And none of them are as good as the first one. Another photographer made pictures of pickup trucks for years, until she finally nailed it and moved on. To some, political content is a no-no; for others, every picture is political. One photographer might avoid using a tripod, while another avoids snapshots. Some will not photograph a person without their consent, others never ask permission. Some avoid distant cultures, others avoid their own hometowns.

We reached out to photographers, curators, and writers, asking about things they avoid. Many who responded sent in lists of subjects, compiled here in alphabetical order. We then asked each contributor to write about one of the topics on their list.

This book is framed in terms of negatives, but the stories highlight the reasons why people are motivated to make pictures in the first place, and the underlying message is positive. Rules can be useful, until they aren't. Things are subjective. There are no *no*s. You could even think of this as a challenging shot list.

—Jason Fulford

**Abandoned Buildings**

**Abandoned Farms**

**Abandoned Houses**

**Abandoned Shopping Carts**

**Abandoned Umbrellas**

**Above-Ground Pools**

**Absent Fathers**

**Absolute Certainty**

There is one formidable, collective, and near-monolithic No! that coincided with my introduction to photography in such a way that all the other little Nos that followed sort of pale in comparison.

Photography and the critical thinking surrounding it began for me in the late '80s at Sarah Lawrence College in a range of different contexts: Joel Sternfeld's photography classes, Shahnaz Rouse's Media Studies class, Gregg Horowitz's Art and Aesthetics seminar and, best of all, hot 'n heavy late-night, two-fisted, position-taking, dorm-room debates. While Sarah Lawrence had gone coed the same year I was born (1968), it was (and remains) a school whose culture and paradigms provide an unavoidable challenge, if not a clear alternative to what some might call patriarchy, but for my purposes, I'll call assholes. In the late '80s, Sarah Lawrence

might have tolerated straight white men, but straight white men faced a gauntlet of scrutiny and sniff-tests, which might not have always produced enlightenment, but absolutely demanded self-reflection, possibilities for revision, and at the very least, a degree of adaption that was a hell of a lot more than would have been asked of a straight dude at the Frat 'n Lacrosse College I'd dropped out of before landing at Sarah Lawrence with art and photography on the brain. Theories of the male gaze, Chomsky-style analysis of visually encoded ideologies within big media, the unmissable lessons of ACT UP protest aesthetics were all compelling in their own right. Collectively, they crystalized a certain characterization of the straight-white-male photographer, committing acts of public lewdness in full Pepé-Le-Pew effect as he bopped down the sidewalk in his khaki multipocketed vest, omnivorously priapic and looking for cheap exploitative thrills at thirty-six frames a roll. That guy, it would have been argued, probably had it coming.

At Sarah Lawrence, I mostly wanted to be Irving Penn or August Sander. To be more precise, I wanted to be a portraitist, a photographer of indelible—but not entirely knowable—characters, because Sarah Lawrence was, to my eye, so full of genuine eccentrics: ripped-from-the-screen femme fatales, fierce intellectuals, often in leather (and more ethereal ones in tweed), not to mention the haunting uncategorizable enigmas, such as the pale, blue-eyed boy with the baritone voice whose dorm room remained as spotless and unpersonalized as the day he'd been issued the key (the only visible evidence of his occupancy, the silver-framed, black-and-white photograph of his mother on the nightstand). Then and now, photographing makes my pulse race and in those moments, every emotion is true and false, intuition is the solution and the limitation. And while ambiguity is never the goal, on a good day, anything is better than the dull familiarity of absolute certainty.

A slightly older, straight-white-male peer and most-likely-to-succeed photo major with a savvy postmodern flare, explained to me in 1989 while we waited in the salad-bar line together, "Photography is a form of violence, and when YOU photograph women, it's a form of violence against women."

"So . . . what about de Kooning? Are his paintings of women violence against women?"

"Yes."

I had no response, but he wasn't waiting for one. I wasn't skeptical about his conviction, so much as suspicious that he was in the process of removing risk from his artistic equation. If he had a serviceable list of Do's and Don'ts, he could safely proceed as a straight-white-male artist/photographer. Why would I have reason to argue with that? The exchange was neither a debate nor an argument, but it taught me a lesson—one that I'm reminded of all the time as a grad-school critic working with evolving artist/photographers: there's no escaping the fact that the medium is perceived as dangerous, and no one is immune to the trouble that photographing can stir up.

The fine-art thing only raises the stakes on photography trouble. You won't find a more rich or varied conversation about ethics and photography outside of the artist/photographer context. Photojournalists might find themselves in an ethically sticky situation now and then, but they do not sit around philosophizing about ethics for the simple reason that their Code of Ethics is written down, memorized, sub-scribed to, and as second nature to them as a medical doctor's Hippocratic Oath. When a journalist is discovered in an obvious breach of their profession's ethics, they lose their job and, more often than not, their career. When an artist/photographer is interpreted as having done something wrong (at least at this moment and in the US), anything might happen, including the possibility of nothing at all.

—John Pilson

## Absolute Nothingness

## Abstraction

Photography has an embarrassing relationship with abstraction. For the most part, it can't really do it. Even the most tasteful photogram is an image of something: the edge of a torn piece of cardboard or some chemistry sloshed on paper. Photographs stand on the roof and look over the edge of abstraction, but usually don't leap into the baby pool below. But it's so tempting. Representation is hard work. People care about what things mean, and they recognize the camera as a meaning-making machine. We'll never get tired of pictures of people, but every gesture is contestable, and it's exhausting. Sometimes you just want to settle down and do some lines.

I can't resist trying to use the camera to speak with clarity and certainty, and that means I slink toward the rain gutter of abstraction, but I don't actually go over. Abstraction isn't harmful: strip clubs must have accountants. If you've ever used a rototiller, you know how hungrily the camera rumbles toward *aboutness*. It has something to say, and I like letting it say something. The difference between an abstract photograph and a descriptive one is like the contrast between an artist's statement and a really good story.

After World War II, my grandfather called every dentist in every Long Island Rail Road stop until he found one too busy to give him an appointment, and opened an office in that town. My grandmother became the secretary for Tatyana Grosman, the founder of Universal Limited Art Editions (ULAE), the lithographers for Jasper Johns, Barnett Newman, Cy Twombly, and a generation of great (and mostly abstract) artists. My grandfather would go on painting trips with Maurice, Tatyana's husband. They were arrested once for painting a landscape that included a munitions plant off in the distance, and the police took their belts and shoelaces so they wouldn't hang themselves. My grandfather was a good painter, a Sunday landscapist with direct ties to a globally

dominant groundswell of modern art. I sleep next to an artist's proof of one of Larry Rivers and Frank O'Hara's *Stones* (1957–60). When I started making photographs, I'd show them to my grandfather. He'd turn them 90, then 180, then 270 degrees, insisting that a really great composition should be just as good in any orientation. It was infuriating. He'd ignore me when I'd say, "But the building is upside down." He'd turn and tumble my picture, analyzing its shapes and lines, ignoring its every instinct and intent. He'd sip his Sanka and turn on golf.

—Tim Davis

## Accidents

## Ace in the Hole

## Actors

I used to film actors in narratives when I first started making movies. It always felt artificial, and the whole process of directing people felt dirty and dishonest to me. The real thing is already out there; you can film it without any money if you know where to find it.

—John Wilson

## Ad Nauseam

## Advertising

## Aerial Images

## Aesthetic Still Life on Seamless Paper

## A-Frame Houses

## Aimless Shooting

I don't allow myself to do it as often as I should, but sometimes, I go back to photographing aimlessly. No project in

mind, no concern for how or if the photographs will be used. It's all for the pleasure of making them. I'll make them with my phone or a point-and-shoot camera. This kind of intuitive practice suffers when there's a desire to ensure a particular outcome or conceptual meaning, or to streamline the work structure. It might seem like a modernist holdover, but it's the method that got many of us hooked on making photographs in the first place.

—Mark Klett

## Airports

## All the Known Photos

I like to shoot all the known photos first, the ones I have seen before, or that have become clichés. They are often too seductive to ignore, and there is something satisfying about having your own version. Once these are out of my system, I can get on with seeing afresh, becoming more aware of the now and finding the space to understand if a dialogue opens up and can somehow be incorporated into the final images.

When I think about traveling around the US, with its rich photography history and its iconic landscape, topography and small towns, everything feels so familiar and pictured that it's easy to imagine not producing any work. Maybe it's the one place in the world where photographs and films have produced a visual history so implanted in our memories that it becomes too hard to shake off. In *Americans Parade* (2016), I ended up embracing the urban and small-town topography as a nod to those who have come before and influenced me. But instead of it being central to the work, I used it as a backdrop, as a way to complete the frame.

—George Georgiou

## Aloofness

## The Alps

## Altering Protest March Photographs to Hide Marchers' Identities

When protests broke out across the United States following George Floyd's death in police custody in late May 2020, some concluded that the law-enforcement response was high-handed and hostile. After a couple of his friends were rounded up by police at a protest, the software developer Noah Conk created an Apple mobile-device shortcut that enabled blurring the faces of individuals in photographs before sharing them on social media. He reasoned that such anonymization would make it harder for law enforcement to identify and target marchers with recrimination.

Conk's intervention came amid a raging debate over the ethics of altering documentary photographs. Eventually, the subject split into myriad other questions: Does the public have the right to alter a photojournalist's images? Conversely, does a photographer have the right, never mind an obligation, to obliterate a subject's identity without that person's approval? Whereas Conk saw hiding the identity of protest marchers as a form of protection from law enforcement—that is, as a measure of safety and privacy—others saw it as dubious alteration of history at large and, on a personal level, even violent and unfair erasure.

As scholars and photographers weighed in on the issue, one key voice was prominently missing. Maurice Berger spent many years investigating the critical role that protest photographs of the Civil Rights Movement played, not only in documentary history, but also in activism. In his most recent curatorial work and scholarship, Berger focused on the protest photographer as witness. Sadly, only two months before the outbreak of the summer protests, Berger became an early victim of the coronavirus pandemic. What one would give to have Maurice Berger's take on this subject.

—Olu Oguibe

**Amazement**

**Ambience**

**American Flags**

**Analogue Photography**

**Animals**

**Animosity**

**Answers**

**Anthropomorphic Anything**

**Anthropomorphic Rain Gutters**

**Anyone Who Says "Make Me Look Good"**

Some time ago, I had a frustrating experience with a celebrity shoot. It was entirely outdoors and the temperature was nearly 40 degrees Celsius. Because the celebrity had committed to only three hours of shooting, each scene was fully prearranged, without opportunities for communication or observations. When she arrived on set and started posing in front of my camera, the sound of the shutter became the guiding voice, prompting her to shift poses. But when I stopped pressing it, I sensed immediate disappointment and irritability. The only thing I could do to keep the shoot going was to keep pressing the shutter. Feeling panicked, my sweat blurred the viewfinder, and I lost my ability to carefully compose. I realized that there was no chemistry between us, neither through eye contact nor body language. She was immersed in her poses, showing off her beauty and confidence.

As the shoot continued, I tried to direct some poses that I thought would look good. She didn't trust my suggestions and asked me to stop, and even came over to check the photos. She accused me of making her look weird. In the

end, the best I could do was to keep pressing the shutter blindly, rather than being a more engaged and observing photographer.

—Xiaopeng Yuan

## Anything at 1 P.M.

When I photograph someone and they turn on a table lamp, they always ask, "This should be enough light, right?" The apartment's only window faces a brick wall, and the lamp illuminates nothing but a faint yellow cast on the armchair. Their light is not a tool, it's a peace offering. I recognize their courtesy and return my own. "This is great!" I say, as I set up my own strobes. I am nothing if not destructively kind.

People are always suggesting we shoot at 1 p.m. They send me a mood board of ten images shot at 6:30 p.m. and say, "We're available from 1 p.m. to 2 p.m." Photography is a mystery to all of us but for different reasons. I often type out, "Your funeral!" but quickly replace it with "Sounds good!" What I'm saying is if you see me taking an editorial portrait in a New York City park, that wasn't me.

I googled "Pictures at 1 p.m." to research writing this. All the results were images of clocks. Pretty good joke.

One time, I was at a nudist festival and I overheard two men discussing the perfect white balance for vagina color. This is what men mean when they say they're feminists. One guy's wife thought he was on his annual camping trip. I asked him what he does with all the photos he takes at these events, and he said he puts them in a folder called TURBOTAX2011. It reminded me that two of my former boyfriends hid naked photos of their ex-girlfriends in TurboTax folders. Art helps you recognize what you already know.

The problem with taking pictures at 1 p.m. is that it makes me feel weak, as if someone with less trauma would know what light modifier to use. Or: The correct modifier is awarded to the person with the healthiest family group chat. I

stick the subject in the shade and call it a day. Tree beats sun. You can't turn a photograph into a picture by calling it so.

I have a tab open titled "How to Shoot Beautiful Portraits in Harsh Sunlight." It's a listicle-style blog post by two wedding photographers in San Diego. Number four on their list: "GO INSIDE."

Even though I should know by now, I still give 1 p.m. a chance. I trust that my eyes and my camera are seeing the same things until I look down at my screen and think, *how could you do this to me*. If the secret is how a photograph is made, then the photograph itself is not that important. At least that's what I tell myself. Just when I think I'm done with taking pictures, I wait until 5 p.m. and it all seems okay again.

—Caroline Tompkins

## Anything at F1.2

## Anything at ISO3200+

## Anything I Am Not Curious About

## Anything Out of a Moving Car Window

## Anything Overworked/Overdetermined

## Anything Resembling an Aesthetic Coming from Windows 98 & the Latest PlayStation Graphics

## Anything Sexy

During my late teens, in the 1980s, I maintained a personal ban on photographing anything "sexy." I was especially opposed to images of women looking vulnerable. As a man and a feminist, I felt I should not make that kind of work. Years later, I "came out" on camera as my drag alter ego, "Cheri Nevers," who looked like a 1950s sexy cheesecake photo model. Inspired by those images, a friend invited me

to make teasing pictures of her; she found them spiritually uplifting. I began to find a more positive path toward "sexy" photographs.

In college, in the mid-nineties, I searched for ways to address the predatory element of the male gaze. Around this time, I fell in love with Lee Friedlander's picture *Shadow—New York City* (1966), and tried to imagine making work about the ways men are perpetually stalking women in nearly every aspect of life, without turning into the stalker myself. I saw the work of Ron Jude, who photographed the backs of businessmen in suits on city streets, and Harry Callahan's close-ups of women's clothes on the street. When I first looked through Nan Goldin's book *The Ballad of Sexual Dependency* (Aperture, 1986), I remember having an epiphany: her images were sexy without being misogynistic, yet delivered warnings.

This research process culminated in a years-long project in which I photographed male photographers making pictures of women in lingerie at "camera clubs"—before the internet and digital photography changed that dynamic. I collaborated with a writer who posed as an aspiring model, and who helped me investigate the power structure from the model's point of view. The resulting project, Camera Club, was exhibited widely. The experience of making that work also inspired my performance-based project The Self-Esteem Salon (1997–present), in which people live out positive, self-esteem–boosting fantasies in front of the camera.

—Chris Verene

## Anything That May Cause Indignity

## Anything Too Familiar, Derivative—Unless, of Course, It's as Good

## Anything Well-Meaning People Tell Me That They Think I'd Like to Photograph

## Anything with a Name

Near the end of his life, in Los Angeles in the early 1980s, Garry Winogrand seemed to have given up on identifiable subjects. Many of his later pictures feel like accidents, often snapped indiscriminately from the window of a moving vehicle. Remarkably, he never processed these California films, yet he continued, exuberantly as ever, making new exposures—thousands of them. And then he died. It's as though in those final months, with death at his heels, he suddenly waived all photo-taboos and allowed anything and everything into his camera's frame, disregarding the viewfinder but compulsively releasing the shutter. By leaving most of the content to chance and never viewing the outcome, he had almost entirely removed himself from the process. Experiment, mad-ness, or failure? Impossible to say.

Winogrand, as Geoff Dyer has noted, appears to have been relentlessly aiming at *nothing* during this time, producing an inscrutable mess of "boring" exposures that rarely suggest an intentional picture. But why would a guy like Winogrand commit so hard to photographing "nothing"? Might these exposures reflect some eleventh-hour epiphany about the limitations of subjectivity, a liberating certainty that *everything* is a potential picture? He did once say: "Any moment can be something." If Winogrand was knowingly depicting some *thing* for which we don't yet have a name, maybe he could convey this nascent insight about reality (and perception) by letting it *all* in, *everything*, leaving a mountain of indecipherable exposures in his wake, each frame a Zen koan from the threshold of eternity. Maybe he finally disappeared into his own work.

What makes *anything* worthy or unworthy of being photographed? For now, one of my mantras is: "If it has an obvious name, don't photograph it."

—Mike Slack

## Anytime When Someone Asks Me Not to Take a Picture

## From Apple to Naked

When we photograph an apple, I question myself and think: What is this apple supposed to say about me or about the world? Shouldn't we rather photograph something political?

When we photograph a picture with a political statement, I question my role as an artist, thinking: Shouldn't we rather concentrate on beauty, on the emotional quality of an image that could inspire people and make them grow?

When we photograph something purely aesthetic, I question the necessity to decorate the world, thinking: We should rather contribute to the philosophical or spiritual void around us.

When we photograph an image that builds on philosophy or spirituality, I question my mental capacities and think: I should rather portray the living beings of our time and fulfill my role as a witness.

When we turn our camera onto a living being and record them, we either make a present or we steal. We take the image of a being and with it, we appropriate the being's ability to represent itself. A part of the being becomes ours; it becomes our work. It also becomes us and how we represent ourselves. The picture of a living being becomes a tool, a value, a commodity.

Every image we make comes with a narrative. It can be a narrative of trust, friendship, respect, and desire—or a narrative of abuse, exploitation, ego, and hierarchy. These narratives are fluid, interchangeable, and easily manipulated. As soon as we let an image out into the world, we lose control over the narrative. The passing of time changes the narratives too. Today's applause might turn into accusations and denunciations tomorrow.

The climate of fear makes us increasingly cautious, and we tend to censor ourselves and analyze before we create. Reason overshadows intuition. By considering all possibilities and imagining how the intended meaning will be twisted and turned, we let doubts crawl in and obscure our curiosity.

We have seen this happen to generations of students—to young, enthusiastic and promising photographers. At some point, they just think about images instead of making them. This happens because they are taught by people who warn and censor more than they encourage testing and succeeding or failing.

We are all walking on a tightrope. If we keep looking down, we will never advance. We have to be brave. And we should remember that we are all naked.

—Taiyo Onorato & Nico Krebs

## Approaching Sexuality in a Trashy or Vulgar Way

It's important to differentiate between being sexual and being sexualized. As a woman, I believe that the patriarchy retains control over female sexuality by shaming women for being sexual. Women learn early on that they will be slut-shamed for being sexual, and that the only acceptable way to be sexual is to be sexualized by men. Using photography to represent sexuality in a vulgar way means objectifying human beings. It reduces us women to sex objects, and promotes victim blaming and rape apology. I don't want to be part of a system that I fight.

—Bettina Pittaluga

## Aquariums for Screen Savers

## Arches

## Architecture

I studied architecture in college and graduate school, and practiced professionally for a few years afterward. In many

ways, photography was my escape from its rigidity. The transition between those two careers isn't unique, but to me, it felt like taking the shackles off. I wanted to shoot anything *but* buildings. I've mostly stuck to that over the years, though architecture continues to inform my way of seeing. The irony isn't lost on me.

—Ike Edeani

## Arranging a Photo the Wrong Way Round

For many years, I did the layout for numerous magazines, and I could never put a photo round the wrong way, much as I would have liked to. Now, I'm tempted to do it. I can do what I want here. Shall I put it back to front? I can't make up my mind. Perhaps I'd better wait.

—Bruno Munari

## Arrows

## Artificial Plants

## Artists

## Artists Standing in Front of Their Art

## Artlessness & Artiness

## Artworks (Unless They Are in Motel/Hotel Rooms)

## Asking Permission

I rarely stop to ask permission before taking a picture. It represents an extreme break in the fluidity of looking, and what would I say? "Can I take your picture?" "Why?" "Well, it is not really you, or your face. No, I am interested in what is in your bag." Or, "You have a cool shirt," or "Let me see that shoe." I just want to get into that private space for a second and see what elements I can expose, what kind of psychological or social detail I can reveal by using this complete stranger. If we talk too long, even five seconds, then the danger will be gone. The flux of working in this tiny bit of camera-generated hostility counts.

—Mark Cohen

## Aspect-Ratio Obsession

## Astrophotography

## Aura

## Autobiography

When I discovered photography as an undergraduate student, I made pictures to understand and explore the myriad life changes that seemed to hit me like a freight train daily and weekly. I photographed friends, family, relationships, and myself. At times, it seemed that the more drama there was in my life, the better the photographs. This way of thinking, at twenty-three, sometimes betrayed a dangerous and damaging state of mind. I carried this way of working into my late twenties, even as my life started to settle down. Eventually, I made better decisions, developed a healthy community of friends, and the drama dissipated. The photographs I made drifted off the subject as well.

I decided to attend graduate school for photography. Initially, I was worried about what I would do over the three

years of study. I knew I needed a "project" and thought I would pick up where I left off, looking inward and exploring my peers and my psyche. But my first day of graduate school was September 11, 2001. Like many, I spent two days in my apartment glued to twenty-four-hour news broadcasts, trying to comprehend what had happened and its magnitude. It dawned on me that we were undergoing the stages of grief together; that we American citizens now had a common bond, a shared experience of the moment. The 9/11 events were unique; they had the potential to break down class boundaries, socioeconomic strata, and racial biases. I thought, Perhaps we can all talk again. In those first few weeks, citizens were terrified, unmoored, and somewhat united in how the nation should react. I knew I was no longer artistically interested in the minutiae of my own life. Rather, I needed to attend to the realities and complications of my country and culture.

—Brian Ulrich

## Automated Curation

Holiday scenery, food, books, online research, everyday curating processes, social-media screenshots: I snap it all using my phone camera as a notebook. In the digital sphere, however, editing falls not only to us. Today, it's built into the machines we use; the apparatuses curate our content. And they are strikingly candid about this, as my phone recently told me: "Photos and videos are curated [tagged, classified, sorted, and arranged] when your device is connected to power."

—Kathrin Schönegg

## Automobile Details (Body Contours, Instrument Panels, Mirrors, Chromium, Rust)

## Autumnal Landscapes

## Autumnal Leaves

**Babies Dressed as Vegetables**

**Baby Horses**

**Baby Pictures**

We all know that feeling when someone (who is not related to you) shows you pictures of their baby and you act excited every time, even though you're not. Yet, surprisingly, I catch myself in a loop of taking the same photo of my niece over and over again as soon as she does something cute, or anything at all. So much so, that I find myself buying extra cloud space because my phone fills up. I'd rather pay money than have to delete one of the thousand identical photos of my niece drooling. I'm afraid of missing out on her newest accomplishment, but I wonder what I'm going to do with all of these photos.

Recently, when I was showing off her latest crawling skills from six different angles, I could see the other person's interest fading.

—Coco Olakunle

**Backlighting**

**Backpacks (Cute Character Ones, Maybe)**

**Backs of People's Heads**

**Balding Heads Shot from Above**

**Balloons**

**Ballyhoo**

## Banality

## Bandwagon

In middle school, I only photographed on vacation. I'd stock up a bunch of rolls before we went somewhere and made prints throughout the school year, like collected acorns. I was encouraged by the results. By contrast, when I photographed my house, family, floor, or my neighborhood during the school year, these "local" photos were met with less regard. For the want of awards and scholarships, and through feedback from my art teacher, Alison Youkilis, I learned they weren't all that great. She preferred vacations. I stuck to holiday snaps.

In college, Dan Larkin encouraged me to photograph the ordinary, in color. For a while, I only photographed during sunset, underexposing slides by one-third of a stop, or making C-prints a touch too dark. Then I went to Memphis to meet color's warrior-in-chief, William Eggleston. He wanted to talk about a piano keyboard he had just bought.

In photojournalism class, I was told to photograph something of consequence, so I photographed my family reeling from my mother's death. We were also told to photograph Rochester's poor; that definitely seemed against my rules, so I refrained. If your subject wasn't disabled, impoverished, or at peak action, you couldn't get a job in the field. Then on the first day of class, they rolled in a TV showing a plane hit a skyscraper, and I had no desire to run to Lower Manhattan like the rest of the guys in class. I didn't get a photojournalism job back then—and around the same time, they all disappeared.

In grad school, when the color processor finally died, I gave up on traditional color. I hated the way a digital camera made color look, printed on a rubbery, plastic substrate. Chip Benson cursed at me when I tried to desaturate my colors. His rule was that I couldn't go back. After I ignored that, I was told that my black-and-white work was retrograde, not abstract enough, that formalism is dead. That wasn't the

actual art definition of formalism, but aren't photographers allowed to have their own language? What is a topographic?

Everyone started shooting black and white—and it looked like I was a bandwagoner. Then all of these black-and-white books came out and I missed the bandwagon. They called them *photobooks*. My rule is that's not a word either. *Pho-tog-ra-phy* Book. I'm trying to figure out what the rules are now. My prints were too big—that was the rule back then—but now where do I store them? Another rule is that you can't throw anything out. What if you get famous? Should I make something that will help me get a job? What's the point if it's so easy to do? Now, I photograph my family, what I see while walking around, the rich, the poor, your yard, a piece of metal, men, women, kids, strangers, all on my phone, without looking, without permission and without a real camera, defying all the rules of photography—my own and others'. I photograph the light coming in through the windows on our oversize parlor floor. Who is this work for? The strangers in my algorithm? Am I allowed to photograph my life? Am I allowed to photograph our privilege—if we pay low rent? Will they scan our faces, know where we were and when? It seems like that shouldn't be allowed—but it's allowed in photography.

—David La Spina

## Banks

## Barbed Wire Silhouetted against the Sky

## Barbershops

## Bare Back of a Woman Facing a Wall

## Baseball Dugouts

## Basketball Hoops

## Bauhaus-Style Chic

## Beaches

## Bears

## Beautiful Landscapes Seen from Above & from Afar

Years ago in the book *Unclassified* (2000), I read with great curiosity a rather long list of themes and subjects that Walker Evans had suggested to himself. I was trying to discover in what way the idea corresponded to the result.

In July 1979, I had had the opportunity to attend a workshop with Nathan Lyons in Venice. Much of the advice he gave was aimed at breaking out of conventions, but it was also an invitation to free oneself from the formula coined in fourteenth-century Florence: "Every painter paints himself."

I remember, one exercise consisted of photographing what we had never "looked at" and then what we didn't like to photograph. We photographed each without looking at the subject and then while looking, separating the different modes with a blank (by covering the lens with the cap), so that we could compare what had been recorded by the camera on a contact sheet.

Italo Zannier gave another technique of "estrangement toward the subject" that I followed in his 1960s Superior Course of Industrial Design: walk a straight line, with the camera perfectly level and oriented in the same direction. Take X photographs, one every X steps. Then print everything and compare.

I think most subjects are easily photographable a priori, before observation, and this leads to an annoying proliferation of certain subjects. I would add that the real problem is not the subject, but the way you deal with it. If I had to indicate a subject that I usually avoid, I would say beautiful landscapes seen from above and from afar; perhaps because of the strong myopia that has affected me since childhood. I want to believe that for this very reason, as well as in

homage to Eugène Atget, I have become a partisan of the close-up view.

I am wary of categories and subjects constructed from a distance or a priori; they are incompatible with the close-up gaze.

—Guido Guidi

## A Beautiful Picture, but Not Mine

Even when I'm not photographing, I'm always making pictures in my mind. I watch the way light falls on people and objects, constantly framing the world around me in rectangles. Often, when I'm out driving or walking, I see a scene that is formally stunning—the compelling gesture of a stranger, soft light falling on a building or landscape, the last glow of light at the end of the day—and I think to myself, That's a beautiful picture, but it's not mine. My rule for making pictures is that they have to come from me, to be reflective of who I am, and say something about my interior state in that particular moment. I answer questions through my work; it is the vehicle through which I explore myself and my own experiences while also forging meaningful connections with others. One of my strongest guiding principles is to listen to these questions—my internal voice as an artist—and follow where they lead.

—Jess T. Dugan

## Beautiful Ugliness

As a photographer, you must carefully balance between two poles, two ways of seeing, two aesthetics: ugliness and beauty. In other words, when does your image become too ugly, or too beautiful? Carefully searching, you walk on the edge of a knife. How far can you go in either direction? And where can the two still match and mingle? What decisions do you make, aware of your responsibility? How far can you go, where do you stop, before beauty turns into ugliness, before ugliness defeats beauty?

—Bertien van Manen

**Beauty**

**Becoming a Fuddy Duddy**

**Beds**

My coming of age as a photographer was during what I'd call "the Soth years." I had seen Alec's first solo show at Yossi Milo Gallery and his install at the 2004 Whitney Biennial, bought the first edition of *Sleeping By the Mississippi* (2004), and heard him lecture at RISD, where I was a student. These were formative experiences that had me photographing with a large-format camera and occasionally looking at beds for photographic fodder. Around this time, I also began photographing my parents and their partnership between New Jersey and Hong Kong. One morning during my first year of grad school, while I was home in New Jersey to see my mom, and to make some photographs for crit, I photographed my mother's slightly unmade bed—the left side virtually untouched while the right was tossed open. Up until then, I never knew which side of the bed she slept on. Once that picture was made, I decided to avoid photographing beds for this project. I was in grad school, after all. As an artist, I needed to start figuring out where my influences ended and where I began. Luckily, I left with this one sheet of exposed 8-by-10 film with some serious potential. I avoided photographing beds for another eight years, until one morning in Hong Kong, I got a glimpse of my father's slightly unmade bed: the right side was tucked and neat while the left side was unfurled from the night before. It was revelatory to discover and record these intimate and idiosyncratic habits of my parents. This was photography's way of revealing new knowledge to the maker, while also showing a son how his parents remain together, but apart. It was worth breaking the rules for.

—Nelson Chan

### Beginning

Hah!
You think becoming a butterfly is easy?!
Even then,
YOU WILL CRAWL BACK TO THE COCOON.

—Cary Fagan

### Beige

### Being Told What to Photograph

As the photographer in the family or group, I am often instructed, "Hey, take a picture of that!" My response is usually, "I'm glad you think that would make a good picture, why don't you take it?" I'm not interested in being a proxy for somebody else's vision, especially now that we all carry cameras in our pockets.

—Rafael Soldi

### Being Too Literal

I look for a poetic mood in my stories. So I avoid revealing too much information, as well as being too literal about a specific subject. I generally like my images to have a quality of suspense and ambiguity so that the audience is invited to think and eventually explore the photographer's world by moving forward through the visual narrative.

What is the difference between a statement and a verse? The instant between two moments that do not have any suspense or ambiguity. The fleeting pause between these moments is less observed than felt. This is exactly where verse is born, where a new door opens: in the center of implication where nothing is definite or absolute.

—Hashem Shakeri

### Being Unkind

## Belly Dancers

I haven't photographed a belly dancer in nearly twenty-five years.

12/3/12 Business Card: Hi Elinor, This is an odd question, but I was going through some old boxes at my parents' house from my college days, and I found this business card: "Elinor. Belly Dancer. 212- . . . " Is it yours? My guess is that it's from the mid-1990s, but I have no idea where I got it. Maybe we met way back when? To be honest, it feels like finding something from a past life.

12/3/12 Re: Business Card: Oh My God!!!!! That is so weird, Aaron. It *is* mine—from 1996 when I was dancing and also starting as a photographer myself. I'd just arrived in New York and made the cheapest cards. That's still my home number! We must figure this out . . .

12/5/12 Figured It Out: Elinor, I don't believe this. I ransacked my archive and found this picture of you (and more) in a file of forgotten negatives. When I realized, I laughed out loud. This is what I remember: I think a film student posted a flier at NYU looking for a photographer to shoot stills for around $100. I was nineteen at the time and I needed the money, so I called him. He gave me an address on the Upper East Side and told me to show up a few nights later with lights and a camera. When I arrived, there was a guy in a convict costume, some 1920s flappers, a dominatrix, and, apparently, a belly dancer. He directed (and starred in) the shoot himself; I think it was for some club night he was throwing. There are five rolls of film; you feature prominently in three—one is entirely of you dancing solo—but then you disappear. All of the photos are pretty ridiculous, but I did the shoot as he asked, which felt very uncomfortable and embarrassing thanks to his terrible ideas—ie, you handcuffing

and manhandling the convict like a belly dancing bad-cop. I also seem to remember that he never paid me. I must have just thrown the negatives in a box with my other work from back then and never looked at them again. But apparently you gave me your card, and I saved it. Mystery solved.

12/5/12 Re: Figured It Out: Aaron, I had to sit down and breathe. I can't get over this crazy chain of events. It all comes back to me now. I remember the others were annoying, but feeling a connection with you. Around that time, I did many different jobs for the money too—I had even weirder ones, believe me. But I asked for my $75 cash as soon as I got there. As a belly dancer, I knew better.

<div style="text-align: right">—Aaron Schuman</div>

## The Bereaved

## Biases

"Bruno, you are so sensitive, you take everything so personally," I remember my first boss in book publishing scolding me after I would complain to him about the rudeness of photographers we were working with. It was true; as a young editor, I was not only very sensitive, but I also easily muddled my feelings with my professional judgment. So I gave myself a simple rule: never dislike work just because I dislike the photographer who made it (and vice versa). What I didn't realize then is that, while a dislike for someone is easily detectable, other biases are slyer and more indecipherable. A whole web of experiential and culturally formed ideas is at work at all times, influencing each one of our judgments. Sometimes the reason why we "like" a photograph has more to do with the age, gender, race, educational pedigree, or social affiliations of the photographer than the image per se—its intrinsic qualities. Fighting one's personal biases is an ongoing process, first to recognize and then to dismantle

them. To really *see* a photograph clearly, you must always see it entangled with your own biases.

—Bruno Ceschel

## Bicycles

## Bicycle Wheels

My excellent college photo professor Roswell Angier had a rule: no pictures of cats, homeless people, or the sad statue of an elderly couple standing in the center of town. It seemed at the time like an arbitrary list but thankfully, my camera was pointing elsewhere. When I came around to teaching, especially beginning photography, I understood the need for such an edict but my issues were more of a formal nature. How many poorly printed photos of bicycle spokes could one photo teacher endure? Why do innocent beginning photographers fall prey to ho-hum subject matter? If I were less naive, I would put my foot down: no photos of your bicycle, or worse yet, of a line of bicycles, unassumingly locked up in graphic formation, begging for depth-of-field flexing. No, I leave the door open, remaining hopeful that one day, walking into a critique, in a sea of totally soporific bicycle wheels, would hang that one redeemer—spinning, spiraling, intergalactic, a radiant spaceship ready to teleport me directly to . . . heaven? The class, in awe and silent consensus, would agree that this is genius. "What is it?" we'd ask, breathlessly. A student in back, who had probably never spoken until now, would say: "That? That's just a bike wheel."

I am not good at saying *no*. In my own work, there isn't a *no*. The rules I set are broken so quickly that I've stopped making them. Everything can be interesting, surprising, edifying. Hoping to reconfigure the familiar, I walk the tight-rope above the jaws of the cliché. How to make it new? What matters is the approach, the consideration, how you see what you see, the feeling it generates. It's not that simple, of course,

and there are photos that feel wrong to make and that make me stop short. Usually, those have to do with people and the blurry territory of feelings, dignity, and privacy. I don't want to be in a position of power or judgment when I photograph. I don't want a camera that is a weapon, a peephole, or a pointing finger. I hope the camera can connect rather than classify or inflict pain. It's easier to photograph bicycle wheels, but it's not always the answer.

—Irina Rozovsky

## Big Hugs

## Bigwigs

## Billboards

## Bingo Parlors

## Birds

I don't think I censor myself very much, if at all. As long as no one yells or barks at me, you can be sure that I'm going to spend some time photographing what is around me. Interesting things will happen if you take the time to let them. The camera gives me the ability to focus attention on anything or anyone, applying worth where one may not initially see it. If I get lucky, I'll find wonder, curiosity, and beauty in the details that I overlooked. A few details I'm a sucker for are hands, the back of people's heads, birds, birds, and more birds. Hopefully, I'm challenging the tropes I actively try to avoid, but I admit there is a freedom in succumbing to them every now and then.

—Jim Goldberg

## Birds That My Cat Killed

The first bird my cat killed was a beautiful female cardinal. It broke my heart. The sadness was so overwhelming that

I wanted to memorialize its perfect little body. But it felt irreverent and disrespectful to photograph it, so I drew it. In many ways, drawing is the opposite photographing: you need to trace over the entire surface of the thing with your eye, you have to really observe it and question everything you think you know about how you are seeing it. It's a time-based process, and the first one took me hours. I've had my cat for eight years now, and I've made fourteen of these drawings. My cat also kills baby rats and brings them to us. I've never felt the need to draw the rats—or photograph them, for that matter. I'm not sure I would have started drawing these dead birds if the first one hadn't been a cardinal. Why should the death of the most beautiful be the most sad?

—Penelope Umbrico

## Birds Staring at the Infinite from the Edge of a Building

"Aesthetics survive even when intelligence slips away because anyone is capable of artistic production," I heard them saying. Yet they wish the same bus ticket was valid for more than one ride. I saw them waiting for a lizard living behind a mirror. How lonely the time must have been back then. Such work to be awake on green velvet meadows, to crush stems under worn soles. The rain has left puddles in their path. I haven't touched the ground in months. I look at them from the edge of infinity. Their passage leaves no imprint, no long-term trace. They look at me from behind transparent umbrellas, shadowing heads going bald. Their eyelids on double chins look pretty terrible in the sun, like fish in brown paper. Once wrapped, the gills cannot speak or ask questions. They think this building is their life, the delicate taste of a uniform gray, iron gates eager to be open. Some piece of advice—the concern of a man is just as his place. Immobility is here to stay.

—Valentina Abenavoli

**Blank Signs**

**Bleachers**

**Blurry, Running Water**

**The Boonies**

**Boot Prints in the Sidewalk**

**Boredom**

**Boring Houses**

**Boring Things**

My colleagues are all sorted: they shoot special things in a special way. Sometimes I reflect on that; had I been shooting something boring, they might see my work and respond. They would say, "Look at that! If we, too, were shooting such a boring thing, this guy would unmistakably have realized that he should shoot something else, something special, for instance. Surely he'd even proceed to do that!" They deduce, in order to stay on a safe side, that they'd better keep shooting something special rather than something boring. For that matter, as all my colleagues are shooting something special, I must, in order to stand out, be shooting something special.

—Peter Rauch

**Boxing**

**Boxing in Cuba**

**Braggadocio**

**Brand Names**

**Brand New Things**

**Brass Bands**

## Breadlines

In spring 2020, thousands of people who fell on hard times during the COVID-19 pandemic lined up each day for hours, in rain or blazing sunshine, to receive a bag of free food. This was a historic and overwhelming event in Geneva, the wealthy city where I live.

I had been working for over a year on a project on immigration violations in Switzerland, revealing the instability in which illegal workers lived. And yet I didn't want to go see these lines. Every week for over a month, the numbers grew larger as the same people lined up, joined by others who had also fallen into extreme poverty.

On the last day—before the food distribution was decentralized to the municipalities—I decided to go. I saw several photographers I knew from the press and television there. The project I had been working on was committed to showing the ways the fundamental rights of illegal immigrants were being disrespected. Except that there, in the line, the situation was different. They couldn't choose to be part of my project. They were subjected to our gaze and our cameras as they endured their fate. The closer I got, the more tears came to my eyes. I never took my camera out. I walked along the line with a quickening step, as if I was there by chance. I was ashamed that I had come.

This fall, a large exhibition in the city commemorated the food distribution efforts, which the wall text described as "the beauty of the mutual aid between the citizen and the poor person." I had not been able to bring myself to photograph any trace of it and, in a way, I felt guilty.

Later, one of the protagonists of my project, who lived through this horrible situation, told me that she found the exhibition to be awful. She said that these photographs were a reflection of great hypocrisy. She was right.

I'm not saying that information, images, archives, or art are not important, but at what point should photographers

refrain from having to document everything? From documenting too much? Or rather, how can we do so more ethically without being the privileged person in front of the victims? I don't know, and above all, I'm not sure I've done any better so far either.

<div align="right">—Laurence Rasti</div>

## Breaking News

## Brick Walls

It's absolutely repulsive to place boundaries on what I shoot. To shoot or not to shoot, that's all. I can't think that much in the act. It's while scrolling through thousands of images that freeze and load as I wait for my computer to crash that I begin to contemplate, Why all the brick walls? Again with the brick walls? Really? More brick walls. The sentiment that one is too many and a thousand never enough is a recurring theme in my work. I keep getting the same shot over and over and over and it results in nothing different. Is that the definition of insanity?

<div align="right">—Jason Nocito</div>

## Bridges

## Bright Sunlight in the English Landscape

## Broken-Down Cars

## Broken Windows

## Bubbles

## Bucolic Scenery

## Bullet Holes in Window Glass

## Bull Fights

## Bumpkins

If I consider someone a bumpkin, or a hick, dum-dum, Joe Sixpack, etc., then I'm probably starting with a prejudice, and that's a problem for the pictures.

—Amy Pinkham

## Bunting

## Burning Candles

## Burning Man

## Buzzwords

# C

**Cabin Porn**

**Cables**

**Cacti**

**Cairns**

**Cameras**

**Camp**

**Candid Photography**

After I moved to New York from suburban Southern California and in my early explorations with photography, I was fascinated by candid photography, usually taken in the street and with the idea that chance is a conduit that puts the jumble of people, things, and structures of dense environments into accidental visual arrangements. I have since moved in an opposing direction, making images based on what I think about beforehand. I haven't taken chance out of the equation, just the jumble of people, things, and structures of the city.

—Arthur Ou

**Cannons**

**The "Canon"**

**Cappuccino Designs**

**Carcass, Flies**

**Car Crashes**

**Career**

**Car Fires**

**Car Headlights Approaching in the Distance**

**Car Hoods That Are Sunburned**

**Carnival Mirrors**

**Carnival Rides**

**Car Pictures**

I didn't avoid taking car pictures. My archive is full of them. But I didn't fully realize the prevalence or richness of those images until I scanned my archive on retiring. The car, in my work, epitomizes the desire for the American dream or symbolizes our degradation of the environment. I try never to stop myself from photographing subjects that are interesting to me. Yet this question of what I avoid photographing, regrettably and sadly, reminded me of a time when I implored my students not to make the car picture. It was likely that cliché picture that I wanted them to avoid, the car as a symbol of status and wealth. Boy or girl standing proudly next to their car in the late afternoon light. Their self-portrait and their desire to be part of the American dream. I think now of the pictures lost in their photographic archive due to my shortsightedness, and my bias. Likely, hopefully, they were smart enough not to listen to me.

—Mimi Plumb

**Carrots**

### Carrying a Camera around my Neck

Whether indoors or outdoors, I have always used a tripod for my photography practice. This is, in part, due to my initial training as a photographer at the Académie des Beaux-Arts in Paris, where I reproduced master paintings for the academy's catalogues.

Last summer, I went to Bretagne to buy a medium-format camera. I held it around my neck to test it. I was on the edge of a wild beach, and the camera was so voluminous that it prevented me from seeing my feet and the ground I was treading on.

Tragicomedy ensued—I fell in a hole because of this box and broke my ankle.

—Lise Sarfati

### Cars at Night with a Long Exposure

### Cash & Credit Cards

### Catcallers

I make a lot of photographs along busy commercial roads. Often, I get catcalled by young men moving past me in cars or on mopeds. Approaching fast as I focus to make a picture, they'll let out a suggestive whistle or yell something to throw me off. Many times, these same guys come back around to check out what I'm doing—and then they ask me to take their picture! My first instinct is always to say no and remind them they just hassled me a few seconds ago. Instead, I tell myself not to waste an opportunity with a willing subject, hoping it will yield something interesting. The pictures happen fast. I don't remember any of these men until I see the images later. My perception is clouded by the anger and frustration of being interrupted, and a healthy dose of anxiety and fear around how the encounter will unfold. Something I've learned from looking at the pictures

is these catcalling men are never alone. Does this suggest some vulnerability? Would they be less brazen on their own? They never ask me for the picture I take; I wonder if they care where it ends up. After looking at a group of these images recently, I was struck by how tender they can be. One particular image gave me pause: it was of a young man looking sweetly at his buddy, with their arms wrapped around one another. I don't remember which one of the men called out to me first. I vividly remember my irritation, but when I look at the picture all I see is, Hey, this is my friend, I love this guy. Take my picture with him.

—Manal Abu-Shaheen

## Cats

Ken Gaghan, who was a mat-cutter in the Bay Area, would always say, "I will cut a mat for anything except pictures of cats or the Golden Gate Bridge." He was a mini legend; he published a book on mat-cutting for artists and even had a radio show about photography on one of the public radio stations here, like fifteen years ago. He was truly a jolly man. I didn't listen to him about the cat pictures though.

I once found a cat photograph among studio portraits of a young woman, from what looks like her high-school photo shoot. The photographer must have photographed the cat in the same session, and it looks so stunned, I can't help but think of the picture as a cat mug shot. I ended up taking a photograph of a friend's cat later, which is one of my all-time favorites, inspired by the found image.

—Todd Hido

## Our Cat, Stickies, Looking Really Good on Furniture

Our cat, Stickies, looks so good on the living-room furniture. Every time he's in there lounging alone, he looks so perfect that I have to take a picture. I hate that these photos turn him

into an object, and I hate how they betray my bougieness. I used to hate cats and people who talked about cats and now I've become a cat person, and I hate that too. Pictures of Stickies in the living room combine many photo-crimes simultaneously: pet photos, humblebraggy photos of beautiful apartments, attractive photographs of one's own children. They are as smug as photos of just-plated, homemade food. Stickies does look so great on mid-century modern furniture, though.

<div align="right">—Nina Katchadourian</div>

## Cave Openings

## Celebrities

I will not mislead or manipulate the people I photograph. Given that this rule is met, sometimes, when I do not want to do something, like accept an assignment that seems outside my abilities or interests, the best thing is to do it anyway. Other times, it is important to know when to acknowledge my limits. There is a very delicate line between the two, which each of us has to find for ourselves. How do I distinguish between what is not the right thing for me—not something I relate to or can deliver on—versus my insecurities and fears standing in my way?

A little after I started taking editorial assignments, I began to doubt whether I was the right photographer for celebrity shoots. The way those shoots are conducted with many people on the set and the PR people questioning every decision, allowed little opportunity to show intimacy or real, complex, tense, or even flawed moments, which is more what I am after in my work. I decided I would start saying *no* to those kind of assignments.

Shortly after this decision, I was hired by George Pitts to shoot the founder and lead singer of the Foo Fighters, Dave Grohl, and his mother. A few years earlier, I had met George

when he was the photography director of *Vibe* magazine, and I was mostly exhibiting my work in galleries while making a living as a professional belly dancer. George was the first to approach me about shooting an editorial assignment. Back then, I was too insecure and anxious to say yes. The thought of having to make good images in a limited amount of time, especially when I knew how many weak and mediocre images it takes in order to make one good one (if a good one happens at all), made me doubt my ability to deliver on this challenge. When I said no, George and I talked about what it means to be an artist doing work on assignment, work that is not done as your personal work, on your terms. I kept thinking about this conversation. It inspired me to doubt my doubts, and I eventually started taking on the editorial assignments, learning and expanding my knowledge and abilities as a result. That *no* was as valuable as any *yes*, and George and I kept in touch and became friends.

So when George, then photo director of the relaunched *Life* magazine, called about this assignment, rock stars and their mothers, we talked about why I was nervous about photographing celebrities. He persuaded me that this assignment, in spite of being a celebrity photo shoot, was right for me: the context of motherhood, the location of the shoot at the subject's home, and no PR people or any other person on the set.

So I said *yes* to something I felt like saying *no* to, got over my nervousness, and listened to George's wisdom and experience. Knowing that he knew my work and me well, I could trust his judgment. I took the assignment this time, and it went very well. Despite Mr. Grohl's fame and my intimidation, when his mother stepped into my sight with her love for her son—she called him "my genius baby"—I forgot about it all, and my picture, a picture about a mother's love, happened. And the *no* was a wonderful *yes*.

—Elinor Carucci

### Celebrities Out & About

### Cellophane

### Cell Phones

Nothing has changed people's relationship with mild boredom in public more than the cell phone. People generally don't read newspapers or books on subways and busses anymore, they don't stare out the window into space, or simply enjoy their cigarette while mired in thought on a smoke break. Those are now perfect moments to check your e-mail, contribute to a text chain, play a video game, or check social media to see if Armageddon has finally begun. Those used to be great moments to shoot a photo of someone. What visual benefit is there in shooting a distracted person with their head in a phone? It's too easy and completely boring. I've done it enough times to know.

Even as late as 2010, I carried around in my pocket a folded piece of paper with hundreds of my friends' phone numbers printed out in four-point type across six columns. Coming of age well before cell phones invaded our lives, I was a holdout and refused to get one. I hated them. They were ruining everything, and I believed they caused brain cancer. I lasted a decade before caving. Two things forced me to give up: copper thieves and Google Maps. Increasingly, when I would show up to a pay phone, they were gutted and instead of fixing them, phone companies removed them altogether. And Google Maps was too good to be true. I dove into the rabbit hole. Even though I have owned a cell phone for a decade now, I still struggle with my love/hate relationship. I detest them in my photographs and actively avoid shooting people looking at them. I don't know why, and it's no easy feat these days. It's not as if this will make people think that my photographs are from the 1950s. Perhaps I'm too nostalgic, and look too much at pictures from the time before we all carried around mini computers equipped with cameras. My

wistfulness makes me wary of the current state of street life, its ubiquity of phones and pervasive advertising. It's hard to imagine people of the future looking back on 2020 with nostalgia, like we do with Walker Evans photos from the 1930s. But I suspect we will.

How would Henri Cartier-Bresson or Helen Levitt have dealt with this activity infecting life in the streets? I think I know the answer, but I'm no authority. As chroniclers of their times, they would have artfully shot whatever was happening, even if the streets were 100 percent populated with people whose faces were bent downward into their phones, because it would tell the story of that particular era for future generations. Maybe I need to remind myself of that.

—Ed Templeton

## Cemeteries

Like many beginning photographers, I took some of my first pictures in cemeteries. But as my photography became more sophisticated, cemeteries joined railroad tracks, abandoned buildings, and sunsets on the list of forbidden clichés. Discussing this with my photographer friends Ed Panar and Melissa Catanese in Pittsburgh, Ed told me he still regularly photographs in cemeteries. "Ed is so not cynical," Melissa said, "the idea that something is cliché just doesn't occur to him. He doesn't have a cynical gene in him."

Ed is the single happiest photographer I've ever met. Wanting a little bit of that to rub off on me, I asked him if he'd take me to a cemetery. It was nearly sunset, and he led me to a bluffside cemetery near his home. He pointed to a particular spot where he's made a number of pictures. I couldn't imagine photographing in the same spot. Everything was too spectacular. But after setting up my camera and looking through the ground glass, I realized why Ed was so happy.

—Alec Soth

**Censorship**

**Centering the Subject in the Frame**

**Chainlink Fences**

**Changing Your Vision to Meet the Market**

**Chaotic Backgrounds**

**Chauvinism**

**Cheap Shots**

**Cheerleaders**

**Cheese Sandwich**

I will photograph anything, the less promising the better. I have, though, never taken a picture of a cheese sandwich.

—John Gossage

**Chickens**

I have a phobia of birds, so I do not even like thinking about taking pictures of them.

This started when I was around seven years old. At that time, our house was a wooden shack, or "barraco," as the houses with a small piece of land in the favelas of Rio de Janeiro are called. Our bathroom was outside in the backyard, and it had just enough room for the toilet and a big barrel of water we used to take showers.

One day, my father brought two live chickens home from the market and tied them up in the backyard. I was always curious around animals and dreamed of becoming a veterinarian, so I started prodding the chickens with a small piece of wood and, somehow, they got loose. My father was so angry that he threatened to hit me if I did not catch them, but the backyard was very big and I was very small. I tried, but it was

impossible. He got even angrier and locked me in the bathroom. After ten minutes, he opened the door and threw the two chickens inside with me.

It was a total chaos! I closed my eyes and felt one of the chickens beating against my chest. I grabbed it and instinctively twisted her neck, my eyes still closed. Everything stayed silent until my father opened the door again. The dead chicken was still in my hands and the other one was hiding in the opposite corner, completely terrified, just like me.

—Bruno Morais

## Children Looking Directly into the Camera

## Children Playing in Water Spraying Out of Fire Hydrants

## Children Unaccompanied by an Adult

Many moons ago, when I was still teaching basic photography courses at universities, it would sometimes become necessary to craft a sign with an image of a duck, or maybe a waterfall, surrounded by a bright-red circle and a strong diagonal slash to indicate that this particular overly photographed subject was now forbidden to students. To be fair, Henri Cartier-Bresson made one transcendent photo, late in life, of a duck in a canal turning to glimpse its own shadow. And somebody somewhere has possibly taken a photo of a waterfall that's more interesting than the scene itself.

John Szarkowski famously observed of Atget, "Ten thousand pictures of Paris, not one of the Eiffel Tower." So, not wanting to defy Atget, I've made fewer than a handful of Eiffel Tower photos in all the time I've spent in Paris, and in these, the tower is in the background and slightly out of focus. But this is still minor-league taboo territory, and honestly, like Atget, I'm just not that interested in the Eiffel Tower. In general, too many people are beating themselves up over what they think is right or not right. So, the

following rule is for me; please, it need not be for you.

The only rule I pretty much stick to nowadays is one I didn't think so much about when I was in my twenties: do not photograph young kids unaccompanied by an adult. I photographed lots of kids in the 1980s; this decade was the tail end of an era when kids could still roam their neighborhoods unsupervised. Something changed in the 1990s; maybe it was all the cable TV channels and the rampant air-conditioning. Cars got bigger, and people drove around with their tinted windows rolled up. New communities surrounded by gates and fences were built. The people who remained walking the streets in the '90s were largely those who couldn't afford cars. Where did all the kids go? I began to miss their public displays of play and mischief.

Today, everyone has a camera with them at all times, and their images can be disseminated in ways that were unimaginable not long ago. Society has also become less easygoing than it once was. I now have a three-year-old daughter, and I'd be startled to find someone photographing her without my knowing why. Now, if I see something that might be good to photograph that involves kids, I look for some sort of guardian. If no mature person is around to ask and explain, I let the scene slip by.

—Mark Steinmetz

**Chinatown**

**Like a Christenberry or an Evans**

**Christian Symbology**

**Christmas Lawn Displays**

**Churches Built in the Last Forty Years**

**Cinder Blocks**

**Circus Animals**

**Classic Cars**

**Classification**

**Clocks**

In 2015, following the painful ending of an equally painful relationship, I made a photograph of a clock inside a Los Angeles senior center. To be more specific, I made a photograph of numbers, one to twelve, orbiting around the gutted remnants of a government-issue industrial clock. At its center, there was a big gash—as if someone had punched the wall and ripped the hands of time right off. It occurred to me that this action transformed the object (and my picture of it) into a conflicted metaphor about timelessness: was the clock *out of time* or *eternally waiting*? What about my relationship and the lost object of my affection? Were we out of time, or waiting? And for what—closure? A reunion? What did it matter? I didn't know what I wanted. And so the clock, in all its uncertainty, also became a picture of me.

For a few years, whenever I saw photographs of clocks, all I thought of was the failed relationship and my ambivalence. I even gave an assignment to students mandating they document them. Perhaps repeated exposure would wipe away the metaphor? It didn't. Ironically, that was something only time itself could do.

As time passes (or, as I get older) and revisit the image, I return less to my life circumstances at the time of the picture's genesis and instead find myself reflecting on the fact that the picture—and more important, the clock—was located in a senior center, a fact that I undoubtedly gave less importance in my youthful rush to assign meaning to my first heartbreak. Now, when I think of the picture, I like to imagine a group of eighty-year-olds playing cards and looking up at the clock watching over them, as if counting the days. Frustrated, they borrow tools from an adjacent woodshop, gather some chairs, and climb carefully on top of

them as they take turns bringing a hammer to time's face. In the process, they put a hole in the wall. Afterward, they continue playing cards, satisfied to have freed themselves from the imaginary prison time makes for us all.

—Mark McKnight

## Clothes on a Clothesline

## Clouds

Big, colorful cotton balls or dark swaths of gray, forever shifting. The clouds always do a superb job of slapping me in the face and yelling at me to stop and look up. I admit that's something I'm not so good at, stopping. Or looking up. I think it's a bit of a photographic cheat to take pictures of something so majestic. Yet I never miss an opportunity to cheat. Every body of work I create includes images of clouds, and I use them as a backdrop for almost every portrait. For something so high in the sky, when I look up, I feel grounded, secure, centered. It feels like a defiantly feminine act to photograph the clouds.

—September Dawn Bottoms

## Clouds That Look Like Sex Organs

## Cloudy Days

## Clowns

## Coastal Sunsets

## Coliseums

## Colonizers

## Color

For years, I didn't allow myself to work with color. I trace this decision back to a critique when someone asked me, "Why

are your colors so ugly?" As a Mexican, I had a very different relationship to color than my peers. The question itself raised more questions, about perception and relativity in seeing, and it changed my way of working. I moved away from color, and eventually took it out of my work entirely. I focused on space and depth in black-and-white pictures, on the ways light can construct the image, and on how photographs shape our perceptions of reality.

I did not think that I would go back to color, but it has become my latest obsession. Now that I have explored some of my questions about perception and space, I can work on those that were too uncomfortable back then: How does color change our perception? What is beyond the visible spectrum? How do I give meaning to something that is already meaningful?

My first attempts were flat, as if color defied the depth of space, and with that, resisted definition. I made my way back to the darkroom, experimenting with color photograms and pushing the image to find more depth. In these explorations, I found parallels to the act of looking: we, too, are capable of expanding our vision beyond our own limits and into hidden depths. Color is an experience; it is elusive and, like light, it is slippery in our perception. When I think back, I realize that I was trying to juggle too many variables. I had to remove color to be able to push on with other aspects of the work. Now, I can explore new ways of working with light.

—Fabiola Menchelli

## Color as a Subject

I try to avoid being unclear in my intent. If the purpose of the work is not clear to the audience, it will fail. I try to shoot only when I'm having fun. The audience knows when you're not; it will show in the work. I try to avoid shooting people who care about how they look. I try to avoid shooting landscapes in general. To me, a landscape is more like a stage waiting for somebody to do something.

Everything else is open for play. A subject is only trite if you're not being honest.

Except, there is one other thing that almost ruined my ability to photograph in color. In 1980, I was at the School of the Art Institute of Chicago and, like most photo programs at the time, they were opening up to the new color processing kits. I wanted to photograph in color, but after shooting black-and-white for ten formative years, I was way over-self-conscious about it. I started shooting *red* fire hydrants and *yellow* curbs. And I was bored to death. A visiting artist recognized this and told me, "Just shoot like you always did in black and white. Don't think of color." I think that was the best advice I received in my entire photo-education. Sometimes big problems have simple solutions.

—Michael Northrup

## The Color Green

## The Color Red

## Columns

## Comfort

As an artist working primarily with photographs, I try to use them to talk about the discomfort of racism. It isn't easy to do. I ask myself, Is it okay to share my personal views on race with the public? And is it okay to post the resulting work, to tag it as beautiful? Talking about race isn't easy to do within photographic culture, in graduate school, or in the art world at large, where many viewers look to art as an escape from political and social issues. As a Black artist in pursuit of beauty, I've often avoided what I see as the comfort of posed Black bodies in the images I take with a camera, or that I appropriate from visual culture. Instead, I'm drawn to images and situations that provoke an empathic response.

**60**

Perhaps I have been naive in my work, thinking that photography can bring forth some form of racial justice. But my tendency toward self-disclosure and critical hypervigilance makes it hard to build relationships centered on aesthetic comfort. I am Black and angry, and I can't help it. This anger is with me when I create art. I wonder sometimes, Why shouldn't I validate my anger through photographs?

One night, after arguing about race with white people, I asked myself: How can I get my white colleagues to understand the fear I feel as a Black man, simply by existing in America? That night, I had a dream: I saw three stacked Zen rocks placed in front of various flashing, sublime landscape images. There were waterfalls, valleys, meadows, and streams. The next morning, I used Photoshop to cut an unarmed Black man from a widely circulated news image, and placed him into an archival landscape photograph from the National Park Service.

—Andre Bradley

## Commercial Assignments

## Complacency

My artistic practice is motivated by people who have never seen themselves in art and are unaware of the power of art in social change. I was once part of this group. Before I begin a new photography project, I ask myself two questions. The first, Does this project reveal a contemporary truth, something greater than myself, that will give a voice to the unseen and unheard? The second, What is the risk? How am I growing and expanding as an artist by making this work?

If I am not even a little uncomfortable in making new photographs, then why am I doing it? A friend once told me, "You have to be comfortable being uncomfortable." My growth as an artist takes place in those moments of fear and insecurity. Yet because of my faith, I am able to pray about it and release any anxiety.

—Endia Beal

**Compost Piles**

**Compromised Subjecthood**

**Concealing Your Face**

**Conceptual Bodies of Work**

**Concession Stands**

**Conch Shell on Colored Paper**

**Condescension**

**Coney Island**

**Confederate Flags**

**Confederate Sympathy**

**Confessions**

**Confetti**

**Conflict**

**Conflict in Eastern Ukraine**

I was born and raised in Stakhanov, a city in Eastern Ukraine. For the past six years, the eastern part of Ukraine—the Luhansk and Donetsk regions—has been an occupied territory and suffered greatly from ongoing war.

This is a very sensitive subject for me, since my family still lives in the area, which is separated by guarded borders. I cross the borders every time I visit my parents, and every time is a difficult emotional experience. I want to help the place where I was born and the people that live there.

My work as an artist lets me *speak*. I would like to make work about the war and what is going on in the East of my country, and I have a few ideas for a project, but at this point,

I avoid taking pictures. To create work about my motherland would require me to cross my professional borders into a very personal and painful territory. I need time to think through each detail in order to be able to express my thoughts and position carefully but clearly. Also, I need to understand how to bring a project like this to life, because not only could it be dangerous due to hostilities, but photography is forbidden in these territories. I have to know I can keep my family, my team, and myself safe.

—Julie Poly

## Consequences

Literally speaking, I try to keep myself away from photographing trees at night with flash, or any type of tree with strange lighting. It does not matter how you photograph trees with lights, it always looks good; it's addictive, and it can fit any story or narrative you are working on, one way or another. The same is true for dead animals. The only exception would be if I was working on a story about trees at night or dead animals.

Metaphorically, I try to avoid (as much as the story I am working on allows it) adding unnecessary layers to an unfolding story, especially those that seem related to purely aesthetic needs. I, like others, have a certain attraction to the aesthetics that emanate from the unfolding drama. Photographically, they're like the drama within the drama. The hardest ones to keep away from are unconscious, those related to our visual education and history, as well as the way we consume images.

Instead, I try to find mechanisms and alternative aesthetics inside the narrative that allow me to document the unfolding drama in a more direct—and possibly even more ethical—way. For example, maybe the best way to portray the complex and unfolding drama of the communities affected by oil contamination in the Niger Delta is to photograph the CEO or the headquarters of Royal Dutch Shell in Amsterdam, rather than the oil-soaked landscape. This may not always be

effective or possible, but for me and my practice, this kind of approach is worth considering. I see it as going to the source of the problem and keeping away from the consequences.

—Mathieu Asselin

## Construction Sites

## Contemporary Media

## Contempt

## Context

Since the first iPhones came on the market in 2007, the abundance of images we consume—mostly on screens—has skyrocketed. It's probably no coincidence that we founded *Der Greif* shortly after, with the intention of exploring individual images in new contexts, juxtaposing images from different sources and makers in an experimental print layout. We see the two-page spread as a white canvas where images meet, becoming like one new image in the viewer's mind. Through open calls, we invite image-makers from all over the world to submit their work and potentially become part of *Der Greif*. Entrants knowingly step back from controlling the context in which their image will be shown. For me, it's a constant experiment. The process of making the publication feels like learning to see through the eyes of thousands of artists. It never gets old that a single image can be considered in so many different ways. Since I have no emotional attachment to their original contexts, I can see freely with these pictures. One could argue that I steer clear of their initial context. Since artists and photographers trust us with what can be a rather delicate affair—finding a new contextual home for their images—I should say that I avoid potentially offensive contexts. Not every visual context works. I try to avoid those that don't.

—Simon Lovermann

## Control

Surrendering control is the impetus for Attraction Experiment, a series where I ask past lovers, best friends, new acquaintances, and other people I'm drawn to, to sit with me and make a portrait of the two of us. The work began as an attempt to neutralize power in portrait-making. I offered past sitters and collaborators the opportunity to direct me in a portrait. They could now control my image, just as I had been in control of theirs. The work is not only about subverting power, control, and desire, but also about making interventions in unfamiliar spaces. Participants are given very little information. Each request to join me arrives by e-mail. We meet at a bar in Williamsburg. It has one of the last remaining vintage photo booths in New York City. The atmosphere is different depending on the time of day. At 2 p.m., there are toddlers running around on the patio, and closer to midnight on a Friday, the bar is filled with a mixed crowd dancing the week away.

At the start of the project in 2017, I was craving spontaneity. I wanted experiences that would make my body feel something. Through each ask and performance, I was forced to consider what my collaborator wanted: How do they adjust my performance? In what ways do they use my body? Do they touch me? Do they want me to touch them? I was also interested in whether that feeling of numbness I had been experiencing since that fall would dissipate with these encounters and requests. It did. I was surprised by how easy it was to give up power, and things moved quickly as the bulb flashed every fifteen to thirty seconds. The time in the booth was fleeting, and perhaps the submission felt safer this way. I knew that whatever was happening would soon be over, and we'd step out and take a breath.

—Naima Green

Corgis

Corn

Corniness

Corporate Logos (Unless Somehow Mitigated, Truncated, or Otherwise Damaged)

Correctness

Cosmetic Retouching

The Country Club Set

Country Roads

Couples from Behind

Creature Comforts

Creeps

Crosswalks

Crowds

Crows

Cruise Ships

The Crumbling Old World

Cuba

Cubicle Life

Culture Shock

Cupped Hands Holding Something

Curios

## Curiosities

## Current & Political Topics

I was born in an era when being an artist was a profession, like being a poet or a philosopher. In fact, I vaguely remember Ezra Pound mentioning that the most ideal methodology to understand art was through poetry and philosophy. In the five decades that I have been an artist/photographer, my goal in producing imagery has ultimately been to create works that are uncanny and virtually indescribable with words. Many of my photographs depict a fragmented world of broken objects, fear of death and annihilation, animals on the loose—a chaotic environment merging fact with fiction, reality with fantasy, and an archetypal mind-space that links us to a hazy, nebulous world. While viewers may not understand how my images were created, the environment they were shot in, or the cultural context, they implicitly understand. The pictures pierce the conscious mind and enter the subconscious. In other words, they hit something inside, through a process most people cannot escape; they are right in your face.

Over my career, I have tried to avoid the issues that dominate contemporary art. As time passes, I have noticed a greater and greater tendency for artists to focus their creative energies on issues that the media exposes as important and relevant. It is exceedingly difficult to determine whether the issues that people identify with are a direct result of media hype, ultimately geared toward expanding viewership (and henceforth profits), or are genuine issues with a basis in human needs and values. Nevertheless, I feel reluctant to find myself in a situation where my artistic expression is being driven by media forces, in whose genuine purpose I have little faith.

It is clear to me that at this time in history, a great percentage of contemporary artists and photographers are not interested in making the transition from exploring

media-driven slogans to coming to terms with the enigmatic, mysterious boundaries of our short lives on this planet.

—Roger Ballen

## Cynicism

## Cypress Silhouetted against the Setting Sun

How can I not take this picture? I have taken it, many times. But the pictures will never make it out of my contact sheets.

—Marcia Quick

*The desire to put a photo in the wrong way round just wouldn't go away. I've been waiting for the right moment for years. Shall I turn it round? Let's see how it would look on its side.*

# D

**Dabbling**

**Dada**

**Daisies**

**Dark Water**

> Capturing the motion of a body of water at night is photographically impossible. A slow shutter speed is necessary in low light, rendering the water as a blur. I forget all of this when I am near an ocean, river, or lake at night with a camera in my hands. If I start photographing, it will be hours, days, or weeks before I give up. It is the hypnotizing combination of scale, rhythms, and light that have me hooked. I want to fix the last light leaving the sky onto a 4-by-5 transparency and to mark the reflection on the water's surface. I want to capture the power of ocean waves crashing on the sand. I want to imprint the fear of entering a dark ocean to swim on a piece of film. I want to photograph the darkness of a river eddy swirling in the night. All of this desire and impossibility inspires the photographs that I can make.
>
> —Sharon Harper

**Dawn**

**Dead Animals**

**Dead Children**

**Dead Flowers**

## Dead Man

"How would you feel if you were lying dead and someone shoved a flash in your face?" That was a question asked by a well-meaning pedestrian who intervened after I photographed a man lying dead on Madison Avenue.

In March of 1991, I happened on a group of people standing around a body lying on the sidewalk. The man appeared to have been in his mid-seventies and was dressed in business attire: white shirt, patterned tie (loosened), dark gray raincoat, and hat. His left hand, still gloved, clutched the leather glove for his right. His mouth was slightly open. His skin ashen. I turned away and continued walking up Madison Avenue.

As I walked half a block north, my mind was in the midst of a debate. I didn't see harm in making a photograph; I had wanted to, my camera and handheld flash had been in my hands, but I did not. I was timid because of the crowd surrounding him. I was angry with myself that I had allowed timidity to dictate what I could and could not photograph. I returned and made six exposures.

The first three were failures: the frames poorly managed, the flash didn't fire during the second exposure. The last three exposures worked. Then the bystander pushed me out of the way angrily asking, "How would you feel . . . ?"

The man's question was the exact kind of response I initially feared. To him, I was an opportunist who was exploiting a dead man on the street for a photo. Why should I care about the presumptions of strangers? Well, because I am sensitive to misunderstandings. I don't see my practice, nor photography generally, as disrespectful. My entire outlook is that photography has very little to do with "making good pictures"; rather, one uses the medium to learn something about the world, oneself, and photography. I follow my instincts and trust in the world and the medium. I am the weak link in that three-way collaboration. I will be the one that fails 99.99 percent

of the time, not the world or photography (flash misfiring excluded). When I walked away the first time, I had once again failed, but in the worst way; I hadn't even honored the collaboration. I allowed a presumption to kill the impulse all together.

Twenty-nine years later I still have a very uneasy relationship with the photograph. Each viewing reminds me there are aspects of photography which can be perceived as antisocial or insensitive. So what I'm writing here is less about what I tell myself *not to photograph* but rather *what I can't photograph* now that I have this picture. Should a similar situation play out tomorrow, I doubt I could raise my camera, but for a different reason. This one picture raises questions that I have grappled with, but what additional questions would two, three, or ten photographs like this raise? What if the answer was no additional questions at all? I can't know without doing, but that possible outcome is why I hesitate in taking the risk.

—Jeffrey Ladd

## Dead People

## Dead Snakes (Especially If Flattened)

## Death

I used to take pictures for the police. I was not employed by them, but took pictures for a personal project. I had a deal with the editor of the police newspaper. I was allowed to accompany the police anywhere, to photograph what and how I wanted and, in return, he would get to use the pictures for the paper. I had photographed successfully in many departments, from the vice squad to anti-theft to forensics. Everyone was incredibly friendly, which I hadn't anticipated before I started.

But when I arrived at the homicide department, I spent a lot of time waiting around the office. After a couple of days of learning a lot about the eating habits of police officers, the

investigators sent me home, saying they would pick me up if anything interesting happened. The following night at three o'clock in the morning, my phone rang. Two young detectives came to pick me up from home, and we drove to a tower block in the suburbs of Cologne to investigate a suicide. The investigators seemed a little bored. They told me that people regularly—about once a month—jumped from a particular tower, the tallest building on the housing estate. For the police officers, it was routine. Murders were rare, they informed me; on average, one a year in a city of over a million inhabitants. On the other hand, there were many suicides, and the police were constantly called to investigate whether each one was really a suicide or a murder after all. They did this thoroughly and carefully—all while talking about the "funniest" and most gruesome suicides they'd seen. It became clear to me that I would never kill myself, if only to avoid being ridiculed by underemployed homicide investigators.

Many photographers have things they don't photograph. There is only this one thing for me: I do not take pictures of death. Death is a powerful subject and also very tempting. Once you get involved with this subject, it becomes difficult to work on other subjects. This is why I don't photograph anything dead.

During my studies, I once tried to cut off the head of a dead blackbird, because I wanted to take a picture of the bird along with the chopped-off head against a white blanket. I had a pair of poultry scissors, and it wouldn't have been difficult to do the job. But I noticed that I had started crying. That wasn't usually my style. My mother believed that the spirit of the dead would rise from the head. This is why decapitation is such a dreadful way to die—the spirit will not be able to find its way. This somehow made sense to me at that time and explains why I leave dead things alone.

Now I stood in front of the suicide victim's dead body, which the caretaker had covered with a black tarpaulin. The police took one look underneath and advised me not to do so.

They talked about how the body had landed and how everything was twisted and distorted. I became slightly distressed, but at the same time, I started thinking about how I could take my picture, since it was clear I wasn't going to be allowed to look at the body—the brutal image of a demolished body was not what I wanted to show anyway.

As I stood by the covered body, I noticed blood seeping from underneath the tarp. It ran along the fugues between the bricks, creating a linear pattern that seemed to reflect the shape and monotony of the tower blocks. This struck me as the solution. I still allow this exception to the rule today: you may take a picture of death, but only if it shows something alive at the same time.

—Ute Behrend

**Decay**

**Decisive Moments**

**Decoration**

**Decrepit Machinery**

**Deer**

**Defiantly Locked Gazes**

**Demolition Derby**

**Dens**

**Destroyed Barns**

It's hard to photograph a real ghost. When I turned forty, I left my hometown of Los Angeles and moved to western New York. I was naive and ignorant and thought I was heading toward a Hudson Valley vibe, not a rural–New York vibe. I had never seen so many dead barns before in such a consolidated and contained landscape. Most of my friends

with photography backgrounds have lived in the Northeast at some point in their lives. They tell me these barns are common sightings—certainly a taboo to photograph. But they excite me so much! It's like seeing a lot of horror films and unicorns at once. I'm scared of them. They look cool. They look forgotten. They look like how I must look trying to learn to play the guitar now.

—Whitney Hubbs

**Detroit**

**Diagonal Forks**

**Didactic Messages**

**Dioramas**

**Direct Copy**

**Discarded Sofas, Chairs, or Pillows**

**Disinformation**

**Displaying Pictures in Public**

**Displays of Physical Strength**

**Distant Cultures**

Normally, I don't even feel that I can legitimately speak about my own neighbor—and this difficulty increases the farther I get from my house, my neighborhood, the suburbs surrounding my city, and, more concretely and by extension, Spain's Mediterranean coast. I am not attracted to the Iguazú Falls or the peculiar and ancestral diet of the inhabitants of Papua New Guinea. My game is local. My work explores familiar situations, and to do them justice, I need the tools that only someone in everyday contact with that cultural environment can possess. This is why I don't need to get on an airplane to

take pictures. On the contrary, it makes more sense for me to go for a walk or get on my bike with my camera.

I often need to focus my attention on a narrow territory. For example, a few days ago, I stumbled on a peculiar scene by the Albufera. A trumpet player was rehearsing in a palm garden, enjoying the shade and the quiet of the countryside. After taking his portrait, I found myself trapped, photographing all morning within a one-hundred-meter radius. I was emotionally unable to leave the space that the sound had demarcated.

On the other hand, the photographer's naivete when they try to capture a place that is not their own can be an interesting theme in itself. I explore the tensions and weaknesses I experienced photographing in Mali in *El Blanco* (cowritten with artist Iván del Rey de la Torre and published in 2017). I traveled around the country guided by the clumsy awkwardness of a child or a tourist relying on the beauty one sees when one has no experience or lacks all information—like the misguided enthusiasm with which someone may reach out to touch a jellyfish, tricked by its wonderful appearance. I was moved by a red beetle that is probably quite common to every Malian. I narrated the experience of Africa in the third person through the gaze of a Western tourist who depicts impossible scenes: a restaurant decorated with a loaf of bread, a night as red as blood, a horse with a leg in the shape of a question mark.

"To each their own," as they say. At this point in my life, I know that my emotions are transformed when I recognize things.

—Ricardo Cases

## The Distorting Lens of the Colonial Machine

In March 2020, the Museum of Modern Art, New York, had to close temporarily due to the COVID-19 pandemic. Three months later, I was invited to contribute to this volume

on the unwritten don'ts of photography. I wasn't sure how to respond, given that during the past one hundred days of home seclusion, all I could think of was the do's—what we *should* do in the face of unfolding political and social transformations. I felt that we all had a responsibility to engage purposefully with the unprecedented health crisis, the climate change predicament, and the antiracist revolution that germinated long before the virus, led by the Black Lives Matter movement. After all, visualizations are consequential in shaping our understanding of the world. Still, I was intrigued by the idea that photographers may avoid taking pictures for intended or arbitrary reasons. It mattered that ethics, consciousness, perception, and meaning informed their intentions.

A series of old and new questions surfaced: Who speaks in a photograph? Who is visible, who is invisible, and how has photography contributed to a hegemonic system of visuality? How is truth represented? Is there free will? When is it not morally permissible to take a picture? When is it imperative to take one? Are images mediations or meditations between the world and human beings? Can photography disrupt the dialectics of asymmetrical systems of power, structural racism, and rampant capital gain? Can it decolonize its own distorting lens? Can it envision new models of solidarity? Is there an external world to the homocentric picture of contemporaneity, a collective story of human aspirations with planetary implications?

The question of whether human civilization will survive beyond the next century is being weighed within scientific fields and at the level of government, and it is reflected in photographic discourses. With the first-of-its-kind image of a black hole stitched together from the observations of eight telescopes, registered fifty-five million light-years from Earth, how does such a likeness reflect on humanity? Perhaps in response to the accelerating dark time of

the Anthropocene, artist and geographer Trevor Paglen produced *The Last Pictures* (2012). It's a selection of one hundred images based on four years of interviews with scientists, philosophers, anthropologists, and artists about the contradictions that characterize contemporary civilization. Sourced from libraries or directly from artists, the pictures were micro-etched onto a gold-plated disc and launched on a communications satellite into space as a means of distributing to some extraterrestrial destination an abbreviated transcription of our culture. *The Last Pictures*, an artifact designed to last billions of years, may prove to be the last visual imprint that survives of human life on Earth.

How did we get here? It's consequential that photography's advent in the nineteenth century coincided with European colonial dominion and Western imperialist exploits—the "civilizing missions." Colonialism was connected from the beginning with its own intellectual inheritance, a received language of looking, and a history of images and the role these images could play in the political imaginary. Photography was never neutral, and contributed to the fabrication of visual mythologies and stereotypes associated with far-afield regions and non-Western peoples and practices. The medium thus, early on, provided a window on foreign lands, interpreted through the optic of Western culture that not only shaped imperial sovereignty and colonial expansion, but also controlled and nurtured collective memory in a rapidly changing global world. What is the one set of pictures that you would send out into space for futurity? What would you *not* photograph? Can photography dismantle a world founded on systemic inequity? Can it refocus on reparations? Can it imagine a new beginning? I'd say, let's start by looking at the field currently and question its historic assumptions. Then, we can begin reconfiguring its visual narratives, its do's and don'ts.

—Roxana Marcoci

## Distractions

Through photography, I try to manifest my vision and hopes, to keep looking for and re-finding ways to connect closer to others and to the world that I live in. Yet so-called civilization seems to be driven by technologies that dazzle us into multiple layers of distraction. In T. S. Eliot's poem *Burnt Norton*, he writes: "Distracted from distraction by distraction / Filled with fancies and empty of meaning." For me, the recurring question remains: how can I see those distractions and turn away from them so that I might put my attention toward the beauty, the tenderness, the sensuous, the magical, and so much more that is here to translate through the camera and shape me in the process.

—Léonie Hampton

## Dock Leading out to a Lake

## Dog in Hat & Sunglasses

When I began to photograph my dog Man Ray in the early '70s, I was careful to steer clear of anything anthropomorphic or cute. I had an aversion to dogs dressed up to look like people. I dressed Man Ray to look like an elephant, a frog, and other kinds of dogs. That was okay. But working with my second dog, Fay Ray, and the vertically oriented 20-by-24-inch Polaroid camera led me to abandon that manifesto. Still, I would never photograph my dog in a hat or sunglasses. Okay, maybe once or twice.

—William Wegman

## Dogma

## Dogs

It is my job as a curator to be discerning about what I see. I mostly trust my eye, but my critical faculties often fail me

when it comes to photographs with dogs in them. For all
the pictures of canines by Elliott Erwitt, William Wegman,
or Peter Hujar that I know are great, there are others that
I struggle to assess. Do I respond positively to a given pho-
tograph simply because there is an adorable pooch in it, or
because it is a good picture? Sometimes I am not sure. Since I
know that dogs short-circuit my judgment, however, I can ask
people I trust for their opinions to check mine.

A bias for photographs of dogs is, of course, a relatively
benign, if not ridiculous predilection, but it reminds me to
be aware of other preferences I may have that are potentially
more insidious and of which I might be less aware. Like
a good photographer, I must rigorously interrogate why I
gravitate to one kind of picture over another, or why I am
partial to certain types of subject matter and not others. If I
neglect to question my choices, I risk potentially perpetuating
stereotypes, favoring artists or subjects who look like me, or
upholding established inequities.

—Erin O'Toole

## Dog Shows

## Dogs in Coats

## Dogs Pooping

## Dolls & Action Figures (Especially if Mangled)

## Doors

Thinking back through past projects and books, I remember
a white door with faded red towels for curtains; a door taken
off its hinges and held by hands in gloves; an anarchy symbol
spray-painted on a studio door; a close-up of a cheap lock
that had scraped a groove in the adjacent wall. It's all too easy
to see a picture of a door—especially in a photobook—as a
transition, a path or a view, an in or an out. There's something
facile about placing a door in the sequence of a book—using

it to pull the narrative forward, giving the reader a false sense of access. As if they're being let in on something, or as if the photographer has uncovered some secret—both tired tropes. And of course, the opening of a door mimics the opening of a book. But I've always liked the flatness of a door, the feeling of a dead end. When I look at a door, I think of it as shut. Is that like seeing the glass as half empty?

—Michael Schmelling

**Double Negatives**

**Doublethink**

**Downright Laziness**

**Dramatic Scenes**

**Droste Effect**

**Duck Decoys**

**Ducks**

**Dusty Things**

**Dying**

## Easy Metaphors

I've had a goal of avoiding easy metaphors, those made in response to a perceived uneasiness or darkness that feels pervasive in our world—like the truncated remains of a tree, one that has been lopped-off at its midsection or de-limbed and left standing as a totem. This type of ironic symbolism closes down too easily around darkness, injustice, or evil and perpetuates a sinister state of mind. It also feels like a missed opportunity to maintain a more lasting emotional connection with the viewer.

Mostly, I'm bored by such a default depiction. As seductive as evil can be as a device and perhaps as a counterbalance to sentimentality, I'm more interested in toeing as close as possible to the line of sentimentality. A quote from author Jim Harrison resonates closely: "The novelist who refuses sentiment refuses the full spectrum of human behavior, and then he just dries up. . . . I would rather give full vent to all human loves and disappointments, and take a chance on being corny, than die a smartass."

—Raymond Meeks

## Easy Subjects

## Echo Chamber

## Editioning Prints to Make Them More Expensive

## Editorial "5 Minutes in a Hotel Bedroom" Portraits

### Editorializing

### Efficiency

Digital technology is great, but there's something to the inefficiency of working with film and paper that I enjoy. And I suspect it makes the final product better. When I'm making pictures, I almost immediately forget what I've shot, and then when the contact sheets come back, I see the images with some distance, which makes me a better editor. Also, I don't categorize any of my pictures with keywords, so there's a randomness when I browse through my contact sheets, and that leads to surprises, which I love.

—Dale Ingraham

### Eiffel Tower

### Elderly Folks in Erotic & Public Embraces

### Elegance

### Embellishment

### Empty Squares

Approaching St. Mark's Square in Venice from the side opposite the basilica makes it possible to admire the square with the majestic cathedral in the background. This is the perspective chosen by many photographers as well as artists, such as Tintoretto, who over the centuries have represented and celebrated this magical place. In Rome, the Piazza del Popolo reveals an architectural structure that uses optical illusion to underline the perception of the sublime; this, too, is made visible in photographs.

These past months, as my country, along with most of the world, sank into a crisis whose tragic extent we still have to grasp, we have been overwhelmed by photographs of empty squares: magnificent, silent, even rediscovered in

their tourist-less presence. This is the most recent manifestation of a trend that has been consolidated over the years: the flaunted narration that finds a safe and easy refuge in the aesthetics of history.

—Giulia Zorzi

## Empty Stairs

## Entropy

## Errant Gloves, Socks, Hats, Shoes, Underwear (Especially in the Desert)

## Ethnographic Images

## European Beauty Standards

## Everyday Objects

For years, I told myself not to photograph representations of everyday objects. Instead, I preferred the timeless classical still-life subjects: fruits and vegetables, vessels, plants, and flowers. I told myself that adding contemporary iconography could never function in my pictures. In fact, attempting to transcend my internal restrictions, I even tried and failed to successfully include modern commonplace objects, solidifying my feeling that I should definitely not photograph any representations of household items.

But then COVID-19 hit. I was spending all of my time inside and, since I could not process film, I began shooting with a digital camera. Normal working patterns changed; by day, I was helping kids with online school and running what my wife and I considered a "low-level restaurant," and by night, I was working. As my perspective on daily life changed, so did my feelings about what to photograph. Suddenly, including a representation of something like a battery, or pliers, or an iPhone did not seem so strange. It is hard to say whether it was the quickness of the digital technology or the

psychological implications of living through a global pandemic, but adding these utilitarian objects seemed natural, and the pictures came quickly. For me, discovering a way to photograph the things I told myself not to brought me to the exact things I needed to photograph most.

—Daniel Gordon

## Everything

I try to avoid photographing everything,
unless I really have to.

—Clare Strand

## Excess

I once photographed a woman at a motel who was suffering from drug addiction. She had been kicked out of her dealer's room and was sitting outside my door at 5:30 a.m. She was missing a good portion of her left calf and had left her crutch in his room. I sat and talked with her and then made her picture. I decided not to show her injury. The image said all that it needed to without it and hopefully, allowed some sense of grace.

—Danna Singer

## Exotic Places

## Explanations

## The Extraordinary

I hear the expression, "What an extraordinary view, take a photo." But to me, looking at a sunset is always a better experience than looking at a photo of a sunset. I'm interested in ordinary views, often overlooked. That's where I feel the real magic is, in front of you. That's my picture.

—Nigel Shafran

## Face Masks

What is a street photo without a damn face in it? When I walk around New York with my camera in the Age of the Pandemic and see someone covering their face, I don't bother snapping a picture. Hiding behind the masks are our public expressions of joy, anxiety, and everything in between. I miss them all!

As a photographer trying to capture the city, all I'm left with are homogenous crowds of people all masked-up, looking like they're ready to perform surgery. Sometimes, if I'm lucky, I'll get a peek of a bare nose perched on top of an N95 like a tiny, rare bird. Don't get me wrong; masks have brought us a few positive things, such as protection from the coronavirus. They've also dawned a new golden age for people looking to hide their weak chins. But photographically? They're killing me. Walking up Broadway, I pray that I'll round a corner to see a brood of anti-maskers, not out of spite, but to experience the ecstasy of the lower half of someone's face. It's almost illicit, so wrong that it feels right. As I press the shutter, I'm probably blushing.

However, if this is the new normal, I may have to evolve and figure out a way to make this work. After all, beauty is in the eye of the beholder, and a mask only covers your nose and mouth.

—Chris Maggio

## Face Paint

## Faces

When I first saw the work of Diane Arbus, at age sixteen, I was shocked. I realized that I would never reach this level of portraiture. I find faces too dominant, too emotional, and too melancholic. To compensate for this, I make portraits of animals.

—Paul Kooiker

## Factoids

## Factories

## Fake Scenes

I've taken many jobs with fashion magazines, shooting models and objects in forced and unnatural postures. They haven't come out well, and it has drained my inspiration and creativity. I don't like to fake a scene.

—Luo Yang

## Famine

## Famous People

When I started working as a photographer and contributing images to publications, one of the areas I wanted to avoid was celebrity. Much of my work involved placing individuals into my own world, and I felt that this would be an imposition for a prominent industry figure, especially given most celebrities' control of their universe, brand, and image. My perception was that celebrity meant an unavoidable level of production that would diminish the DIY or spontaneous nature of the kind of work I had been doing. I wanted natural and honest imagery, unprovoked, documentary-style pictures. With time, I was brought into projects that focused on celebrity. The process was not at all what I had

anticipated. I didn't lose spontaneity or organic chemistry. I've learned not to place too much emphasis on avoiding particular circumstances. It's more important to learn how to carve out an identity that feels like me even when I'm out of my realm of comfort.

—Justin French

## Famous Places

## Fashion

Even though clothing, style, hair, decoration, and a strong sense of personality dominate my photographs, I have always been against the idea of intentionally photographing "fashion." I feel a certain level of resistance toward the idea of setting up an image with a stylist and hair and make-up artists in an enclosed environment. I prefer going out to search for the energy and to stumble on characters that embody fashion instead of setting it up.

—Musa N. Nxumalo

## Fast, Shiny Cars

## Faux Pas

## Fear

I often find myself contemplating the relationship between fear and responsibility. As embers pirouette a wooden bridge, the uncertainty of this space leaves me on edge. But what is the journey of introspection if not comfortably uncomfortable?

—Bobby Rogers

## Feathers & Sticks

Let me say, I am not a hippy. But I have been collecting sticks and feathers for the last five years. I make little

arrangements around the house and studio, and secretly photograph them. I would never think of or show these photographs as my art.

<div align="right">—Sharon Lockhart</div>

## Feet

In general, I find very few feet attractive or compelling, and therefore, I find it interesting how often I come across them as a subject matter in photography. The sheer number of photos of feet with toenails painted red against a checkered black-and-white floor occupying space in my brain is astonishing. The same goes for people photographing their torso while lying by a swimming pool. They make me angry. My friend Jerry Vezzuso shares my anger toward feet photos; he once told me that photographs of feet are like photos of naked chickens, equally as repulsive. I once photographed a foot with a fork for a zine and titled it *This Is for Someone You Care About* (2018). The photograph, for me, is about feeling vulnerable and exposed. Feet are rarely compelling, with few exceptions, but they are placed on one of the most exposed parts of a person's body.

<div align="right">—Fryd Frydendahl</div>

## Feet on the Dashboard

## The Festival of Koovagam

## Firearms

I remember shortly after taking this photograph in the summer of 2001, feeling like I had accomplished something. I now had a gun picture, an image with edge, a powerful image. I was in my twenties then and still had some insecurity issues to work through, obviously. Now when I look at this picture, I feel little connection to it, thankfully, and certainly do not see it as accomplishing much of anything, except perhaps in its ability to deceive.

I don't remember too many specifics from that particular day, other than I was back in Kansas visiting my family and had gone target shooting with my father and an old friend from high school. After returning home from the range, when it was time to clean up, I grabbed my camera and smoothly switched roles from participant to observer. I stood back a little and watched all of the important elements come together in my frame: coincidental red shirts, revolver, fake painting, can of Budweiser, 9mm pistol, brown shag carpet, dining room table, etc.

I still naively believed back then (at least to a degree) in the idea of objectivity. I'm sure I instinctively stepped back, attempting to give a more nuanced or open view, a view that would present all of the elements as evenly or democratically as possible. Looking back now, it is clear that I achieved nothing of the sort. I was slyly dishonest in my hovering distance. I should have been shooting my pictures from the vantage point of a participant, seated at the table with the gun I had recently fired in the foreground. Maybe from that point of view, there might be more of a thread of honesty to the image, at least for me.

In the time that has passed since taking the photograph, my feelings toward guns have changed. I will no longer pick one up and will definitely not fire one. I'm more aware of how images play a distinct role in the distorted myths of the gun in America. The photograph of two white men cleaning guns in a domestic setting will most likely be viewed within a context of "rights" or "liberty" and not in a context of "criminal" or "threat," as would likely be the case if the subjects were not white.

My father inherited the .38 caliber Smith & Wesson revolver he is cleaning in this picture from his father, and I will most likely inherit this same gun, if life proceeds as planned. If the "family gun" does become mine someday, I will keep it. I'm not exactly sure what I will do with it; maybe I will lock it in a box and throw away the key, or take it to a foundry and have it melted.

—Darin Mickey

**Fire Hydrants**

**Fires**

**Fireworks**

**Fixed Ideas**

**Flash**

> I've never turned to flash for personal work. I love shadows and enjoy looking for the perfect spot to place my subject—if they aren't already there. There's something about the way natural light gives shape. If I have to make a long exposure, it's nice to be still with people.
>
> —Hannah Price

**Flashed Flora at Night**

**Flea-Market Stalls**

**The Floral Fabric Patterns of Discarded Mattresses**

**Flower Arrangements**

**Flowers**

**Fog & Other Atmospherics**

**Folk Art**

**Food**

> Every three or four years, I teach a class on vernacular photography, and every time I do I ask the students, at the end of the term, what topics seem conspicuously absent from the photography of the past. By that point, they've spent the term looking at photographs of murder, sex, spirit visitation, labor, poverty, and drunkenness, among other things, so that most of the time, they can't think of a single omitted category.

The last time I taught the class, though, an astute student brought up the subject of food, and his classmates enthusiastically agreed. It had never occurred to me, and yet indeed, food is seldom represented in nineteenth- and early twentieth-century photography. You see people at formal dinners, but their plates are empty. You see shop interiors of all sorts, but there is rarely fresh food on display. You might see apple or orange festivals, but never people eating them. Food seldom appears as a subject until photography becomes indispensable in advertising, which only really gets going in the 1930s. (The signal exception is Owen Simmons's great *Book of Bread*, 1903.)

Almost as important as my student's revelation was the fact that after decades of looking at hundreds of thousands of historic photographs, I had remained oblivious to this omission. Which led me to wonder about changing cultural attitudes toward food. I like good food as much as the next human, but I don't spend a lot of time thinking about it, and I believe that is true of many of my contemporaries. Food, for us, is a private matter. (I'm inevitably reminded of the scene in Luis Buñuel's *The Discreet Charm of the Bourgeoisie*, 1972, in which host and guests defecate around the big table, then repair to private cubicles to eat, furtively.) In contrast, for the younger set, food looms large, for good and bad reasons. People, at least privileged ones, now eat better than they ever have, with fresher ingredients. On the other hand, where there were once bookshops and record stores, there are now restaurants. I've never written about food, and I probably never will. It remains something too intimate to put on public display.

—Luc Sante

**Food on My Plate**

**Footprints in the Sand**

**The Former Soviet Union**

**Found Photographs**

## Free Play

On January 1 of 2020, I set myself a project, something that I've never been interested in before, nor worked on in any serious way. A year of daily self-portraits.

On the one hand, I wanted to see how inventive I could be with the subject; on the other, I wanted to see what my eighty-two-year-old self really looks like and if I could divest it—myself—of ego. To that end, I set up my Leica's twelve-second self-timer to make a photograph as I lived my life in a somewhat normal way, while my alter ego, the Leica, made photographs of whatever it saw. It was like having a live-in photographer documenting me whenever the time was right.

Of course, I played a role here in that I was trying to see which odd and unexpected moments in my life might be photographic. I've now completed 365 days without missing a day, and I still find it was challenging, while being a bit dumb in a way, which I like. I did much of this while in lockdown during the pandemic in London and then in Italy. I lost my pretensions early; I don't care what I look like, I'm often in action, and finally, I was challenged and entertained by doing it. If I ever do a book of this work, I will call it *Playing with My Self.*

—Joel Meyerowitz

**Fried Eggs as They Cook & Form Funny Faces**

**Fruit**

**Funerals of Strangers**

**Fun House**

**Funny Ha Ha**

**Funny Juxtapositions**

# G

**Garbage Bags with Smiley Faces on Them**

**Gas Masks**

**Gates**

**Generality**

**Geodesic Domes**

**Geometric Eye Candy**

**Geysers**

**Ghosts**

> I think about not photographing ghosts. After all, the camera is terrible at imaging these phantoms. Although I *am* one for turning tricks for the camera, I'm not interested in constructing spirit photographs. The act of picture-making alone is already a form of modern ghost hunting, and at the same time, an exorcism. To be a photographer is to see visions of the undead, pictures of the past that are present in the room, poltergeists.
>
> —Tommy Kha

**Ghost Towns**

**Gimmicks**

**Glamorous Interiors**

**Glass of Coke with the Sun Shining through**

**Glitzy Sets**

**Glorified Poverty**

**Goats on Rooftops**

**Golden Hour**

**Golden Oldies**

**Golf Carts**

**Gondolas**

**"Good" Pictures**

Since my early years of curatorial apprenticeship, I've felt resistance kick in when faced with accomplished, "good" pictures. I sense a modality of control rather than openness. Highly intentional and concluded photographs trigger for me a "capturing" of a subject, an overdetermination of a vantage point, a "marking of territory." I'm sure this is a philosophical issue. The idea that a photograph can ever be a fully resolved, complete picture—its meaning fixed as a fully authored form, a photographic signature in perpetuity—is something I deeply reject. I prefer to love photography as a metabolic form, an open-ended personal and creative journey that can purposely swerve away from completion. I was born under a waxing gibbous moon, and I suspect that I am most comfortable in the in-between phases of growth. The most rewarding conversations with artists, the ones that feed my curatorial projects, hinge on the *becoming* and on the potency of drawing into focus a multitude of pictures just waiting to happen.

—Charlotte Cotton

**Google Images Search**

## Graffiti in the Background of a Portrait

I refuse to photograph portraits with graffiti or a mural in the background. It's something I often encountered early in my career shooting family portraits, weddings, and other types of noncommercial photography. It screams "amateur" and in addition to looking terrible, makes absolutely no sense. But for some reason, it's a frequent suggestion from subjects when discussing shoot locations. People always want to "help." Often, a bride-to-be proposes to photograph her and her partner's engagement photos in front of an artwork spray-painted on an abandoned building. I respond with a polite but stern, "Let's keep the focus on you." Typically this works. The only time I break this rule of thumb is if the graffiti or artwork is part of the narrative and relevant to the story being told.

—Sean Pressley

## Grand Canyon

## Great Dams of the Desert

Whenever I've had a preconceived idea for a project, it's never panned out. There've been times when I've thought, Oh, I should go photograph Las Vegas casinos or the great dams of the desert, and then I drive all the way there, and the pictures just aren't strong enough. My best projects are sparked by driving and looking with an open mind—being aggressively receptive.

In 1979, the building next to my studio burned down, and I lost almost everything, mostly from smoke and water damage. I was actually there when the fire started and was able to grab my negatives, which were all in one box. After that experience, I stored my negatives at the color lab that did my printing, thinking that would be safer. But then, in 1982, the lab burned down, and I lost three thousand 8-by-10-inch negatives, and about a thousand 2 1/4 negatives. That was brutal.

A year to the day after that, on February 18, 1983, I photographed my first desert fire. *Desert Fire #1* was an accidental discovery. I saw a large plume of smoke twenty to thirty miles away and raced toward it. I got there to find a vast palm tree grove in flames. The fire fighters hadn't arrived yet, so I just started photographing. One key image—of a palm bursting into flames—was a keeper and launched a new series. For the next couple of years, I made hundreds of images of desert fires.

I was sensitive to the idea of fires from my studio and lab fire experiences, but global warming and environmental issues were already an area of concern. This picture showed me a novel way to use my work to address these subjects. All it takes is one good picture to suggest a new direction. I started noticing fires everywhere.

—Richard Misrach

**Green Grass**

**Groupthinking**

**Gum Wrappers**

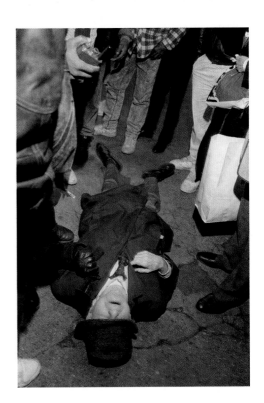

1. "Why should I care about the presumptions of strangers?" (p. 70)

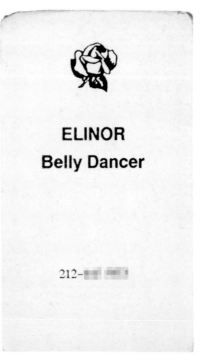

2. "Maybe we met way back when?" (p. 37)

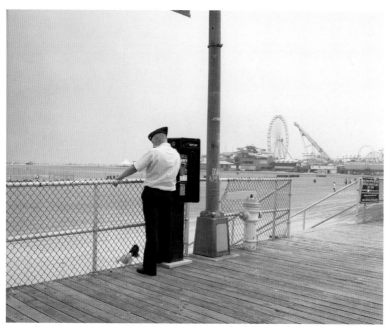

3. "That's not your picture." (p. 264)

4. ". . . the other is me too." (p. 170)

5. "I had not yet learned to never say *never*." (p. 258)

6. ". . . and when I don't really know I do know." (p. 196)

7. "... this tiny bit of camera-generated hostility ..." (p. 28)

8. "... positive, self-esteem–boosting fantasies ..." (p. 22)

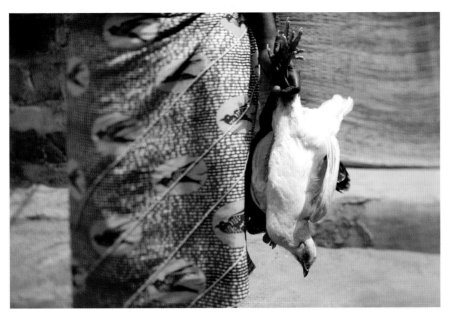

9. "I have a phobia of birds . . ." (p. 54)

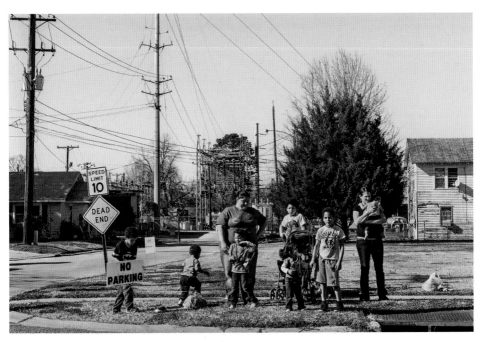

10. ". . . everything feels so familiar . . ." (p. 18)

11. "... the one person I needed to collaborate with ..." (p. 145)

12. "... the endless possibilities of a gesture ..." (p. 121)

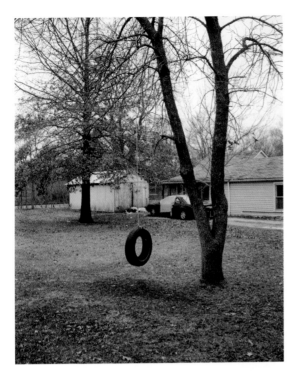

13. "Probably, Hardee's is not a cliché." (p. 122)

14. "Difficulty shrouded in beauty." (p. 129)

15. "... one for each eye ..." (p. 173)

16. "... my genius baby ..." (p. 50)

17. "I will cut a mat for anything except pictures of cats or the Golden Gate Bridge." (p. 49)

18. "I came to regard them as treacherous subject matter." (p. 260)

19. " . . . equally as repulsive." (p. 88)

20. ". . . will there be meaning at all?" (p. 210)

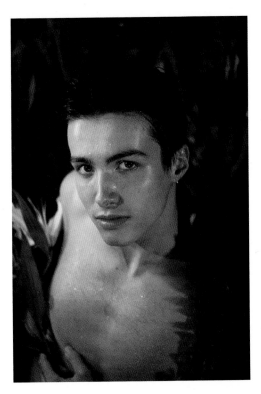

21. "Actually, I have been a THOT photographer too, at times." (p. 125)

22. ". . . something particularly noticeable to a Russian who grew up in the West." (p. 269)

23. "I decided not to show her injury." (p. 84)

24. ". . . a means of keeping people at a certain distance . . ." (p. 126)

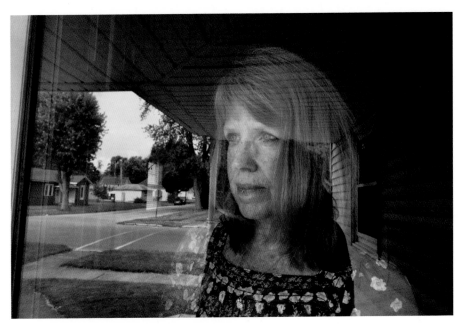

25. ". . . in the early morning, when many of us come into the world . . ." (p. 159)

26. "Hey, hey Jo-chan." (p. 293)

27. "I was shocked." (p. 86)

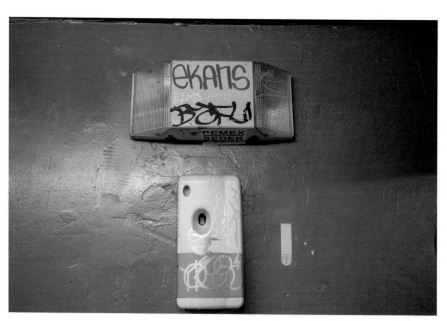

28. ". . . I am also disgusted by them." (p. 209)

29. "(think Guy Fieri)" (p. 259)

30. "But of course, there have to be exceptions." (p. 147)

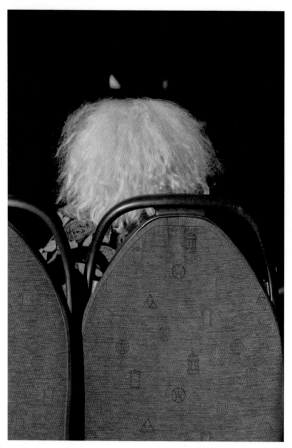

31. "Whether a 'serious' photographer should post works on Instagram was a valid question at the time." (p. 207)

32. " . . . where the ideologies of work sit on the surface . . ." (p. 175)

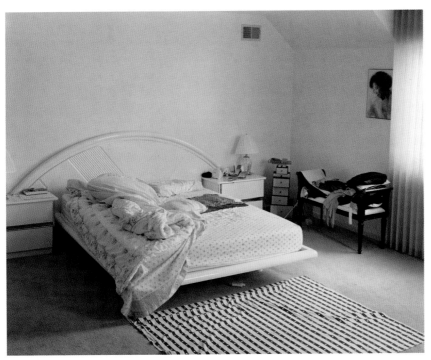

33. "My coming of age as a photographer was during what I'd call 'the Soth years.'" (p. 35)

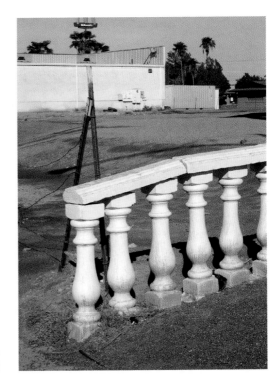

34. "... it remains ambivalent to organized meaning." (p. 168)

35. "I like to cry in cars, but I like to sing in them too." (p. 185)

36. "Where the hell are we—in time, history, and in space?" (p. 181)

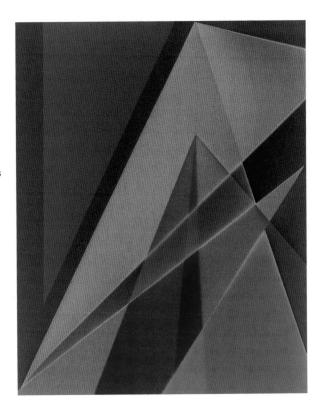

37. ". . . elusive and, like light, it is slippery in our perception." (p. 58)

38. " . . . the most incendiary thing he could think of . . ." (p. 259)

39. "When I look at a door, I think of it as shut." (p. 79)

40. ". . . I was reminded of what I already knew . . ." (p. 194)

41. "My heart stopped and my mind raced." (p. 206)

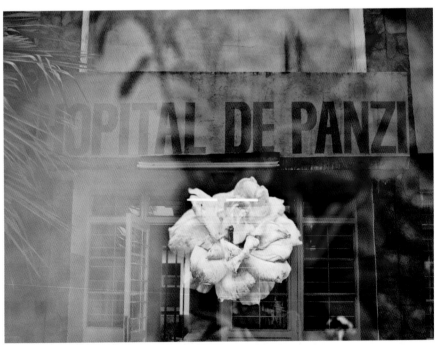

42. "A photo of a rose taken by a woman has a different meaning." (p. 243)

43. "It is a less direct form of demonstration." (p. 198)

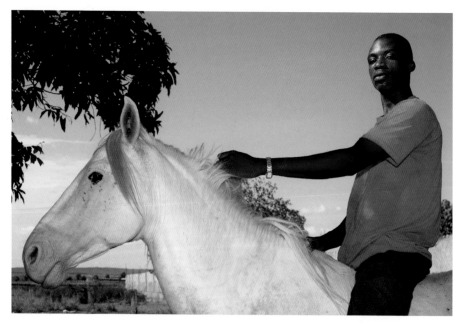

44. " . . . the gaze of a Western tourist . . ." (p. 74)

45. ". . . maybe even a direct reflection of low self-esteem." (p. 160)

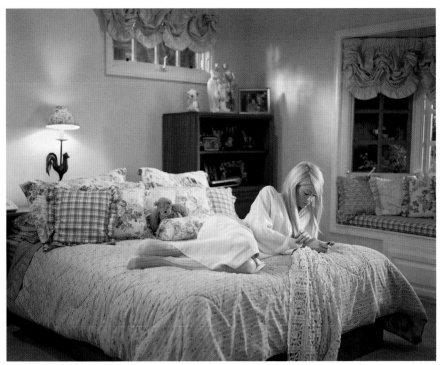

46. "God knows why, but she agreed." (p. 172)

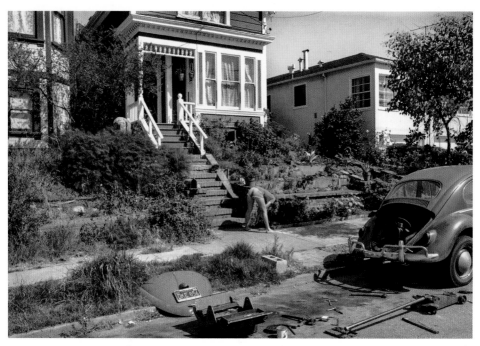

47. " . . . a minor-key cousin to that of the hummingbird and the 'route of evanescence' . . ." (p. 279)

48. " . . . how I must look trying to learn to play the guitar now." (p. 73)

## Habits

## Hackers

Whenever there is a story in the news about a computer hack, they always run the same stock photo of a hooded person at a desk with their face in shadow. Or else it's a photo-illustration of zeros and ones floating in front of a computer. Can't we do better?

—Roby Yeoman

## Ham-Handed Philosophizing

## Hands

In photographs, hands are always alluring. They can be so beautiful in a way that feels timeless, sculptural, even transcendent, though often, all too easily cliché.

At one point, hands became a subject that I felt I may have overphotographed and therefore, should avoid for a while. But after a few years of practicing this arbitrary avoidance, I allowed myself to again appreciate the endless possibilities of a gesture—and, in doing so, I made one of my favorite images.

Whether we photograph them or not, sometimes it's the very subjects that we tell ourselves to avoid that are worth returning to in order to try and see them differently and, perhaps, more deeply.

—Shane Lavalette

## Hands Pointing

## Hardee's

I made a list of all the things I tell myself to avoid making pictures of. Stuff like tire swings, mobile homes, golf carts, and concession stands. Photographic clichés all. Which would be reason enough to dodge them, but for me, the more pressing issue is that objects like these carry a referential weight of their own and thus, short-circuit the kind of photograph I aim to make. My goal is for the meaning of the picture to be a result of the relationships I've created within it, not something that emanates from the things depicted. And yet, alas, that doesn't mean I can resist the temptation of a topiary. Probably, Hardee's is not a cliché. I've no general objection to the chain; my problem is only with the one in my hometown. When I was a kid, the only fast food in Monticello, Illinois, was a Dairy Queen, and it was much beloved. The DQ sits across from the courthouse square (the town being the seat of Piatt County), and most of the area's youth would hang out on the square, or cruise in languid loops around it. Now, there are stop signs that impede the flow. When they came out with the Blizzard, my very young cousin called it a "blithard," and that name has stuck with my family to this very day. One baseball-crazed summer—either '78 or '79—I haunted the DQ to collect small plastic hats representing all the major league teams; these doubled as cups for ice cream sundaes. You could buy (and I did) a fancy cardboard holder to display the caps in the order of the MLB standings. There were just two divisions in each league back then, so the whole thing was simpler than it would be today. Everything was simpler. After a while, McDonald's came to town. Then, a good bit later, a Hardee's.

—Tim Carpenter

## Hardware Store Displays

**Harmony**

**Having an Agenda**

**Hay Bales**

**Heroic Self-Portrait**

**Heterosexual Desire**

When I see the word *desire*, I remember studying Latin at my Catholic high school, and think of the infinitive form of fourth-conjugation verbs, which have *-ire* at the end. *Desire* is both a noun and a verb, reflecting its amorphous tendencies. It is also a space—between what is wanted and the one who wants it. In its most obvious and impulsive forms, it is sexual or rather, sexed, in the same way a house can be haunted.

Queer people have always been experts at riffing: taking elements of heteronormative culture and renaming and reclassifying them to blend in and stand out at the same time. We have always been adaptable while also transforming our surroundings. I think of Alvin Baltrop's intervention at Pier 52 as opposed to Gordon Matta-Clark's: Matta-Clark thrust and cut himself into the structural support while Baltrop immersed himself, documenting light and shadow as coequals, not opposites.

Photography often feels like an orchard full of low-hanging fruit. Sexuality as a subject is among the most often plucked, though its ultimate iterations and implications are highly dependent on the maker and intended audience. Photographing queer desire can be a form of representational and expansive resistance, whereas images of heterosexual desire often embody patriarchal ideologies within their modes of production and dissemination. Neither of these designations is automatic, however, nor are patriarchy, racism, ageism, or heteronormative standards of beauty absent from, especially, white-male gay culture.

It is the territory of queer artists to envision and build new worlds. It is a declarative rejection of things as they are and of people as fixed or stagnant objects. That the latter quality—of "fixing"—is embedded in the very nature of photography speaks to this history of queer riffing: of embracing what is and transforming it through boundless, generative permutations. In this way, the canon of queer photography is limitless, whereas heterosexual desire will always be bounded by the structures of the culture it emanates from.

—Rory Mulligan

**The Hidden Face of the Moon**

**Hiding the Subject's Face by Having Them Look Back or Far Away**

**Highfalutin Essays in Photobooks**

**Highly Manicured Landscapes (i.e., National Trust Properties)**

**Highway to Infinity**

**Hipness**

**Histrionics**

**Holding a Flower with the Same Pose in Your Hand Every Year When They are Blooming**

**Holes**

**Holga**

**Holidays**

**Holi Festival in NYC**

**Hollywood**

**Hollywood's View of Reality**

## Homeless

I have always been conflicted about photographing the destitute. I questioned the purpose and wrestled with how to portray someone homeless. I am not a photojournalist; I work more conceptually, but I am interested in how people inhabit their environment. Then tents-as-shelters—a sight more associated with America and skid row—began appearing on the streets of London. They rendered the homeless invisible while in plain sight. Passersby would see a large tent on the pavement and just carry on with their day without questioning what was going on. I decided this was important to document, to talk about our own relationship with the homeless. When you see a homeless person in a sleeping bag, it's something you've seen many times before, and you can become desensitized to it. But when you see a tent, it appears almost like it is bolted to the architecture of the city.

—Jermaine Francis

## Homeless People in Beautiful Late Evening or Early Morning Romantic Light

## The Homes of Homeless People

## Hometown

## Horses

## Hot Guys

Everyone I photograph is beautiful in some way, and that is why I photograph them. But there is way too much photography of hot, muscle gays. My friend William J. Simmons came up with a term called "THOT photography," which in my view, encompasses all of those gay photographers making flattering photographs of hot guys, often as part of a game of seduction. Many frame it as activism by virtue of their

representation of queer bodies. But hot, muscle gays are not really an underrepresented group in today's world, so I don't think it's subversive or surprising anymore.

Actually, I have been a THOT photographer too, at times. When I moved back to New York in 2017, I noticed all of these young, gay men who seemed to want attention, and I thought, Maybe I can be part of that, and produce a kind of sexy glamour with them for an image. I love photographing people who really want to be photographed. But these people were actually very hot, not muscle gays but twinks, whose beauty aligned with current fashion trends. Lately, I feel that it's more important to photograph people who might not already feel hot.

—Matthew Leifheit

## Houses

I developed a fascination with looking at American houses when I came to the States for graduate school in 2012. I was dumbstruck by the homogeneity of their design, and read an interesting essay about the propagation of this one ubiquitous style of suburban house in D. W. Meinig's anthology *The Interpretation of Ordinary Landscapes* (1979), which intrigued me. But I was also fascinated by the way that they so often pointed to a particular history of American expansion that (to my untutored eyes) evokes wagon trains and the "open" frontier, and that sublimates settler-colonial violence under an aesthetic of humble domesticity. I gradually realized that photographing houses was not only pleasurable, but also served as a means of deferring having to make other kinds of pictures—a means of keeping people at a certain distance—or as a way of avoiding having to knock on people's doors, so I forbade myself the freedom to make pictures of houses. Bit by bit, the other pictures began to change and improve as a result of the constraint.

—Stanley Wolukau-Wanambwa

**Houses at Night**

**Housing Projects in the Middle of the Night**

**Humans & Animals That Suffer from an Illness or Injury**

**Humblebrags**

**Humorlessness**

**Humorous Images Using Multiple Selves**

**Hunting Trophies**

**Hyperbole**

*Here we go. I've turned it upside down. What an emotion . . .
whatever will the reader say? How can I justify myself? They'll
think it's a print-ing error. What now? What a mess!*

**I**

## Ice Machine

## Iconic Images

I work for the New York Public Library Picture Collection. I'm one of those who decide which pictures clipped from books and periodicals will go into our thousands of subject folders. A dilemma arises whenever one page has interesting pictures on both sides. Which heading will it go under? If it's a choice between an iconic image and something I've never seen before, or something familiar shown in a new way, I almost always choose the new or unfamiliar one. So, Leonardo da Vinci's *Vitruvian Man* (ca. 1490), Michelangelo's almost-touching fingers in *The Creation of Adam* (1508–12), and Dorothea Lange's *Migrant Mother* (1936) make room for things like a sneaker footprint, water pouring from a pitcher, or a baby tapir. Ralph Waldo Emerson said, "Every hero becomes a bore at last," and for me, that counts double for imagery. After looking at something many times, then seeing it analyzed, parodied, and critically worshipped, I don't want to see it again for a while. But don't worry. We have three other intelligent, curious people who work here and select pictures; they have completely different takes on life in general and imagery in particular. We have plenty of pictures of that art deco poster of the liner SS *Normandie*, or the guys eating lunch on the skyscraper beam—and when there's nothing else on the back of those pages, most of the time, I clip those too.

—Joseph Vissers

**Ideals**

**IKEA**

**The Illusion of Impartiality**

**Illustration of an Idea**

**Images Made by Google Earth, Google Maps, Google Street View (Google at All)**

**Immaculate Anything**

**Immediate Clarity**

I cannot remember how I got the appointment to show my work to a renowned gallery owner in Manhattan. I was really young, probably twenty-six or so. I do remember I was nervous, but I soon relaxed when the owner kept telling me how "beautiful" my work was. I thought, This must be how it feels to be in heaven. I thought I was about to be represented! But after he had looked through all the prints and I asked for a comment, he replied, "Your works are beautiful, but only beautiful." The cloud I was lounging on disappeared, and I crashed to earth. I was shocked but, in that moment, I knew what he meant. My work was all about the technique and very much on the surface. It was all there for the seeing, but little for the feeling. In my opinion, my work has developed immeasurably since then. I now dislike the mainstream in photography; it makes me feel very uncomfortable.

I crave for my work to have the presence of an absence; questions asked, but little answered. Work that reveals, yet conceals. Difficulty shrouded in beauty.

—Nadav Kander

**In-and-Out Reportage**

**Indian Sadhus**

129

## Indifference

## Indigenous Ceremonies

I spent most of my early life between Washington, DC, and New York City, where I had virtually no exposure to Indigenous history or culture. So the first time I photographed in Indigenous communities, in 2014, involved a steep learning curve. Early on, a Cree woman named Deb gently implied that Indigenous prayer and spiritual ceremonies shouldn't be photographed. I didn't get it. I'm sure, at the time, I thought to myself, But I'm different!, and believed that as long as I was quiet and deferential and sensitive and empathetic, it would be okay. I convinced someone I'd been following to let me photograph her smudging with a group of Indian Residential School survivors—it was a very photogenic act, these older women burning sage and sitting in prayer together. It wasn't until years later that I better understood the context of Native spirituality in North America. Until 1978, with the passage of the American Indian Religious Freedom Act, most Indigenous ceremonies and religious practices were criminalized, so it was particularly inappropriate for me, as a non-Indigenous journalist, to try to push back against boundaries that Indigenous communities were able to establish only recently. I haven't done it since.

—Daniella Zalcman

## Infrared Film

## Inhibitions

## Injection Drug Use

## Innocent White Fantasies

In 1962, James Baldwin wrote in "A Letter to My Nephew" that ". . . it is not permissible that the authors of devastation

should also be innocent. It is the innocence which constitutes the crime." White Americans, Baldwin said, ". . . have destroyed and are destroying hundreds of thousands of lives and do not know it and do not want to know it." Photography can reinforce that innocence, or it can be an entry point to dismantling it, and replacing it with knowledge and nuance.

Don't be innocent. Don't be white. Don't be passive. Don't take more photographs than books you read, conversations you have, stories you listen to, systems you analyze, and lives you celebrate.

If you are white, don't wear your newfound discoveries and disavowal of racism like a badge. Don't substitute self-censorship and up-to-date slogans for actual learning and real engagement. Don't incessantly refer back to the conventions of representation and photography's role in subjugation, which reduce non-white, non-cis-hetero subjects anew to those who are appropriated at best, and exploited at worst. Proceed with respect and, most of all, with knowledge.

I am white, I am queer, I am Jewish, and I am a woman. In the late 1990s, I made Girl Pictures, a body of work featuring mostly white girls fleeing normative, suburban existence and using its detritus to create a world of transgression and fantasy. I asked girls from a wide cross-section of identities to sit for these images, but not surprisingly, with few exceptions, only white girls were willing to trust their lives and their images to my hands and lens. For some time, I felt that the work was too insular, and did not do enough to challenge the colonialist implications of photography. I feared that the photographs presented an overly romanticized version of what it means to cast off the chains of society.

I look at these pictures now and see that I both shaped and captured the racialized dreams of young white girls. Our longings for freedom and adventure are profound and valid. Too often, however, in order to express these longings, my photographs drew on symbolism readily at hand—both a desire to be primitive and a glorification of regeneration

through violence, which white Americans used to ennoble their nauseating violence toward Indigenous people. When unexamined and shorn from historic context, dreamworlds of resistance are inevitably tainted. Girl Pictures depicted a dream landscape, and a world at large, where even imaginations of resistance are misshapen by white supremacy.

Photography is my attempt to be free from the dictate of history; if I achieved that goal, I could stop photographing. The point is to use the space left open by failure and propelled by the necessity to recognize ourselves among and through others. In this regard, photography is a process of ongoing revision, a state of becoming. As Baldwin says in the same letter, we are in effect trapped in a history which we do not understand, and until we understand it, we cannot be released from it.

—Justine Kurland

**Innuendo**

**Inordinate Moralizing**

**Insecurity**

**Inside Big Box Stores**

**Insincerity**

**Inspecting the Image Preview after Each Shot**

**Instagram Live Videos**

**Intimacy**

**Introductions in Photography Books**

**Invisibility**

People often ask me why I photograph young women and children, almost like it is an unnatural subject. Why should it

not be an obvious subject for me? Of the few assignments I've received, they've always been on subject matter conventionally covered by women, "soft" subjects: family and the world of children and health. As a photographer, especially a woman photographer, if you offer a series of pictures, publications will always chose those featuring the young over those with the old or men.

My work with youth has had attention, but there are images of other subjects. My feeling is that today, certain subjects are more off-limits to male photographers, and since men remain the dominant tellers of our histories, these subjects have now entered the realm of taboo. I have several series featuring pregnancy and birth, which have never seen the light of day, because they are not part of the male canon of what has value. (Though things are shifting, as seen in MoMA's showing of Carmen Winant's *My Birth* in the *Being: New Photography 2018* exhibition.) My fear is that if we do not stand face-to-face with one another, if we do not see one another—beyond just women and children—we may end up more and more unknown to each other.

In April 1999, standing at the border between Albania and Kosovo, I questioned my purpose in being there. It had been a long drive to get there, so I had plenty of time to think about it. I felt strange going in the opposite direction of those escaping from the conflict. My question was answered soon enough, as I began to see and then began to photograph. I was there as a witness. Something cathartic happened during those moments; it was almost as though the pictures didn't really matter. It was the act of being seen by the camera, by a witness, and not forgotten, that mattered most.

In the essay at the end of Ed Panar's *Animals That Saw Me* (Volume Two), philosopher Timothy Morton addresses this:

If you have suffered from a trauma, one of the most healing things that can happen to you is being seen. Being

seen doesn't have to mean that someone actually lays their eyes on you, although that certainly helps. Being seen means that your being is held by the other person without comment, without praise or blame or indifference, just with some kind of open care.

—Vanessa Winship

**Ironic Signs**

**-isms**

**Isolated Houses in the Center of the Frame**

**Issues That Reflect Consumer Tastes & Preferences**

**Italian Landscape as Bourgeois Fantasy**

# J

**Jackasses**

**Jack-o'-Lanterns**

**Jello**

**Je Ne Sais Quoi**

**Jerks**

**Jigsaw Puzzle in Progress**

**Jokes**

**Joylessness**

I don't like rules. I realize there are some one needs to learn
in order to operate certain equipment and work with chemi-
cals, but most rules can be broken for experimental purposes
and for the sake of being inventive. The main rule I have for
myself has to do with enjoying photography. Sometime in the
early 1990s, a few years after I graduated, I got stuck with my
work. I had artist's block. The longer it went on, the harder it
was to start something, and each time I tried, I hated the new
photographs. I started looking through my archive of contact
sheets, and printing images that I liked. I started building
new series from old work. It was exciting and allowed me
to develop a more relaxed approach toward new ideas and
projects. My rule now is to take photographs even if I do not
have a project in mind, and to enjoy those aspects of photog-
raphy that I've loved since the beginning: capturing different

light conditions, color, making ordinary things special, and ultimately, putting new perspectives on things and stories about life out into the world.

—Anna Fox

**Jungle Gyms**

**Junior-High Basketball Sneakers**

**Junk Boats in Hong Kong Harbour**

**Junk Food**

**Junk-Store Shelves**

*Actually, the reader may be right to be worried. A back-to-front photo! Eh! But on the other hand I ( . . . ). Let's try to make everyone happy. Let's try turning it like this. We'll just try (it's a compromise though).*

## Keke Looking Sad, Serious, or Gloomy All the Time

Keke and I met toward the end of my photography degree, fourteen years ago. Like all the people whom I love and spend a lot of time with, he began appearing in my photographs right from the beginning: here he is sleeping, here he is running, here he is floating. At some point during my studies, however, I picked up the idea that for a portrait to be "proper" and worthy of consideration, the person in it needed to look serious. Surely if they were joyous, laughing or smiling, the picture couldn't be "decent." As a result, Keke would often look sad, serious, or gloomy in the photographs, even if he wasn't feeling that way at all. How silly, I knew absolutely nothing then. Fourteen years later, it still makes us laugh.

—Katrin Koenning

## Kicking away Trash

Someone once told me that the art of painting lies in addition, while the art of photography is based on subtraction. I apply this idea in my own way by kicking away trash (such as a Styrofoam cup) from the foreground of a subject I want to photograph. Does this kind of interference make me a wannabe street fashion photographer rather than a wannabe photojournalist?

—Jim Jocoy

## Kisses

I took a picture of a kiss once where my two friends' lips formed the shape of a heart. A kiss seems, to me, the ultimate symbol of sentimentality (which I usually try to stay away from), and then with a heart to boot! I think it works, though, because there is a transformation. That's always the thing that gets me going and interests me most in making pictures. The good ones are most often the result of playing around with something I'm intuitively attracted to in order for something unexpected to reveal itself. Time and again, I need to remind myself that even with the most ubiquitous subject matter, we always filter things through our own experiences and sensibilities.

—Jordan Weitzman

## Kites

## Kitsch

## Kittens in Baskets

## Knee-Jerk Reactions to Current Events

## Knickknacks

## Knit Bombing

## Kumartuli

Even before I became a photographer, I knew that Kumartuli was the place you would go to make images in Calcutta. It is a large-scale workshop of sculptors who create idols of Hindu deities before festivals. In its narrow lanes, the clay heads, torsos, and limbs of the newly formed gods are kept under the sun to dry—fodder for photographers, local and international. As the festival inches closer, the prized image is of the nearly finished idols, getting their final touches by artisans working

with fine brushes and pure dedication. Sometimes, outside the bigger studios, there are groups of people with their cameras, elbowing each other out of the way for the decisive moment until the artisans ask them to leave.

When I took up photography, I felt annoyed at the sight of photo-walk members in the labyrinth of Kumartuli. Later, while working as the fixer in Calcutta for photography workshops, I would often be requested to accompany them down the alleys of Kumartuli. These international workshops were mostly targeted at rich men and women, all of whom would stay at the Fairlawn Hotel, a humble abode once the home away from home of Dominique Lapierre, Günter Grass, Ismail Merchant, and James Ivory. It was run by the charming Mrs. Smith, an Armenian lady in her late eighties and one of the most colorful characters in our city of joy. I would join the team during breakfast to plan for the day. After quite a few requests to go to Kumartuli, I would get asked about other oft-frequented destinations, like the ancient South Park Street Cemetery and, of course, Mother Teresa's residence. After a few years at fixing for workshops, I knew exactly what was demanded of me: all the "big yawns" of Calcutta. The lesson learned from my workshop experience was simple: it taught me to look elsewhere, where no one looks. Also, I think it's better not to do your homework before going to a land unknown to you; let your instincts guide you while you're there.

—Soham Gupta

**Kumbh Mela**

**Kyoto Temples & Trees**

**Lace**

**Ladders**

**Lakes in the Dappled Sunlight**

**Lampshades in the Corner of the Room**

**Landmarks**

**Landscapes**

> The body has been my focus for the last thirty years. But
> when I look through the archive, there's always a landscape,
> whether it's Los Angeles; Aquinnah, Massachusetts; Venice;
> Accra, Ghana; or now, Germantown, New York. The land-
> scape is always peeking into my practice in an oblique way,
> be it through the lens of hypervigilance, desire, or standing
> one's ground.
>
> —Lyle Ashton Harris

**Landscapes from the Huntington Beach Pier**

**Landscapes Uncontextualized as Not Fully Natural**

**Laptops**

**Large Format (4-by-5)**

**Large, Large Photos**

**Laundromats**

**Lawn Ornaments**

**Leaning Tower of Pisa**

**Leaves on the Sidewalk**

**Leaving the Lens Cap on**

**Legs of Seated Passengers on the Subway**

**Lens-Based Images**

**Lens Flare**

**Lighthouses**

**"Light Paintings"**

**Light Sources (the Moon, a Lamp, a Bulb; but the Sun Is Okay)**

**Light through Venetian Blinds**

**Lions at the Zoo**

**Little Girls with Bows in Their Hair**

It may be oversimplifying things to state photography owes its vitality to the contributions of countless amateurs, but then, try to imagine the medium without them. Would Alfred Stieglitz have been able to champion Pictorialism as effectively if he hadn't felt threatened by the hordes of Kodak-wielding enthusiasts in the late nineteenth century? Would Instagram be as lively today if only talented artists were permitted to post? I asked the same question about the Foto-Cine Clube Bandeirante (FCCB), a São Paulo–based amateur photography club whose members, particularly in the mid-twentieth century, produced work of remarkable originality alongside predictable photos of kittens and little girls with bows in their hair. There are some FCCB photos I

consider so clichéd, I struggle to acknowledge their existence for fear it diminishes the reputation of the club as a whole. But then I remind myself, this messy, porous history is at the heart of what I love about the medium. The challenge is to articulate an objective basis for one's judgment, and to recognize the subjective biases that inform our opinions.

—Sarah Meister

## Live Music

## Locomotives in Museums (in the Wild, No Prob)

## Logos

As a photographer working largely in portraiture, I am captivated by the ways we adorn ourselves and how that produces personal narrative: the personality of a well-worn pair of jeans, the crispness of a starched collar, cat hair trapped on a sweater, the way a hand heavy with rings drapes across one's lap. In both planned and spontaneous portrait sessions, I often hear stories of where, why, and how a particular garment or object was acquired, inherited, or fought for—or even if they consider it passé. These little shrines of personhood speak volumes.

On both ends of the camera, Black people are too often asked to sell something. Of course, many photographers make commercial work alongside or as an extension of their art practice, but too often, the only contemporary display of Black photography and Black life is through the vanguard of fashion, even within Aperture's own publishing history. The line between advertisement and critical, considered looking is in constant blur and crudely collapsed into "liberatory methodologies," or held up to the work of photographers who paved the way for *looking* in a completely different way. I am sensitive to the commodification of Black life, and I would hate for any photograph I take to be mistaken for an advertisement. Whenever logos or branding are visible, I usually

ask the person I'm photographing to either obscure or remove them—with the exception of band tees or sports logos, which often speak to place and community.

—S*an D. Henry-Smith

## Lonely Tree in a Meadow

## Look-Alikes

## Looking Down on Someone Less Powerful Than You

## Looking Up at Someone More Powerful Than You

## Looking Up at the Sky through Trees or Buildings

## Loud Book Design That Overwhelms the Pictures

## Love

I confess to an obsession/aversion with the Vows section of the Sunday *New York Times.* It comes from an overarching doubt about the ability of a two-dimensional medium to limn the multidimensions of a relationship.

It's not just the pictures, but it's those too. It's the way two lives get folded into several hundred words that somehow are meant to tell us, the distant readers, what magic equation it took for these people to come together: where they met, who their parents are, where they grew up, went to school, work; their online-dating profile, the first drink or dance or sunset they shared. It's not like that. Just as an obituary, which all in all leans closer to the bone, doesn't give us the life, the story line of a relationship doesn't translate the ineffable of the union.

I am suspicious of pictures of loving just as much as I am of pictures of dying. There is just too much going on in the room. Though photographs masquerade as true evidence, when it comes to love and death, they are mere bread crumbs, harkening toward a memory or fear that they echo. Loving

and dying exceed the parameters of the photograph. They all but exceed our own parameters. All but.

—Frish Brandt

**Low Blow**

**Lowest Common Denominator**

**Lowriders**

**Lumberjack Festival**

# M

**Macro Lens**

**Mac Stores**

**Madness & Everything Dark**

**"Main Street" Reportage**

**Majestic Mountains**

**Manifest Destiny**

**Mannequins**

**A Man's Head Surrounded by Flowers**

**Marble Sculptures**

**Masks**

**Matterhorn**

**Me**

**Me, Myself, & I**

Honestly, I never thought I would be the photographer to turn the camera on myself—never, not once. I have found a deep joy in collaboration, making portraits with the people generous enough to give me their time and energy. I've spent a lot of time thinking about the camera and the power it holds, and the care that I've taken (and continue to take) in making my work. It never crossed my mind to apply that care and

time, holding the camera up to myself. Something switched for me in 2019, almost like a snap of the fingers. I had this desire to see who I was becoming since moving to the United States. So I tentatively began making self-portraits, though I didn't intend to share them in a pure photographic form. Then COVID-19 happened, and the ability to work together with another human being became difficult and unsafe. Everything felt (and still feels) compounded. Here I was, in my home, and I knew that the one person I needed to collaborate with, commune with, share, and see, was myself.

—Erica Deeman

## Me Too

## Melodrama

As the director of the New York Public Library Picture Collection, I recently found a subject folder that I have never been asked for by a researcher, nor ever added a new picture to: "Melodramas."

How had I missed these exaggerated displays of emotion by villains, heroines, and heroes—the damsel tied to the train tracks, the robber twirling his mustache, the highwayman with a gun?! Where is all the interest for these pictures from nineteenth-century plays, early motion pictures, and stories from weekly circulars? Has reality become so fabulous that we no longer need melodramatic fantasy? These pictures have captions that read, "Orrin, make haste, I am perishing!" and, "Father, dear father, they have killed me!" Perhaps the scenes they describe have become so embedded in visual culture that the originals of the genre are less sought after. It's shocking, I know!

—Jessica Cline

## Memories You Never Had

## Men with Guns

When I was starting as a young photojournalist, dramatic images were key. How can you make an impression with editors quickly, in order to get the always-desired assignments? My own desire to document history, amplify the voices of those in need, and have an impact that could make things better on the ground were irrelevant. The "coveted" dramatic images often featured man versus man, frequently with guns, and were found in some far-off place, so distant from my home of New York City. Off I went. The dramatic images I captured had some effect, but was it enough? My mentor Christopher Morris explained to me, "Forget you ever did these images. Prove that you can do more." A few short years later, I found myself once again documenting men with guns, with similar drama but fewer results. Chris's words came back to me once again, "do more." In today's world of image-saturation, the editor—and more important, the viewer—needs more. I had to go beyond the dramatic images of violence and show the causes, the consequences, the path to the future. When these contexts combine with the "dramatic," the story can then be told.

—Ron Haviv

## Men with Snakes

As a photographer working in public space, I take great pleasure in making pictures out of seemingly insignificant material. With that in mind, my list of taboos is populated with things that are designed to catch the attention of the public eye: advertising, people who are dressed over-the-top, buskers, people screaming, face tattoos, and above all, men with snakes. There is nothing more uninteresting to me than a man on the sidewalk with a snake around his neck.

Perhaps I choose to make these subjects taboo because they feel like low-hanging fruit, or because I think the

content itself will win no matter how artfully or clumsily I put it in the frame (my own ego as a seer is certainly involved in the decision).

But of course, there have to be exceptions. And in thinking about how little attention I want to give to men with snakes, I now realize that one of my favorite artworks of all time—so much so that I have a small picture of it in my wallet—is, in fact, a man with a snake! The sculpture *Laocoön and His Sons* was dug up in Rome in 1506 and depicts three life-size figures wrestling a snake. The expressive poses of the figures have inspired me to look at gesture from head to toe on the street and to think about the unseen snakes that we wrestle together.

For the most part, I have held the line and focused on the invisible nagas, while instantly turning away from any man with a snake. But again, exceptions must be made: on Friday the 13th of March 2020, close to the day New York City went into quarantine, I found myself halfway across the Brooklyn Bridge . . . pointing my camera at a man with a snake.

—Gus Powell

## Mermaid Parade at Coney Island

## Messy Bedsheets in Soft Light

## MFA

## Milk Bath

If you close your eyes, you might be able to picture it. Whoopi Goldberg's head, arms, and legs are coming out of a bathtub of milk, and her tongue is sticking out with a smile. The photograph was taken by Annie Leibovitz and appeared in the July 1984 issue of *Vanity Fair*. Milk baths were not a new idea. Cleopatra used sour donkey-milk baths as skin treatment. But this is the first photograph I have found of someone floating in milk for the sake of art, and it is *memorable*. When a

photographer has a totally original idea, and they execute that idea well, it becomes their own—especially after it is published. Milk-bath photography, along with a few other near-nude poses belong, in my mind, to Annie Leibovitz. That is why I will never take a picture of someone in a bathtub full of milk.

When I am trying to make photographs, the work of other photographers looms overhead, reminding me not to take pictures of certain things. Harold Bloom discusses this problem in his book *The Anxiety of Influence* (1973). Bloom's work is about the creative paradox that poets face, but I believe it applies to photographers as well. He says that if an artist's work is too derivative of another's, it will be bad, but also that artists need to be inspired by and learn about other people's work in order to make good work themselves.

Perhaps it is better to make work in an artistic vacuum, to ignore all art bookshops, galleries, photography blogs, old issues of *Vanity Fair*, and this book. Lest you be bested by that one photography professor who has a permanent link in his brain to every reference possible in photography, film (he calls it "cinema"), music, and art history, who subtly suggests you "check out" any reference that relates to the measly pictures you have created and displayed in a photo critique. He would definitely know about Annie Leibovitz.

—Catharine Maloney

## Miniatures

## Minimal Still Lifes of Sticky Garbage

## Mirrors Reflecting Mirrors

## Misery

## Misspelled & Handwritten Signs

## Misty Landscapes

## Mobile Homes & Parks

## Mockery

## Models

For many years, I refused to photograph models. I felt, as many have before me, that to photograph a model too often is to turn a person into an object rather than a real person. I preferred to photograph people I knew. My favorite nonmodel to photograph, Tracy Ma, poses with irony, with a slight wink to the viewer, and with the history of representations of women in her mind. She works in design and knows intimately how images take on lives of their own once they enter the world, particularly images of people. She is very much herself in the photos, and I think that gives her a power that is missing from many of the pictures of models we see.

I have, however, recently broken my rule. I've been photographing models from the popular e-commerce site SSENSE. On the site, the models are photographed almost like robots or statues, in three distinct, identical, standardized poses. I think about how standards get applied to actual people and contexts, and start slipping. For example, how can the same color red be reproduced in a million different ways? How can a model's slight smile or clenched fist burst through the depersonalizing parameters set for her to display a piece of clothing? I have been inviting these models into my studio and photographing them differently, trying to take them out of context, to comment on the actual people behind the mechanisms of desire and capitalism that drive fashion. I want to make a different picture of these models to put into the world alongside all the other identical ones.

—Sara Cwynar

## Moiré Patterns

## Monarch Butterflies

## Monoliths

**Monomania**

**Monopods**

**The Monorail at Epcot**

**Monuments**

**The Moon**

**Moss**

**Motel-Room TV**

**Motorbikes**

**Mug Shots of Black People**

As a collector of mostly vernacular and anonymous photo-graphs, there are few things I consider taboo. One is physical violence. The theatrical rope-and-chain bondage imagery of much classic 1950s and '60s male physique work makes me uneasy, but when it edges into S and M—when pain seems to be the whole point—I draw the line. For all their cold neutrality, mug shots suggest another sort of violence and restraint. Their subjects are under arrest; even if they're not physically shackled or handcuffed, they're not free to go. The camera, as impersonal as a photo-booth device, pins them down head-on and in profile, specimens to be filed away in an unforgiving system. Some of them are visibly injured, whether in a fight that led to their arrest or in the course of that arrest, we don't know. For many of them, this is one of the worst moments of their lives, and the ordeal is just beginning. But for all their negative charge, mug shots are fascinating as portraits: deadpan cool, definitively postmodern, occasionally glamorous (see Frank Sinatra, Jane Fonda, Jim Morrison). I've included examples in every book of my collection. But I no longer want to publish or exhibit photographs of Black people under arrest. Even when their "crime" isn't listed as

"disorderly conduct" or "resisting arrest" or merely "suspicion," the circumstances of their arrest are all too questionable. I don't want to put pictures back out into the world that perpetuate the image of the "Black criminal," unless those images are used to help establish their innocence.

—Vince Aletti

## Museums

## Mushrooms

## My Childhood Home

## My Children

When I was pregnant with my first daughter, people often made glib comments about looking forward to the body of work I would inevitably create about her. Since I rarely make pictures of subjects found around me, this seemed unlikely. Despite being a photographer who tries not to talk myself out of ideas or to think of any subjects as off-limits, I understood that there was a murky history, and perhaps a cliché, of the photographer-mother making pictures of her children, a history that, unfortunately, has too often been dismissed, misogynistically, as sentimental.

During pregnancy, I was photographing a mishmash of dying flowers and ancient tombs, subjects that didn't readily fit into any project I was working on—pictures I had no idea what to do with. After my daughter's birth, I realized that this time of growth had me thinking about its counterpart, death: about my mortality, her mortality, and the deaths of my loved ones that I had already experienced. I began making work about death, and once it became clear that a project was taking shape, I realized that a return to birth was necessary. It no longer made sense to explore death without exploring the birth that had gotten me there. This is how I backed myself into photographing my children.

Parenthood involves self-erasure, but this obliteration functions differently for mothers, who are more often judged on their mothering. As someone who went into motherhood hoping to resist this erasure, to not become a mother with no other identity other than being a mother, there was something particularly cringe-worthy to me about making pictures of my children. The simplest reason, of course, that mothers photograph their children is that they are there. Unlike every other thing we do that takes us away from them, forcing us to continually justify our absences and assuage our guilt, photographing our children combines our artistic practice and our domestic obligations.

Grappling with the history of other mothers photographing their children, not only in art history, but also in social media, I think about how I can make images that won't merely add to the incessant stream or be dismissed as sentimental. I feel challenged by that. I've learned that I want the photographs of my children to share similar qualities to the pictures I make of other subjects: to be ambiguous, confusing, and to straddle fact and fiction. Additionally, and more than ever before, I want my pictures to be uncomfortable—to sit on an edge. A specific image that comes to mind is a picture of my six-year-old lying on her stomach with a handful of small ceramic vases resting on her back. The vases are slightly blurry, revealing her inability to hold still for the shot, a challenge for anyone, and even more so for a child used to motion.

As an artist, perhaps the hardest challenge I face is simply the detachment needed to see my children as subjects and not as *my* children. Sometimes I succeed at this, and other times, I fail. Perhaps in the long run, this detachment will serve me when it's time to release my children into the world; although I realize there will also be some failure in that.

—Ahndraya Parlato

## My Daily Life
## My Dreams

## My Family

Like many photographers, my first pictures were of my family. When I was ten, my father gave me my first camera, a Brownie Hawkeye. I still have the black-paged album filled with square snapshots made during the years of my photographic innocence. They say something, uncertainly, about how I grew up. That album, if found today by a stranger, would become part of the vernacular photographic record of the 1950s—anonymous, decontextualized snapshots. The details of clothes and furniture, or things left in the yard, would perhaps be of more interest than the badly placed subjects themselves, about whom the viewer would know nothing. Indeed, little can be gleaned from those snapshots of the true history of my family's dynamics or psychology. Therein lies their charm and value. Viewers may bring to them their own nostalgia and romance. As unfiltered historical records, these photographs carry value that a photographer's intentional study of their own family could never display.

Everyone photographs their family. Billions of digital images are made every day. So what's the point for an aspiring photographer of becoming obsessed with their own family? What stories could they possibly tell that aren't already available anywhere and everywhere, online and in real time? It's about what might appear in other people's family photographs. Looking at the "other" might offer an escape from one's own comfortable, domestic bubble and expand one's understanding of difference: race, class, gender, etc.

Damn you, sir! This is a pretty harsh position to take! No! One's own family is a good subject for practice. I did it in my salad days, but it is a theme too shielded and should remain one for practice. The tyro doesn't have to go anywhere else to risk failure. The exercise is too easy; there is frequent and usually total access, and despite some squabbling about intrusion, or disruption, one has perfectly willing and manipulable models. You will become the kinsman's paparazzo, always on call, for

whatever occasion. Yes, your mother will always say, "You are a wonderful photographer, but get a real job." You need to explore the extrinsic world, looking for the unknown and unexpected. Leave the family document to the family. In time, the study of the vast, ever-growing digital vernacular archive of the web will reveal the universal family story in all its diversity.

—Charles H. Traub

## My Father

I never managed to take a good photograph of my father. Whenever I wanted to, something would stop me. Maybe it was deep, long-lasting teenage angst, or a lack of courage. I look back on this with regret.

It was my mother, a quilter not a photographer, who took the most enduring photos of him. Her practical images of my father dutifully holding up her newly finished quilts for the camera—he was the only one in the house tall enough to fully display them—are some of my favorite images. His face and body completely obscured by the task at hand, the pictures show only his hands grasping the top of the quilt, and his ankles in faded, light-blue jeans, and well-worn white sneakers protruding from the bottom. These unintentional portraits are some of the best collaborative images that I have seen; they're the work of a proud artist and a patient companion.

—Michael Vahrenwald

## My Girlfriend

## My Grandmother Naked

I remember my grandmother sitting on the divan in the kitchen in front of me. She was in her underwear and tried to reach her socks to take them off. Her big belly was touching her knees while she leaned forward. Her breast was like dough, light golden beige, and stretched from the weight of age. Her skin was so transparent you could see almost every

vein, purple lanes through the landscape of her body.

She often undressed in front of me and while doing so, she talked about her old body. She wasn't ashamed to be naked. The body she was used to has taken on another form; she says she feels withered. She no longer defines herself as beautiful at the age of eighty-five. But to me, my grandmother's old body is a treasure. She was and is beautiful, and each wrinkle and mark are like words in a book that's taken a long time to write.

I often imagine taking photographs of her naked. At the same time, those moments feel so precious that I have the impression a camera could destroy the naturalness of the moment, and between us. I am afraid she could misunderstand. So I've been unable to share my admiring gaze out of respect for her. Perhaps I am also afraid of her saying no; it is an answer I would expect.

—Stefanie Moshammer

## My Lover (If Ever I Have One), Especially Naked

## My Mental Image Archive

I used to reach for my camera every time I saw a situation worth capturing. However, I slowly realized that I was taking pictures that were already imprinted in my mind's eye, already lingering in my mental archive. Why did I want to retake more or less the same pictures? I found comfort in knowing I wasn't alone. Many photographers stand on the shoulders of those who came before them, those who defined the standards of what was photogenic.

At first, the realization of how and why I was photographing felt like a loss of open-mindedness, but was followed by a sense of freedom. I decided to let go of the idea of original authorship and began to embrace the uninhibited freedom and mundane beauty of vernacular photography. Amateur photographers don't often work with concepts. Instead, their interest is focused on the object of their attention: a dog, a garden, a

mountain, an aunt posing beside a flower display in a public park, and so on. Such images unintentionally and unambiguously tell us about the ways we encounter the world through the camera, about how we see when we look through the lens, and about who we become when the camera is pointed at us.

—Rein Jelle Terpstra

## My Mexicans

When I finished my first big photo project, I had the opportunity to share my work with a fancy curator at a prominent arts institution. She looked through the work quickly, dismissing most of it, and asked me where I was from. Because I was flying in from Istanbul, she assumed I was Turkish. I began to explain my background: that my family arrived in California from Mexico; how my father, an illustrator, immersed himself in Silicon Valley's tech culture; that, for the most part, my upbringing was that of a typical American suburbanite. Her eyes lit up. *That* is what she wanted to see.

I've had numerous experiences where my worth as an artist is quantified by my personal backstory, expected to be neatly told through the conventional narrative of the immigrant's son. It has been a point of resistance and contention, because my cultural heritage is not the sole factor that dictates how I experience and process the world. But as a friend said to me recently, pushing back against this pressure is also a form of submission, because I am not making that decision independently. It's an ongoing dilemma.

—Andres Gonzalez

## My Mother's Death

This year, when my mother and I were told that she had at best three months to live, my first thought—apart from the obvious, that my world was about to fold in on itself and spit me out on the other side of an alternative reality—was that I

wouldn't do anything as cliché as photograph empty chairs, hanging clothes, or her hands bathed in light. And I certainly wouldn't take pictures after she died; that was a fantasy reserved for my father, eighteen years older than Mum, who was sure to die first. This imaginary narrative also never applied to Mum because I loved her too much.

It was right in the middle of the pandemic, and I bumbled along, caring, cooking, cleaning, endlessly cleaning—to keep myself busy and make her proud of my organizational skills. I was determined to give her, much like a good home birth, a successful and efficient home death. What the fuck was I thinking? In my defense, there was so much to arrange: caregivers, nurses, hospice, food deliveries, visiting rights—or not, as it would turn out. I was grieving, deeply, dreadfully, with an emotion and furor that I had never experienced. The pain was in my bones and I needed distraction. What could a photograph say of any of that? All I knew was that she loved me, and I loved her—very simple, really. So when it came to sitting with her while she gasped her last breath and her body rattled into the abyss, my first thought was of love, and of taking the photos I never thought I would. The blood drained from her body and with it, everything that I knew her to be.

—Lisa Barnard

## My Mother's Funeral

My mother died five years ago. The day of the funeral, she lay peacefully in the coffin, holding in her hands a bunny puppet I had given to her. It was the symbol of our bond since I was a little kid. Since that day, I've doubted myself about taking her final picture. Was it ethical? Was it inappropriate? What if a family member felt gutted seeing me take that picture? What would I do with that picture in the future? Would I ever look at it? Should I have kept this image only in my mind and heart? I feared it was a voyeuristic act that could have

dishonored the memory of my beloved Mamy. A few days after the funeral, I flew back to Paris and bought the exact same bunny puppet I had given to her. It's in my bedroom now. The moment in front of the coffin was so intense that I sometimes look through my phone's camera roll to see if I actually took that picture. Maybe one day I will find it.

—Marianna Sanvito

## My Mother's Wedding Photos Where She Cut My Dad Out of the Picture

## My One-Hundred-Year-Old Country-Doctor Father

I'm currently finishing a book, *Night Calls*, about my one-hundred-year-old doctor father, in which I've retraced the route of some of his house calls through the same rural Indiana county where we both were born. Echoing his work rhythms, I photographed often at night and in the early morning, when many of us come into the world—my father delivered some thousand babies—and when many of us leave it.

Since my father is camera shy—ever since he had a stroke about twenty years ago—I was reluctant to photograph him directly. But the deeper I waded into the project, the more intrigued I became with the challenge of trying to create a portrait of him at a slant, perhaps by suggesting his presence in the lives of the patients he served.

Near the end of the project, I stumbled across how to do this. Reading Max Kozloff's *The Theatre of the Face* (2007), I learned how the German photographer August Sander visited the farmers in the countryside near Cologne to make portraits in their homes or gardens, working "much like a country doctor making house calls." Trying my best to channel my father's gentle bedside manner, I visited the home of Suanne Sloan Evans, whom my father delivered in the late 1950s. While making this collaborative portrait with her, I asked Suanne to let her mind wander. Struck by the dreaminess of

her gaze, I asked her what she'd been thinking about while I'd been photographing her. "I was remembering when I was five and cut my knee," she told me, "and how your father carried me in his arms all the way to the hospital."

So I consider this image of Suanne a kind of slantwise portrait of my father. And since Emily Dickinson has long been one of my creative inspirations—ever since I was a girl in Rush County, Indiana, who memorized her poems—photographing this way allowed me to follow her directive, "Tell all the truth but tell it slant."

—Rebecca Norris Webb

## My Own Drop Shadow When in Sunlight

I probably shouldn't photograph my own shadow. I think the subject could be an embarrassing self-portrait situation, maybe even a direct reflection of low self-esteem.

Nevertheless, I always end up obsessing over how my own human drop shadow casts itself on walls or sidewalks, usually in connection with odd objects. This requires awkward physical poses to get the distortion right in the photograph. Anyway, it ends up taking a lot more time than I realize and substantially delays my commute to the studio. Not that it matters, since I don't really need to be anywhere at any specific time.

—Asger Carlsen

## My Photographs

I bought my first Olympus mju in 2001, a great analogue point-and-shoot camera. It's now fourteen mjus and thousands of photos later. A publisher once approached me about turning those photos into a book, and I've been asked a few times to show them in exhibitions. But I've never accepted. Ten years ago, I probably would have agreed right away. But not now.

I tend to adopt an active editorial role in my work as a designer, whereby the line between authorship and design can become very thin, even disappear completely. In my collaborations with Stephan Keppel, for instance, I act as an image-maker and manipulator, adding my own images to the book, or extremely transforming his. In the collaborations with Marie-José Jongerius, I write and edit texts. With Andres Gonzalez, Nicola Nunziata, and Michael Ashkin, I adjust their work by adding layers—texts, images, or experimental printing techniques—recontextualizing their work and thereby creating a new body of work together.

In all of these cases, I am able to move easily between my roles as designer, editor, image-maker, writer, and publisher. The roles all emanate from the same standpoint: an actively responsive attitude to the artist's work that can evolve into a more proactive collaboration. Everything is interconnected in a natural way.

The idea of publishing or exhibiting work myself as a "photographer," especially in a photography context, makes me uncomfortable. I fear it might produce an imbalance with regard to authorship, and dilute my practice through the assertion of one particular creative role.

Over the past fifteen years, I've often used a pseudonym in situations where I've assumed too many roles in a given production. As writer, photographer, color separator, reproduction photographer, editor, that pseudonym now has an impressive curriculum vitae. Maybe *he* is ready to publish a book of photographs or make an exhibition.

—Hans Gremmen

# N

**Nail-Salon Windows**

**Naked Children**

**Naked Moms**

**Naked People**

**Naked Women in Bathtubs**

In graduate school, my classmates and I participated in the process of reviewing applications for the next class of students. This entailed long days in a darkened room, systematically working our way through carousels of projected slides. We viewed and reviewed thousands of images, and measured them against one another. There were overlapping visions and enough good pictures to make some of us feel that there were degrees of arbitrariness in our own admission to the program.

One kind of picture that surfaced frequently was of naked women in bathtubs. I don't recall them being particularly erotic, and if I thought about it enough, I might be able to connect the phenomenon to the suppression of cadaver images coming out of the wars in Iraq and Afghanistan at the time. Whatever the reason, their repetition drew enough commentary in the room to solidify the subject as a taboo in my mind. I don't think I have made that picture since.

I'm sure there are layers of irony that could be excavated here, since I took up photography at the age of fifteen, when it was impossible to disentangle artistic and pubertal motivations. What drew me to the medium was surely, in part, the

adolescent belief that it might facilitate encounters with naked women in bathtubs. I'm also now connecting this to the fact that I recently made a book full of pictures of my belongings in a bathtub.

—Matthew Connors

## Name Tags

## National Flags

## Nature

## Nautilus Shells

## Navel-Gazing

## Nazis

## Neon Signs

## Neutrinos

## New Age

## New Photos from Real Life

I never take a new photograph. Every photo I make comes from a photograph that already exists. Everything that I want to say has already been said. I'm just finding new ways to say it.

—Pacifico Silano

## New Pictures

At some point before I turned twenty years old, I decided that there was no point in making new pictures. There were enough already, and I should just use the ones that already existed. It wasn't a formal rule, but it developed into one. I needed photography to be more physical, less fly-on-the-wall and more bull-in-the-china-shop. I color-Xeroxed a Christ on the cross—it was El Greco, if I remember correctly—from a

Renaissance art history book and lacquered it to a Frigidaire door I found in an empty lot next to my house. I bought nine toilet seats at Walmart—some of which came with studio images of "perfect" toilet settings—and hung them in a grid at the end-of-year show. I returned them after the weekend show and had a friend videotape it.

For years as a photo major, I didn't use a 35 mm camera. Polaroid SX-70, yes; Nikon, no. Maybe this was a rejection of the nerd aspect of the darkroom, or maybe an overstatement of my nonconformity, so that even my Sunday-school teacher would see I was punk rock.

A few years later, I took a large-format photography class that kicked my ass. I remember standing in the Grant Park cemetery in Atlanta with the dark cloth over my head, staring into the ground glass. I want to say I was crying, but I think it was more like a mini-sublime. It was the magic of the darkroom, but it was happening in the field.

—Roe Ethridge

## New York City

## NGO-Style Pictures

"NGO-style pictures" is a poorly worded term for the category of superficial, shock-provoking, patronizing, heartbreaking images depicting violence, abuse, and the full range of human misery. Such images have long been the signature visual language used by nongovernmental organizations (NGOs) and charity and activist groups to raise awareness and funds. I mostly support them and understand their needs, but find it infuriating that such important and necessary organizations come forward with such unacceptable images. I struggle with them and think, Where is the crack? In the photographers' eyes? In the brief? Somewhere along the chain of photo editors, communications managers, and publicists, who think this is what the public needs to see? Is it in ourselves? How

can we interrupt this process? Such pictures are easy to find in each year's edition of important photojournalism contests, such as World Press Photo. It is no accident that many photographers operating in that field are photojournalists and so-called "classic documentary" photographers—but what does that even mean anymore? Our current understanding of photojournalism and its functions is a big part of the problem.

Whenever I come across these types of photographs in my work, a special alarm goes off in my head. I relegate them to a far and hidden corner of my brain, categorizing them as toxic and contagious. I wish I could unsee them. But then I fear that I am preventing those stories from being told. So I start looking for stories employing different visual strategies and languages, which do often produce challenging images and fresh, necessary perspectives. And yet, those "NGO-style pictures" keep haunting me.

—Elisa Medde

**Nonchalance**

**Noontime**

**No-Pants Subway Ride**

**North Korean Ceremonies**

**Nostalgia**

**Novelties**

**Nude as Arte**

**Nude Self-Portraits**

**Nudes in Nature**

**Nudes of Ex-Girlfriends**

## Obelisks

## Obeying the Rules

I am part of the floating population, that is, I am one of the people who reside in one area but have to travel daily to another for work or education. Therefore, most of my photographs are taken in or around public transport, and many ideas occur to me there. When the subway police tell me I can't take photos, I always tell them that it will be the last time I do it. This has been happening since 2009.

—Sonia Madrigal

## Obfuscation

I'm drawn to photographs where a significant aspect is hidden or obscured: shadows, blur, a fog (of the lens, or actual mist), haze, a flare, a cloud, a mask, a curtain, a sheet. This all sounds a little gothic, and maybe that accounts for some of my taste in photographs. I think about the classic Diane Arbus quote, "A photograph is a secret about a secret. The more it tells you, the less you know." Maybe I'm just looking for secrets.

—Rebecca Bengal

## Obituary Photographs That Are Not Handsome

## Objectified Women

While preparing my master's thesis, "Performative Photography," in 2017, I did a lot of research on the body.

What I realized came as no surprise: there's an overwhelming amount of images of naked women and sexualized female bodies throughout the history of photography. Why aren't there equivalent images of male nudes—"sexy" male bodies, gazed at, desired, objectified, and dissected? There are some images in the gay photography scene, though these are still by men doing the looking. We women have been so busy fighting to reclaim our gaze and bodies, that we have rarely turned our gaze and lenses toward men.

In the past three years, masculinity has become a trending subject in photography, and many female photographers, including myself, have inserted themselves into this narrative. Back then, I made a radical choice: I decided I would strictly photograph men for my personal projects, as well as for commissioned work. So, oddly enough, during this time, women ended up on my "do not photograph" list. Given that my work revolves around topics of intimacy, sex, emotions, and relationships, I wanted to avoid, yet again, representing women as emotional, crying, fragile, sexualized. No, thanks. Can't cis men get emotional, cry, be vulnerable, or be desired as well?

This rule lasted for two years (you can't just photograph people of one gender forever; it becomes nonsense). In addition, as I reflected further on gender representation and fluidity in my work, I had to let go of such a strict imposition.

Today, I continue to be tired of females being objectified and treated as *pretty* things in art, with their value only measured by their looks and age. Don't take this the wrong way, but my imperative now is: fewer naked women, and more naked men, please!

—Karla Hiraldo Voleau

**Objectivity**

**Objects about to Fall from the Corner of a Table**

**Objects in the Center of the Frame**

## Objects Shot According to Their Self-Presentation

Every object carries a strangeness within it. Beyond the mental image we form of an object lies a history and experience we can never access. Our habitual perception of objects insulates us from a truly lived experience with them. Photography, as a pragmatic tool, seeks to further solidify our certainty of objects and their position in the world. Yet it remains ambivalent to organized meaning. Contradictions and uncanny appearances are often the result. And both provide a potentially liberatory space within a photograph, pointing toward truths that elude description. For this reason, I am reluctant to frame objects according to their self-presentation. Even a slight shift in perspective can provide the shock necessary to restore them to life. For the same reason, I am suspicious of categorically avoiding certain objects; a reluctance to engage them might only reflect our surrender to the oppressive nature of their conventional presentation.

—Michael Ashkin

## Obsessive Reframing of the Picture

## The Obvious

## Oil Stains on Concrete

## Old Bathrooms

## Old Cigarette Butts

## Old Couches

## Old Family Albums

## Old, Gorgeous Stephen Shore Cars

## Old, Ruined Monuments

## Old, Weathered Faces

## Old, Weathered Photographs

## One-Armed Bandits & Smoking Senior Citizens

## Only One Feeling

With each photograph, I try to provoke more than one feeling. Our minds are like storage closets with a box for each emotion. If a photograph makes someone truly happy, they will store its memory in their happy box. If a photograph makes someone truly sad, they will store its memory in their sad box. And so on. Once the memory is stored, it is easily forgotten. If a photograph provokes a mixture of emotions, then people will not know where to store its memory. They will keep on feeling, thinking, looking. A great photograph compels someone to look at it and makes them ask questions, but doesn't give all the answers.

—Lucas Foglia

## Open & Empty Fields

Empty fields fascinate me: big, open fields; misty fields; green fields. Whenever I'm driving, I feel the urge to stop and photograph them. I wonder about all the lives that have walked through them. I visualize multiple times—deep time, cyclical time, human time—converged and suspended. Giving in to my desire, I get out of the car. Then I remind myself that I have done this hundreds of times and that I never end up using any of these photos. I retrace my steps and continue my driving, until the following day, when the urge arises again.

—Karen Miranda-Rivadeneira

## Opportunism

## Oranges on Trees

## Orange Traffic Cones

**Orca in the Aquarium**

**The Other**

> Critics like to talk about "the other" in photographs, but the other is me too. When I photographed *On the Bowery* (2019), I did not feel that I was breaking rules, but I did hold back on showing and publishing the photos for more than forty years. I wanted to see the Bowery, but not intrude on it by publishing the photos. The rules that I broke were shooting from the hip, with a new 28 mm Elmarit lens, and not looking through the viewfinder.
>
> —Edward Grazda

**Other Photographers**

**Other Photographers Covering the Same Event**

**Other Photographers' Pictures**

**Outstretched Palm**

**Overconfidence**

**Overdoing It**

**Overexposure**

**Oversaturating Colors**

**Oversharpening**

**Oversimplification of Anything**

**Overthinking**

**Overt Visual Deliciousness**

**Owls in Cafés**

**Pain**

**Painted Brick Walls (Especially the Mysterious Zone Where a Wall Meets the Ground or the Floor)**

**Painted Nudes**

**Painted-Over Graffiti**

**Painted Pigeons (Ricardo Cases Did Them Too Well)**

**Palm Trees**

**Parades**

**Paris**

> I've seen more than enough photographs of the Eiffel Tower. And the Champs-Élysées. And Montmartre. The Louvre Pyramid. Centre Pompidou. Booksellers along the Seine. Adorable street cafés with cursive writing on chalkboard menus. Glamorous women smoking cigarettes. Glamorous women drinking coffee. Glamorous women crossing the street. Couples under umbrellas. Enough already! Basically, if it's recognizable as set in Paris (particularly new pictures of the city that look like empty, vapid advertisements), then please, no. If it's the seedy underbelly, however, that never gets old. But mostly, forget Paris; we need more photos of other wonderful cities around the world!
>
> —Elena Goukassian

## Paris Hilton

When *Interview* asked Larry [Sultan] to photograph Paris Hilton in 2007, he initially and immediately refused. At that time, we were inundated with images and press about her, and he told them the last thing he was interested in doing was adding his photos to that massive pile.

But after hanging up, he began to think about the offer. Since they wanted him to fly to Los Angeles for the shoot, there might be a way he could actually make it interesting: he could photograph her as an apparition—an embodiment of his adolescent fantasy—standing there in the flesh, as if transported back in time to his childhood home on Katherine Avenue, where he lived when he was a teenager. As luck would have it, he had driven by the place on a recent trip to LA, and knocked on the door. The guy that answered was the very same owner who had purchased the house from his mom. It had been her first sale as a budding real-estate agent. The Sultans had decided to move when they learned of the city's plan to build a freeway within view of their house, and Jean was convinced she could sell the place herself. It turned out she was right. She had a natural "gift of gab," as Irv called it. She sold the house by telling the future owners that they would never be lonely, because all they had to do was look out the window and see all the people driving by on the freeway.

Remembering he had the guy's number, which Larry got on a hunch that he might want to revisit his childhood home, he called back *Interview*. Larry said he would consider the Paris Hilton shoot if she agreed to do it inside his old home on Katherine Avenue, and wear big white underwear for the shoot. God knows why, but she agreed.

Larry set up two shots: one where Paris is standing in front of the flagstone fireplace in the living room, staring directly at the camera while the owner of the house is in the background, working at his desk in the adjacent den, seemingly unaware that Paris Hilton happens to be standing in

his living room in her underwear. He staged the second shot in his parents' former bedroom. Actually, he didn't stage it as much as just took advantage of the fact that Paris had thrown a hissy fit and wouldn't come out. She hated the way she looked in the big white slip in the first shot and retreated to the bedroom, where she got stoned and refused to get off the phone. So Larry shot her there, lying across the bed in her robe, distracted by her phone.

—Kelly Sultan

## The Parthenon

## Partners or Myself Trying to Look Attractive

## Party Pictures

## Pastel Colors

## Pastoral

## Patterns

## Peacocks

## Pears

## Peeling Paint

## Peepholes

To photograph a peephole seemed a fun idea a while ago. My reasoning was that you would transform the surface of the photograph into something the viewer would want to look *through* and not only *at*. It would also imply a certain frustration at not being able to do so, and thus highlight the desire involved in the act of looking. I was fascinated by Sartre's famous parable of the voyeur caught peeping through a keyhole in a hallway, who suddenly becomes shamefully aware of himself as an object for someone else. I was also

inspired by Duchamp's installation *Given: 1. The Waterfall, 2. The Illuminating Gas* (1946-66), which involves not one, but two peepholes, one for each eye, and is something like a little theater of perspective and desire.

I came across a keyhole in Kafka's novel *The Castle* (1926): in a sudden reversal of roles, the protagonist, like "a photographer looking through the aperture," spies his adversary, the all-seeing Klamm, sitting in his studio. As we know, power and vision are often entwined, and much has been written about cameras and surveillance, but I think Kafka hints here at the subversive potential of prying eyes when they are turned on the mechanisms of panoptic power.

Peeping is also about the joy of discovery. My friend Javier Ortiz-Echagüe, who is very fond of telling anecdotes, once told me that the famous Basque sculptor Jorge Oteiza built his first camera by puncturing a stone with his chisel, making "a hole of light in a world of darkness," or something like that.

I have been toying around with peephole photographs for a few years now, but like many similar ideas, it served its purpose and then became a tiresome repetition. Now, it feels a bit like a cheap metaphor, a way of explaining what I think I know instead of expressing awe for what I still find mysterious. So it's forbidden.

—Federico Clavarino

## Pelicans at Outdoor Bars in Florida

### People

When I am out wandering with a camera, I generally do not photograph people. The things people leave behind have always been confirmation enough that there are plenty of other worlds. Those other worlds might reflect the lives of people back to us, albeit from an oblique angle. It's difficult to say exactly where any place begins or ends. Places are built up over time, accumulating layers, evidence of lives lived.

Could we extend the idea of "personhood" to nonhumans? Aren't buildings individuals too? Are places for people only? What role do nonhuman entities play in shaping a place?

—Ed Panar

## People as Subjects

I am interested in the difference between a photograph where the meaning is driven by the subject (it is about the person depicted) versus a picture in which a person is part of the overall idea of the photograph—an element among picture-matter—where identity may be arbitrary and the picture's meaning comes from intent of the photographer. For much of my work, I opt for the latter.

—Joel W. Fisher

## People at Their Worst

## People at Work

Despite years of obsessing over the problem of work and labor, I am uncomfortable with the idea of photographing people at work. The question that bothers me is: how can you produce images of workers that critique the idea of work itself?

In South Africa, there is a rich history of images that have exposed working conditions, unfair and unequal labor practices, and the apartheid and postapartheid mistreatment of workers. I am drawn to many of these photographs, however within this language of images, the work being shown is often naturalized. As a result, I am constantly trying to think about how to question the structure of the idea itself. The ideology of work is fundamentally racialized and gendered, colonial in origin, and at the heart of the problem of unemployment in South Africa.

Yet despite knowing the visual language is overdetermined, I still have to fight the desire to take images of workers. I've found an outlet for the constant suppression of this desire by

photographing and filming other people's images of workers—
not the documents and photographs of work, but the mon-
uments and sculptures. This is where the ideologies of work
sit on the surface—idealized and nostalgic for forms of work
that are disappearing. These "heroic" representations allow me
to produce the images I wish I could make, but don't allow
myself to.

—Simon Gush

## People Crying

## People Dancing

## People Eating

Photography is often a very private act, and editing, even
more so. The major decision is what to reveal. Photography
has, therefore, become a means of determining and challeng-
ing my value system, which evolves and shifts over time.

Still, I remain totally averse to taking pictures of adults
eating. On some level, it seems absurd to write these words.
I've extensively photographed wars and social discord, situa-
tions fraught with questions of privacy, consent, and represen-
tation. Yet these seem like necessary challenges to navigate.
The act of eating is almost always vulnerable and undignified
when rendered in a photograph. Being served food, or sitting
at a restaurant or at the dinner table is fine. And I think we
all take a kind of pleasure in charming pictures of babies and
children eating. Yet a frozen moment of someone shoveling
food into their mouth makes my skin crawl. I can only find a
modest logic in my argument. I love to eat and to cook, and
watching people eat in real time is a joyful act. But I just can't
photograph someone eating. I suppose we are all entitled to
our strange quirks.

—Peter van Agtmael

## People Giving Birth

**People Holding Photographs of Lost Loved Ones**

**People Holding Trophies**

**People I Already Know**

**People I Can't Be Empathetic With**

**People I Don't Know**

I used to enjoy photographing strangers. As a teen, I would approach people on the streets of New York (I loved going to Union Square, especially) and ask to take their portrait. I think I was mostly interested in the thrill of a meeting—a moment where I, at sixteen years old, could be in charge of something or someone. I was a shy kid, but the 35 mm camera in front of my face granted me permission to do as I please. I didn't always ask before clicking the shutter. Now, I have no interest in photographing people I don't know, even when I see the image so clearly, when the light is just right or I witness a particularly charged moment between strangers in the distance. Perhaps I have become more shy over time, or probably just more interested in myself—no longer seeking, or needing, that power I once felt behind the lens, no longer trying to capture, but instead creating something I can release.

—Dionne Lee

**People in Costume**

**People in Danger**

**People Looking Homeless**

**People Looking into the Camera**

In May 2011, I was on my third trip to Marseille, France, to finish a project on the Mediterranean city's immigrant communities. One of the world's true melting pots, Marseille is

home to the largest Muslim population of any European city, as well as to a number of powerful mafia groups that make the local streets unwelcoming and treacherous for the probing photographer's gaze. During one such confrontation, I experienced an epiphany that prompted an examination of both my work and the role of a photojournalist in society.

I was walking in the streets of an ethnically and racially diverse neighborhood, looking to create powerful images of its inhabitants. I noticed an elderly Frenchman passing a couple of young Arab men hanging out near some graffiti. It struck me this could make a telling image, but before I could even raise my camera, all three turned their angry gazes at me and said something aggressive in French. Their point was clear. Don't even think about it. Feeling defeated and fatigued at the frequent rejection of my camera, I later wondered what would have happened if I had spoken to them first, created a connection, and then attempted to make an image? Of course, the candid moment would have been gone.

Historically, photographs made in the context of photojournalism or reportage tend to be rejected during the editing process if someone in the frame is looking straight into the camera. Eye contact viscerally places the viewer into the shoes of the photographer, who is constantly prodding and pushing against a world of reactions, and often, a world of defenses. Does eye contact in a documentary or journalistic image threaten the authenticity of the subject, or the moment? When a subject looks back into my camera, do they stop being an anonymous entity in my frame? Does this transition allow the viewer to identify more with the subject, breaking down the conventions of visual interpretation of images that are meant to operate as documents, pieces of reality, visual reporting? Can eye contact prompt the viewer to ask more questions? In theater or film, "breaking the fourth wall" disrupts the invisible line separating the actors from the audience. As Tim Raphael, a theater director and professor at Rutgers University, describes it, "eye contact in

photographs reframes the person in relation to the environment. The returned gaze, and the consciousness of being photographed to which it testifies, makes the photographer and viewer complicitous in placing the subject in this environment and framing their identity in relation to the scene the photograph depicts."

As a visual documentarian, I strive to disappear and remain invisible while capturing sincere moments. Since my goal is to erase the intangible line between documenter and documented, I feel that direct eye contact ruins or diminishes otherwise successful images. But as a photojournalist, my presence elicits myriad emotional responses, including distrust, hostility, paranoia, fear, vanity, disgust, curiosity, and even violence. And now, in the age of digital publishing, the camera is often perceived as a violation or invasion of privacy and personal space. After forty years of working around the world, often feeling like an intruder encountering harsh, suspicious stares, I wonder, Am I that threatening or is it my camera?

—Ed Kashi

## People Making Things by Hand

### People of Botopasi

In Botopasi, Suriname, a small village in the Amazon rainforest right on the Suriname River, together with local construction workers and a lot of positive energy, we created a house on poles with an open-air studio below. The idea was to have creatives stay there to work, think and reflect, or relax while living in this transformative natural environment and learning about Saramacca culture. I thought about the idea that "the West pays for the rest" when I figured that by collecting rent from the financially stronger Western visitors, we could create a fund for locals to stay for free. But right when the construction on the house was completed,

COVID-19 arrived. At the moment, it's mostly tarantulas chilling in the empty wooden house.

The Saramacca people descend from enslaved people who ran away from plantations and started small settlements throughout the jungle. After slavery was abolished in Suriname on July 1, 1863, they obtained their freedom and the right to live according to their own traditions and political system, and to this day, they continue to live in this way. Theirs is a life based on fishing, hunting, and farming. There are barely any shops or infrastructure, except for the river, which serves as the highway. There are maximum three hours of electricity per day. You drink rainwater. The Digicel telecom pole is the pride of the village. Wherever we are, internet remains our hero.

My hyperconsciousness and sensitivity with regard to the Netherlands' colonial history—Suriname is a former Dutch colony and obtained independence on November 25, 1975—extends to my use of the camera. I love to give my phone to the kids to make photos and videos, and I like to occasionally make pictures of the people I know in Botopasi, ranging from wonderful, daily-life shots to "official" family portraits. I like to document Botopasi, but this is not part of my art practice or my final artworks. It's more of a social exchange.

I have a complicated relationship to this. Even though I know many people in the village well by now, and there are some who ask to be part of my art projects or offer to help and collaborate, I still avoid it, because I feel that the residents of Botopasi (and their likeness in photographs) do not belong to me or to my work. Instead, if I really need a body, body part, or face in a photo, or a person to hold objects for installations, I make that photograph in the jungle or on the river, and work with someone very close and dear to me. I guess that's my solution to the problem.

—Anouk Kruithof

## People on Beds

## People on Computers

I take pictures to move. Like walking a dog, it makes life more full, the chance of discovering something unexpected. Whether on a train, by foot, or on my bicycle, it's a feeling of freedom. I remember once strolling at night in Amsterdam and looking into a beautiful office with rows of high-tech computer equipment and a sleek design. With my nose pressed up against the window, it occurred to me that for all its flashiness, it was still a kind of prison.

Like the rest of us, I try to shoot things that seem to reveal something once photographed. Maybe I like photos to be a kind of respite from the norm. Often, this means that something or someone appears different. But images of people on computers always seem to be less than what they are. The picture of somebody happily sitting in front of a computer with a cup of coffee is one of the biggest clichés of our age, and untrue. We know that the reality of most interactions with a log-in page or an online bill is often a hellish labyrinth of misunderstanding, frustration, and wasted time. Some things are stubbornly what they are and can't become signs for an inner world. Like a new shopping mall or traffic circle, people on computers resist representation. We know what they look like. Perhaps I *should* be photographing people on computers! Anna Fox's and Lars Tunbjörk's work on offices certainly looks amazing now, but they captured a world at the edge of something. Fax, telex, word processors, nylon shirts. Shot sometimes as these very machines were being taken out to be trashed.

Postphotography is all about the digital, so maybe shooting a screen is an act of cannibalism, or technological incest? This puts them in direct competition with the high-modernism imagery of photography. Many of us are still nostalgic for film, slowness, a feeling of materiality—precisely for this

reason. Perhaps I am more interested in what is left behind in the dirty old world. What is happening in actuality, in the physical realm, when we are staring at the computers in our hands? What are *they* up to when *we* are distracted? If we spend half our time in the virtual world, what happens to the old terrain, both real and imagined? That's all photographers have to work with; only the big, eternal questions remain. As online language and behaviors spill over into our lives more and more, what does this mean for our terrestrial reasoning? Where the hell are we—in time, history, and in space?

I'm typing this on an ancient iPad with a cracked screen, using a typewriter app. I'm thinking of Robert Johnson's deal at the crossroads and of the little old man behind the curtain in *The Wizard of Oz*. You work it out, I need to move.

—Robin Maddock

## People Picking Their Noses

## People Playing Guitar

## People Posing for the Camera

## People Praying

I tell myself not to photograph or film a person who is praying, regardless of their religion. I'm afraid to ruin everything without capturing the irreplaceable unknown of this act and the person. To me, this would be something akin to crushing the wonderful nature and culture of a landscape by forcibly occupying it.

In my mind, prayer is more meaningful when it is only visible to those praying. The swirl that forms around the praying person, their space-time, is incapable of being turned into another form. If I drag the praying person into another reality, what I receive from them will collapse and disappear under the Urashima effect [named after the protagonist Urashima Tarō, who has also been dubbed the Japanese Rip

Van Winkle]. So I just take my camera down and meditate on the fact that a human is praying in front of me.

What's mysterious to me are the people who ask to be photographed praying. What does prayer mean to them?

—Rei Hayama

## People Sick in the Hospital

## People Sleeping

I have a phobia of photographing people asleep. *Phobia* is perhaps too strong of a word; *extreme ambivalence* is a better characterization. I think it began on a summer day many years ago, when I tried to make a picture of my father taking an afternoon nap in the backyard. When my camera-laden shadow crossed his face, he woke up, gave me a disgusted look, and fell back asleep. Hardly traumatic, but I was left with no choice but to put the camera down. Since then, my workaround has been to make the picture just after he wakes up, "just close your eyes again for a few minutes." But the images lack the frisson of a sleeper photographed unaware.

Mixed up with my anxiety about sleeping fathers is Martha Rosler's work, *The Bowery in two inadequate descriptive systems* (1974–75). Her critique of photography's complicity in exploiting vulnerable populations has never left me since my first encounter with it in college. What makes this work so haunting and her critique so effective is the *absence* of sleeping figures in the photographs of Bowery doorways and sidewalks. While the broken bottles, cigarette stubs, and food containers attest to a homeless existence, the text of synonyms for *drunk* opposite each image raises the specter of photograph after photograph depicting homeless men and women sleeping on the streets. It's an archive that doesn't warrant my contribution.

Recently, I had an assignment to photograph a Very Famous Artist for a magazine. He had a studio the size of

an airplane hangar and an entourage of assistants, gallerists, and curators who gave me explicit instructions about where I could and couldn't photograph. The VFA, now in his eighties, arrived unshaven and dressed for a day of work in the studio. While he putzed around and smoked his cigar (I couldn't photograph him smoking), I made images of his vast studio. After I had worked for a while in one end of the building, I went back to the opposite side to find the VFA asleep on a small cot under a huge abstract canvas. It was clearly the best photograph of the day, an inverted version of René Magritte's *Le Dormeur téméraire* (1927), but I couldn't make it. Whatever made me hesitate and lose my nerve—my father, Martha Rosler, the artist's entourage, or my ineptitude—matters little. This minor stumble on an editorial assignment serves to remind me that I've lost my taste for capturing a candid world; there's just too much at stake, even for a Very Famous Artist comfortably asleep among the wealth of his work.

—Doug DuBois

## People Smiling

## People Smoking

## People Standing in Front of Famous Places

## People Staring into Space

I tell myself not to do it, but I always have at least one frame with it: the angsty, faraway gaze, the thousand-yard stare. I know, by now, that when I hear myself say, "Look off to the side, stay serious," that means I need to find some excuse to put my camera down, pretend I forgot something, go back to the car, slap myself out of it, think it through, and start over.

—Alessandra Sanguinetti

## People, Things, & Places That Society Has Defined as Conventionally Beautiful

## People Waiting in Cars

Photography deals in obsessions, and I'm obsessed with old cars and trucks. I have to limit myself in taking and sharing pictures of cars, because I know I am repeating myself. Like all obsessions, I can't stop; it's a reflex, a devotion I can't quit. Visually, the car becomes a frame, a stage for a portrait. The windows create a surface and a scrim, refracting light between the subject and the viewer.

But it is more than that. We wait in cars, but a car is transient. Pregnant. Full of potential—taking me from one state to another. A car is a separate planet suspended with its own atmospheres of fog and heat and moisture. I like to cry in cars, but I like to sing in them too. A car is a think tank. I like to brainstorm pictures in a car. A car is my theater. A car is my restaurant. A car is my retreat. A car is my blanket.

For years, I've had a vintage car or truck in my driveway as a location for pictures. I bought my first Chevy two-ton in 2007 off the side of the road. She was red, and I loved her. Then, in 2016, I fell in love with a 1970s faded black GMC for her ripped, deep-red velvet interior and the hula girl on the dash. "Wrap her up," I said. Recently, I got a late 1990s BMW convertible, from which I plan to take pictures of the world moving by in a blur.

Cars equal time. As photographers, our currency is time, and we use the camera to stop it. It's the ultimate hopeless romantic quest.

—Cig Harvey

## People Who Are Hurt or Scared

## People Who Are like Me
## & People Who Are Not like Me

An "ethical photographer" may be defined as an inventor of half-truths designed to defend an essentially indefensible

habit. Yes, I am forced to admit, I am a looker. And the story I tell myself to accommodate this shameful habit of relation to the human world might be boiled down to two rules that I keep, evolved more through instinct and temperament than ethical reasoning:

1. Don't photograph people who aren't like me.
2. Don't photograph people who are like me.

I am aware that these two dictates appear to leave little room to maneuver.

But hear me out. Rule #1 is something like a moral imperative. Lacking the psychologically or physically embodied experience of people from other national, cultural, racial, ethnic, economic, or class backgrounds, I don't have the right or the necessary understanding to make and use images that represent those lives. The distance between their experience and mine is too great, even when close at hand. Distance renders blurry forms and tiny shapes rather than articulated selves: abstractions that lend themselves to projection.

Rule #2 is closer to an aversion dressed up as a principle. People who are like me are boring. Middle-class, overeducated white people. Bourgeois Americans bearing flourishes of bohemianism, as if to excuse themselves. People like me seem to be everywhere, because we are overrepresented at every turn. Sameness leaves me with nothing to learn. I am not interested in people like me. Who would be?

To approach this mathematically, I would like to propose the following equation: *vision* + *learning* = *seeing*. Within this calculus, proximity and distance are the twin enemies of seeing. Yet we are always on a continuum between the two. The photographer's hazard is that looking entails various forms of optical interference—distortion, projection, appropriation, and aggression, to name a few. And the visible is only one tiny evidential spectrum of the human experience. Most things—systems of belief and repression, fear, hate, happiness

and desire, vulnerability and strength, etc.—are mostly invisible. The visible is only the tip of the submerged volcano. But vision is also one of the few senses we have. As distance increases, so does the potential for learning—and for blur.

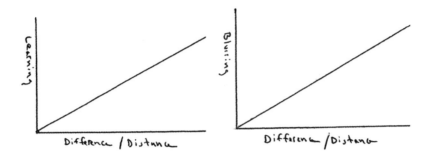

Graph #1: Where x = difference/distance and y = learning
Graph #2: Where x = difference/distance and y = blurring

Difference is the factor that compels me, that drives my desire to learn. If I don't learn anything, I am not creating anything worth making—I am not bringing the world closer. But the distance produced by difference is at odds with the sharpness of vision.

Venn Diagram #1: (no overlap) Unconscionable—no shared perspective for learning
Venn Diagram #2: (almost total overlap) Boring—nothing to learn

But one can attempt to build a territory of shared understanding from which to strain for more revelatory seeing. I try to photograph subjects with whom I can draw a Venn diagram in which I can discover, or forge, enough overlapping experiences to constitute an island. This is not always possible, because it requires language to make this drawing, and that language, at least, needs to be shared. I mean that quite literally: I don't photograph people with whom I cannot speak. But I also mean it in the metaphorical sense: often, the sharedness of experience, especially in a particular context, is not enough to build a viable overlapping set; or the broken ground of history—of betrayal, extraction, or violence—makes the territory too fraught, its echo too loud with injury.

Before I ever take a picture, my fellow traveler and I must stand together on this island: a vantage from which they may orient me toward the horizon of their life, which is now a little sharper, a little closer. Sometimes, this island grows from a shared demographic: we are both gay men; we are both Jewish; we are around the same age. Sometimes, its foundation is psychological or emotional: a relationship to sadness, to the future, to the self, to intimacy, to marginalization, to vulnerability, to violence or tenderness. These are not naturally occurring islands. They must be built up, above the waterline of ignorance, with the landfill I call language.

Through speaking, or writing, a sediment of language forms between us: the delicate, tenuous, nearly illusory ground of what I might call, when I close my eyes and conjure the sensation, solidarity. A word that must also mean love.

Standing together on this little spit of land, a "subject" is no longer fully subject, as they have directed my hand, and my eye, as if at my side, even when they stand before me. From here, I can learn something about the space between us—about the tilt and angle of diverging perspectives, about what my interlocutor might want me to see in them. I hope

to form a conspiracy between us, etched in the code of gaze, gesture, light, space, reflection, and scale. Thus, I tell myself, the picture embeds us both in the frame.

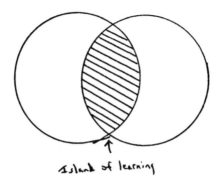

Venn Diagram #3: (some overlap) An island of learning

Call it what you will: solidarity, conspiracy, love, or learning. These sensations grow from difference while dissolving distance. The chimera of an ethical image.

—Nicholas Muellner

## People Who Avoid Me

I consider photographing someone a kind of invasion. Being a photographer is an invasive activity in so many ways. Yet, in order to break down conventions, to seek deeper truths, one must invade. The conflict between caring and invading is a permanent condition. There is always an ongoing, often contradictory, struggle for the meaning of Truth with a capital T.

As the question goes—what or who would you not photograph?—the answer goes that I would not and have not photographed anyone who said no to the invasion. I try to resist intruding into a private personal space—at least conventionally. Even though it is that private space I seek, I also respect it profoundly.

I must say that as I've gotten older, I demure more frequently. I don't have to take a picture. I simply have to experience the life in front of me.

—Larry Fink

## People with Eyebrow Piercings or a Stretchy Ear

## People with Puffy Jackets

## Peppers

## Perfection

## Performative Self-Promotion

As someone who actively uses Instagram to share both personal moments and professional ideas, I've been thinking about the performative uses of photography—especially those pictures taken only for distribution on social media. In the art world in particular, I'm thinking about pictures that record exhibitions, art fairs, and far-flung biennials. Yes, these pictures function as a kind of index as well as a marketing platform, but do they truly serve the artists and their work?

Sometimes, I find this kind of information-gathering invigorating. Other times, it feels like boasting. What are we trying to accomplish with these pictures? What is the role of the photograph in this pursuit? More broadly, do we create experiences merely in order to photograph them? Does our behavior change based on how many "likes" we get? What does this conditioning do, not only to our habits, but to the way we make and share images? Would we still pursue some of these activities if sharing a photograph were not the goal? How are these flattened images used to communicate status or ideology, rather than to take advantage of the expansive possibilities of pictorial language?

—Lisa Sutcliffe

**Performative Uses of Photography**

**Personal Expression**

**"Personal" Pictures**

**Personal Trauma**

**Person Blowing Bubble Gum**

**Phallic Objects in the Built Environment**

**The Philadelphia Wenches**

> When I hear a voice telling me something is off-limits, photographically or otherwise, I tend to charge ahead. This happens especially when there is no bridge in sight between the subject and me, when I don't understand what's in front of me. Photographing is often part of an effort to find common ground. This was certainly the case with my long-term project on the controversial, dress-donning, boozy, exclusively male Wenches of South Philadelphia, who make their appearance in my adopted hometown every New Year's Day. Sometimes it works out and sometimes it doesn't, but the process has kept me engaged as a photographer for decades.
> —Andrea Modica

**Phone Booths**

**Photogenic Gas Stations**

**Photograms**

**Photographing Out the Window of an Airplane**

> I had photographed the view out the window of an airplane for many years. That unhuman point of view of land and sea is magical. There was something so romantic, naive, and somehow reflective about this view, because it had close to no

narrative, idea, or concept behind it. It became my democratic version of the famous photo *Earthrise* that astronaut William Anders took of the Earth from the moon on December 24, 1968, during the Apollo 8 mission. I even tried to add a sense of the physical environment to the concept by bringing 35 mm film in my checked suitcase, so it could be x-rayed many times over several years, before I would use it to photograph out the window. I caused light leaks on the film and photographed the view through colored filters as well. In recent years, however, this view has lost its poetry and innocence. Is it *flygskam* (the flight-shame movement to lower carbon emissions) that has changed the subject and will do so until planes have solar panels on their wings? Is it social correctness, or is it that this is no longer the right distance or angle for us to reflect on who we are and where we are going? I don't photograph the view anymore.

—Peter Funch

## Photographing People from Above

I experience the world from the vantage of five foot four. I feel like I tend to look up at people. One exception is when I look at myself. There's bluntness to this one-to-one ratio, a kind of truth and a lack of distortion. These happen to be the two angles I use the most while photographing others—a mostly practical choice, given my height. But I try to avoid photographing people from above, especially other women. I'm not morally opposed to it, but sometimes, I feel that this way of seeing caters to a male gaze. It prioritizes a specific type of physical attractiveness: when you're looking down, you see big eyes and a small body. It's a perspective that makes me think about diminutiveness, submission, and power. I acknowledge that taking sexy pics from above is not inherently wrong and it doesn't require an audience. But it's a perspective worth considering.

—Eva O'Leary

## Photographing Sex

## A Photograph That Already Exists

I'm driven by the desire to make a photograph that I've not seen before. When I'm out in the world shooting, it is often an intense, kinetic experience. I run around chasing pictures that bubble up amid the chaos and melt away in the same instant. I often recognize something that's happening in front of me as from another picture, or as a photographic trope: two people interacting in a certain way, light hitting someone's hand just so—thousands of references from all the photos in my brain. If I'm lucky, I can catch this feeling, identify it as recognition and not inspiration, and either walk away or fuck it up enough to produce something original. There's something beautiful in trying (and failing) to make something new.

—Michael Marcelle

## "Photography Prohibited" Signs

## Photojournalism

## Photo No-Nos

One time, there was a list at Aperture—Things That Should Never Be Photographed—which started at an editor's desk after one too many portfolio reviews. We all had a laugh adding things as we passed by the list, which was taped to the wall in a high-traffic area of the office. But it was very short-lived. As photographers flowed through, the list felt too snarky and dismissive. Caveats were added: Things That Should *(Almost)* Never Be Photographed *Anymore* and then *Unless You Can Do So Really, Really Well* and later, *or Differently*. After a few days, we took it down. We all knew what could be on the list, but we also knew that the right project can elevate almost any subject, except Babies Dressed as Vegetables.

—Denise Wolff

## Photos from the Car & in the Car

## Photo-Studio Storefronts

## Pickle

I would never shoot a pickle. And if I did shoot a pickle, I would never make a large print of it. If I did make a large print of it, I would never show it in a museum. However, I did make a 48-by-72-inch print of a pickle once. Then I did show it in a museum, but I had hoped to be satirical, funny, insulting, and words to that effect.

I would, however, shoot a pickle if I could turn it into a pornographic joke, like the Man from Nantucket.

I dislike large, large photographs. I don't trust large, large photographs. They look as if they were designed for a museum wall: photographs pretending to be art. An 8-by-10-inch print by Robert Frank is far more profound than an 8-by-10-foot print of a parking lot in Tokyo by Jeff Wall, Crewdson, or Gursky.

My pickle is bigger than your pickle!

—Duane Michals

## Pickup Trucks

I am not entirely sure why I used to make pictures of pickup trucks. I think it might have had something to do with trying to image my dad. When I was twenty-six, he got sick and couldn't drive his black Ford Ranger anymore. Reluctantly, I took responsibility of the car. At first, I didn't like it. I named it Remedios the Beauty to make the experience of driving it fun. I started leaving my Brooklyn neighborhood more frequently, and I noticed that my pictures changed.

When I got to grad school, I made lots of pictures of pickup trucks. They looked like portraits. I don't think those pictures made sense to other people, but in hindsight, they functioned like sketches, working toward my *final* truck

picture. *Up the Hill* (2019) depicts a woman, out of focus, wearing a red T-shirt. Her red nails hug a car-door mirror, and in the reflection is another truck parked crooked down the hill. Only recently did I realize that those pictures of trucks might have been a way for me to process a very real sense of loss through my work, and also to explore the potential brought on by loss. I feel like I had been trying to make *Up the Hill* for years. I was trying to make sense of my relationship with my dad, who gave me that mysterious old car that I grew to love. I now avoid making pickup-truck pictures, because I've moved on in my life and art. But when I made it, I was reminded of what I already knew, something my father has always told me—to always do me, and to do things in my own time.

—Lacey Lennon

## Pictorialism

## Pictures from a Helicopter

## Pictures of an Exhibition

It started from my annoyance with the social-networking algorithms, which randomly, or not so randomly, spoil the physical experience I haven't had yet.

People tend to believe that they have *seen* something merely by learning what it looks like through photographic documentation. The other day, Juhyun told me that she didn't want to visit the exhibition. She saw photos of the installation on social media and, given that, thought it would be okay not to see it in person. Sometimes, people see photos of an exhibition space online, and even mistakenly believe they have actually visited the space.

When I work on making an exhibition, I think of how the viewer will experience the situation. Can a photographic document substitute the actual experience?

It is baffling that people believe what they see in a

two-dimensional photo, especially when it comes to documenting three-dimensional space and events that require time to experience. If the photographic evidence captured in the past were confirmed as the official history, that history would be full of misunderstandings and twisted memories.

—Hyo Gyoung Jeon

## Pictures of Your Lunch

## Pictures That Could Be Favorable to Fascists

## Pigeons

Quintessential New York creatures, resilient and filthy. Gray feathers with spats of purple and green. Wings flapping sound like rubber or people's fat shaking. I can't stop taking pictures of pigeons, really.

Pigeons feed my drive. Overdone, everywhere, again, the same. Avoidance, repeat, question, stop, no more, take another photograph, why not, I don't know, really I don't, and when I don't really know I do know. Worst scenario, I'll put it in a box.

I don't think photographers can stop taking pictures of anything; we just may not show some of them. But then twenty-five years later, we might change our minds.

—Jeff Mermelstein

## Piles

## Piles of Broken Glass

## Piles of Dirt on Graves

## Places Where I Live

## Plants on Balconies

## Plastics

## Platitudes

### Pleased Smiles

"Look at me. Try not to smile. Okay, you know what, look to your left. Up. Further up. Easy, not too relaxed. Try to close your eyes and open them at my 'three.' One, two, three. Think about something serious, maybe something sad or nostalgic, if it helps. Look away, but stay here. Okay, we are almost there, but remember not to smile."

"Why?" he asks with an unenthusiastic look. I click the shutter. I am not able to answer, but I am happy with the picture. His question lingers there, and in my mind, still.

—Simone Sapienza

### Polar Bears at the Zoo

### Police

### Political Photo Opportunities

Working as a photo editor covering politics, I'm always trying to avoid contrived photo opportunities. When I started photo-editing at *PDN* (*Photo District News*), one of the first assignments was to look for a photograph that deconstructed the staging of a presidential photo. After looking through thousands of photos on the wires, I found one that stood out. It was a surreal image of President George W. Bush climbing up to a stage in front of Mount Rushmore. The photographer showed the edge of the grand stage, uncovering layers—the iconic monument set against nature, a stage decorated with bunting and flags, and the president about to step onto the set—to reveal the theatrical mechanics of a standard speech.

Political events usually rely on some theatrical effects that move the event away from reality. My goal is to project a clear message; if you only see the staged image, you get a limited message or straight propaganda. Photographs have a natural relationship to proof, so their meaning and messaging is easy to bend. President George W. Bush unfurls a "Mission

Accomplished" banner on the deck of the USS *Abraham Lincoln*, implying the war in Iraq, just begun, is now over. Obama stands in front of a crowd of doctors in starched white coats, handed out before the event, and health-care reform is in effect. Trump holds a Bible in front of St. John's Church in Washington, DC, on June 1, 2020, and a turbulent time is under control?

Over the years, I've been wary of any moments set up for the cameras. I continually look to photographers who break the contrived look of press conferences, campaigns, and conventions. In all of this editing and searching, however, it's never my intention to find fault or make anyone or anything look ugly, deflated, or diminished. My work is as a journalist, investigating a scene, uncovering another layer, to let the viewer decipher a staged event's codes. Perhaps by peeling back the layers, we find something more real or humanizing: a reminder that these leaders aren't actors, but real people that hold power over all of us, for better or worse.

—Paul Moakley

## Politicians

## Politics

I've tried to avoid politics for more than a decade and have constantly failed. I don't consider myself a photojournalist or an activist; still, I've commented on contemporary political contexts, trying to find a visual response to both propaganda mechanisms and resistance gestures. I like to explore how things work and then deconstruct them—whether it's a region or a stereotype, or issues dealing with communication and the spread of information. I do it because I'm scared and don't want to feel intimidated by the many sorts of manipulation around. Considering the current political situation in Poland, I also feel a responsibility. I don't want to just sit back. With my work, I hope to inspire others to stay wide-awake. It is the

only way for us, the people, to anticipate such a crisis. Visual art can play a role in that process. It is a less direct form of demonstration. It is the kind of activism that I feel comfortable with, including the fact that I can't completely control how it is being received. A few years ago, a right-wing newspaper published an announcement of my *Refusal* show in Katowice, a city in southern Poland. I'm not sure if they realized what the content was about exactly (the various systems of control and pressure exerted in the post-Soviet region, including Poland with its right-wing government), which proved to me that the work can negotiate within the power structures it addresses.

—Rafal Milach

## Pomegranates

## Populated Landscapes

## Porches

## Pornographic Photos of My Girlfriends

## Pornography

## Porn Sets

## Portraits

I would often take pictures of my friends when I first started taking photographs. I didn't have a vision or a particular work I wanted to create in mind at the time. I wanted to hone my technical skills—trying my hand at a variety of different photographs, like portraits, still lifes, and landscapes. Around that time, I won a prize for a certain photo competition; the pictures I had entered for the contest were snapshots—fragments—of my everyday life. A single portrait was among them; it was a picture of my friend, one that I submitted in lieu of a self-portrait. Since then, I haven't released any portraits into a public setting, for the most part, except those of my family. From

time to time, I take private, commemorative photographs of my friends and family, or work on commission. But, in my own work, I don't rely on information about my relationship with the person when people appear in my pictures; I feel that viewers are entitled to view my works freely, from their own unique vantage points. Right now, I don't feel that portraits are needed to achieve that.

—Rinko Kawauchi

## Portraits of Children or Old People Showing Their Age Categories More Than Their Personalities

## Portraits of People Posing in Weird Positions, Which Make Them Seem like They Are about to Fall

## Portraits of People Standing Still in the Center of the Frame, Surrounded by a Landscape

## Portraits of People Where Their Faces Are Covered by an Object

## Portraits through Foliage

## Postcard Racks

## Poverty

To what end do we decide to make images of suffering? Growing up in Paraguay, I knew without question that we were classified as a third-world country; extreme poverty and inequality are a dire fact of life for the vast majority. At that point in my life, I could not bring myself to photograph what seemed inextricable from our national reality—what good could my pictures achieve?

However, recognizing a similar class struggle in the richest nation in the world—on American soil—I have been drawn, with some apprehension, to portray these very fractures in society. There is tragic irony in seeing a multimillion-dollar

interstate that houses cardboard and tarp encampments beneath it, destitute homes segregated by asphalt from the wealthiest neighborhoods, and the way individuals suffer due to systems that celebrate success but blame those who aren't privy to it.

I can't deny the pull to photograph the injustices that lie in the blind spot of the American dream I once believed in. Yet I also fully understand that I run the risk of further harming those who are already suffering under the might of oppressive systems. I know that pictures don't write public policy, but a huge part of me wants to believe that they can illuminate some hard truths about our society at large.

So at what point do I stop myself from taking a picture? Am I seeing someone for their individuality or as a superficial illustration of the plight we gaze at from our own comforts? Do pictures of pain, poverty, and suffering have any power left in our hypersaturated visual landscape?

While I don't believe there are definitive answers, we need to be vigilant and consistently question ourselves as we reach out into the world with our cameras.

—Ricardo Nagaoka

## Power Lines

## Power without Context

I used to avoid photographing all kinds of things. I had this catchphrase: "Photographing a piece of trash is like crowning a prince." In other words, depicting something is an act of power. Either you're asserting power or you're bestowing it, sometimes both. I was wary of that responsibility. I shot mostly garbage, sometimes my own body; everything else felt outside of my remit.

Then I started making pictures for other people and was promptly ushered out of my comfortable little kingdom. The power of my attention now for hire, I found myself alarmingly pliable, as able to photograph a president as an old shoe. I felt

contaminated by commercial imperatives but also strangely liberated. A photograph, it turns out, is just a weird posture: what-it-is posing as what-it-appears-to-be. The power is in the performance or the context of that performance, not in the thing itself. You can put a crown on anything, I reminded myself. What's important is recognizing that power is contingent. Some pictures revel in this contingency and embrace the perpetual ambiguity of their power. Others behave as though they are power itself, or worse, independent of it. I do my best to avoid the latter.

—Charlie Engman

## Preachiness

## Preconceived Ideas

It has taken me some time to realize that what I imagine will make a good picture will never be as poetic or as tender as what naturally happens around me. I can have an idea, but whenever I attempt to stick to that idea, I am forcing the environment to conform to it rather than observing, listening, and paying attention to my surroundings. I try to forget everything that I know will make a good photograph—but not because my formal education in photography is my enemy. I keep my understanding of composition in mind, but I combine it with the immediacy of my life experiences. I believe this will eliminate any pretensions or prescriptions regarding what makes a good image. More important, I don't want to make photographs that just refer to other photographs, and end up with a bunch of images that don't matter to me.

It wasn't until I took the time to think about how rich my own life is that I began to ask myself how my choice of subject matter could be a reflection of something more powerful. One afternoon, I wanted to make a picture of my son Max at the playground. While I was setting up my view camera, my nine-year-old assistant, Pilo, started playing hide-and-seek

with him in leaf piles further away, near some trees. I could easily have been annoyed, because I was not able to make the photograph that I had planned, but I understood that the answer was already in front of my face. I was witnessing Pilo doing what came naturally to him: despite the many years of life still ahead for him, he was playing dead. I would have never been able to capture the innocence of childhood and its inherent fear of the unknown if I had continued to make the image I had originally conceived in my mind.

My uncle always told me that if I couldn't make an interesting picture around my neighborhood, then I had no business traveling to other parts of the world. So I mind my own business and stick to what makes me shine.

—Daniel Ramos

## Pregnant Selfies

Three days before I went into labor with my son, I made a naked and pregnant nighttime selfie reflected in the darkened kitchen window of our little apartment in Queens. It was June in New York City, worries about Zika virus kept our windows closed, and my thirty-eight-week pregnant body was swollen in the late-spring heat. It is among the few photographs I made of myself while pregnant with my son. Because I have documented the relationship between myself and the world through photographs and videos for more than two decades, it is perhaps surprising that I did not make the weekly baby-bump selfies of the optimistic mother-to-be during this pregnancy.

Last week, my son turned four, on a clear blue–sky day in the eye of a pandemic. I made a photograph of him in a quarantine-made, tie-dyed T-shirt, standing in our backyard, next to his homemade cake—blue and yellow frosting forming the word *happy* across the top arch of the cake, haphazard and earnest, like his last days of toddlerhood. I have obsessively documented his childhood since he was born in a thunderstorm high above Manhattan in the third-oldest hospital in

America, after wishing for him for 1,295 days. One day, I will organize the thousands of photographs I made of him during his first four years into a book, which may leave him some hint of what his earliest life was like, years that he may not remember clearly, but which will be the years that I look back to as evidence of miracle.

And what to do with the photographs I made of my first attempts to have a child, the photographs made with the optimism of the never brokenhearted? What to do with the weekly photos and ultrasound images of embryos who lost their heartbeats, during the years we waited for our son? What to do with the mirror selfies of pregnancies that vanished at week ten, or twelve, or fourteen? Nearly scientific in their consistency, they serve as documents of human reproduction in the age of the cell phone. They also serve as fragments of pregnancies that disappeared into nothing on gray static monitors, in rooms I never want to go back to. What do I do with these images I made, these baby-bump chronicles of lost souls, of these wanted children who never had names or birth dates, or homemade cakes, though they, too, are evidence of miracle?

—Laurel Nakadate

## Preoccupations That I've Already Explored & Decided Are Meaningless

### Presence

The statue is missing an arm
The cloud is missing a sky
The wave is missing a sea
The bird is missing a feather
The window is missing a light
The body is missing a warmth
and the whisper is missing a shout.

—Amak Mahmoodian

## Presumption

### Pretending I'm Not There

While I don't have topics or subjects that I avoid shooting, there are ways I avoid *being* while photographing. I try my best to avoid *pretending I am not there*. The photographer is always present. When I started out in photography, I was interested in documentary-style photography and photojournalism, and learned about the idea that I should become a fly on the wall, that I should become invisible. I tried it every which way, and I learned that it was a myth. I was always there, always present. The people at whom I was pointing my camera knew I was there too. So I made peace with being a human being, not a fly. This required me to acknowledge my presence in the world, and all the ways my identities converge to make me visible and intelligible to others. Once I did, it became easy to look beyond myself. Recognizing the intersections of my own identity was the first step toward understanding, accepting, and acknowledging the intersections, contradictions, experiences, and realities of others. It has been a great privilege—as sad and overwhelming as it sometimes can be—to always be there.

—Sasha Phyars-Burgess

### Pretending to Be a Straight Guy

Until I was twenty-one, I lied to everyone around me about being gay. That meant I took many actions to prove I was straight, including behaving as if I desired women. This translated into the way I photographed. To make believe, I exaggerated. I was still studying photography in Beijing then. My commercial photography reproduced stereotypical ways of representing female beauty, and included heavy-handed Photoshop manipulation. In one street-photography image, I used women's legs to frame a view of Times Square,

shooting from an extra-low angle. I feel so embarrassed to look at it now. This male gaze that I appropriated reflected heterosexual values, absorbed not only from the patriarchal society in which I grew up but also from many Hollywood movies and American TV series that modeled how women should be, and how gay men should judge women's fashion standards and taste. I will never make a photograph like this again.

—Guanyu Xu

**Primary Colors**

**Prism Filter**

**Prisons**

**A Private Moment of True Heartbreak & Grief**

I was walking in San Francisco, when I came across a private moment of heartbreak and grief: an older man in a parking lot was embracing his dying yellow lab one last time, while a veterinarian looked on from her seat on a stretcher. My heart stopped and my mind raced. I could feel the tears in all three of their eyes. I wondered if the karmic risk of intruding on their moment with my camera was worth the resulting photograph. I put my head down and kept walking down the hill. But after a few steps, I turned around. I raised my camera, focused on the pet's fading eyes, and pressed the shutter. Only the dog noticed me.

—Sinna Nasseri

**Privilege**

**Produce Stands by the Roadside**

**Products**

## Professional & Amateur

When I first started picking up my camera in my late teens, the question of what to avoid never crossed my mind. It wasn't until my first photography class and my first job as a photo assistant that I was told what should be avoided. But, for the most part, that never bothered me. I guess because I am more interested in constructing photographs rather than shooting them on the fly.

I also started photographing when amateur photography in Hong Kong was at its height, in the early 2010s. Groups of middle-aged, mostly male photographers with their top-notch camera gear (too expensive even for most professionals) would hire models from online forums for a photography session. Others focused their specialty lenses on nature—flowers and birds. At the same time, Instagram was becoming ubiquitous and was the epitome of amateur photography. This was before professional photographers—both art and commercial—had fully embraced it as their platform. Whether a "serious" photographer should post works on Instagram was a valid question at the time. So I guess a lot of advice I received early on about what to photograph, or not, was in one way or another shaped by conflicting ideas of taste between what is amateur and what is professional, whatever that means.

—Sheung Yiu

## Propaganda

I've spent much of my career photographing inside closed and controlled societies—years of my life inside infamously hermetic North Korea and strongman Saddam Hussein's Iraq. These are places where the bleak, or even the ordinary, is often hidden; where mass spectacles and Potemkin villages are sometimes constructed for a visitor with a camera; where reality is served on a need-to-know basis.

Defining such places can be complicated. Even as I tell myself I won't blindly photograph propaganda, I know the lines are blurry. I wrestled with this not just in North Korea and Iraq, but as I tagged along on US military embeds in Afghanistan, where the soldiers and Marines I was photographing were also my protectors—our fates tied together for weeks at a time. I've felt it inside the media corrals at presidential rallies, with their perfectly positioned stages surrounded by supporters in political costume.

I've stood with my camera so many times in front of the extraordinary. But each time, I try to ask myself some version of: What is real? What's the purpose of this picture—to me and to the people who arranged it? Am I being clever or am I being used?

I try to maintain a critical eye, an independent point of view, and include the ropes and pulleys behind the curtains, because even in a propagandist bubble, I know a photo can reveal both the propogandist's hopes and my own search for a different sort of reality.

—David Guttenfelder

## Protesters' Faces

I don't take pictures of people's faces at protests, and am very careful if taking pictures of crowds. This is a practical matter: I don't think people realize how images they appear in can be utilized despite the photographer's best intentions, and I want to protect them from possible misuse. I personally know people who have been photographed at protests and then appeared in stock images that were licensed and put in circulation across different media articles, many of which grossly mischaracterized what was happening. I've also thought of ways that images of people or crowds at protests can be used as evidence at a later date. Even if we think a political situation doesn't implicate someone in a certain way, I don't have confidence that images won't be

weaponized later. I never want the potential for my images to do that.

—Stephanie Syjuco

## Protests

Once, while documenting a protest demonstration in London, in February 2011, I narrowly escaped a brick hitting my camera, and thus also my head. This was one of the main reasons why I stopped documenting protests. That moment made me question, What was I putting my body and my life on the line for? I concluded that this wasn't it. I try to unify with my photography, not divide. I saw the policing of the protesters as totally misaligned—power protecting money, not people. Soon after, I started looking for alternative ways to contribute a unifying and inspiring language in photography. I diverted my efforts and moved away from the front lines.

Back home, I dropped out of art school and started looking for stories that resembled my journey as a Caribbean Black orphan in the Netherlands. I couldn't find Black photographers or architects, and I felt lonely and misunderstood and landed in a severe depression. My photographic practice slowed for the majority of 2012 until 2018. I discovered that my presence in the art and photographic landscape was as queer as it can get and began focusing there instead.

—Dustin Thierry

## Pseudoscience

## Public Bathrooms

Although I find public bathrooms necessary and am grateful for the service, I am also disgusted by them. I hate the way they smell, and when they are too small. When I'm inside a public bathroom, I'm careful not to touch anything with my bare hands. And yet, as much as these spaces creep me out, I am compelled to make photographs inside them whenever

I have a camera handy. I'm intrigued by the architecture, writings marked or etched into doors and walls, and things hanging out of the trash (yuck). I'm also interested in how they differ from city to city. I have a collection of photographs from bathroom visits in New York and cities across the world—Lagos, Nigeria; Abidjan, Côte d'Ivoire; Amsterdam; and Bogotá, Colombia; to name a few—but I have never reviewed these photographs. They are just sitting in my archive. Who knows, maybe one day I will dig up this archive to see what I have.

—Adama Delphine Fawundu

## The Puppy-Like Optimism of the Camera

## Pure Aesthetics

I usually engage with social issues, but I also enjoy producing work purely led by visual exploration and curiosity. Even so, somehow I always return to the bigger social picture. Perhaps it feels disingenuous to produce work concerned only with aesthetics when there is so much turmoil around me, and especially after growing up in a complicated and violent Latin American context.

During the COVID-19 pandemic, I have been trying to shake that idea. The world has changed, and so have the ideas surrounding my identity as a visual artist. I went back into the archive and found that many of my projects actually seem to be aesthetically driven. It only takes removing an image from a project's context to distill from it any social commentary. Even in my project We Are Things (2020), in which I work with archival and found images, I sense an inclination toward more conceptual and form-driven pictures. But the work can't shake its context. Whenever those images are considered in the context of my previous projects, the place where I work, or the origin of the images themselves, social meaning is applied to them, even if I intended them as a more aesthetic statement.

In my latest work, I've tried even more to detach social context from the pieces; they have become sets of forms and lines. What will they mean, or will there be meaning at all? I am still unclear and that scares me. It's an internal struggle whether or not to let go of a specific social purpose. Perhaps I will let the works themselves dictate their meaning, rather than trying to locate it in the project description, or the place or events represented.

—Alejandro Cartagena

## Purebred Dogs

When I was a child, we had a Pekingese dog named Sheru. He had impressive looks but was also imperious. We were all terrified of him, as he was apt to snap at you without warning. He was not a cuddly dog. When my parents moved to Nigeria, they left Sheru behind in Delhi with some friends of theirs, and I can't say we missed him very much. As a teenager, while traveling in Kalpa in the Kinnaur district of the Indian Himalaya, I turned a corner and was faced with a local dog who was perhaps some version of a Tibetan Terrier. She also had some cat in her, judging by her intelligence and feisty independence. Mickey came home with us and became a great love. Later, I brought a street dog home to my parents in Delhi. I'd found her lying on the roadside with a broken leg. Since we could find no suitable shelter for her, Jennie became a part of our household too. I liked street dogs for their gritty integrity.

When I was thirty-nine, my niece Zoya begged my parents for a yellow Labrador as a present for completing her first decade on the planet. And so, Norbu came to us. His name was chosen by my younger sister, Kaveri, and means "precious jewel" in Tibetan. He was thoroughbred, exceptionally beautiful, refined in temperament, and spiritually evolved. He never pressed you for anything. If he wished to go out or for a piece of mutton, he simply rested his head on the bed or

on your knee, and breathed more deeply than usual. He found his way into everyone's heart, including those who had been intimidated by dogs before. We lost him on July 9, 2020. He was not quite eleven and left with true nobility. I often wonder who he really was.

As much as I love dogs, I rarely like looking at images of them. They strike me as cute and clichéd, much like pictures of babies, flattening the complexity of beings we can't easily comprehend. (Peter Hujar's photographs of animals are a rare exception.) Purebred dogs particularly upset me for what they symbolize: bred to exaggerate the features that humans find appealing and acquired to show off, enhancing the superiority and vanity of their owners. In the past, if I were to photograph such animals, it would have been to mock the idea of them. But then we got Norbu, and I longed to capture his sweetness and elegance. He did not like being photographed and often turned away. And in this way, he taught me two important lessons, among many others: love transforms everything, and life itself is more important than photography.

—Gauri Gill

## Pure Landscape Photography

I don't think any subject matter is off-limits if it's photographed well, but I often struggle with "pure" landscape photography. Aside from love and human connection, I believe that nothing in this world is more sacred than the landscape. Some of my most meaningful experiences have taken place in nature, and I photograph the wilderness all the time, especially when working for clients or on vacation. Yet, in my artwork—photos that end up in books and on gallery walls—I rarely attempt to photograph the natural world or landscapes as if untouched or uncontaminated by people.

I recognize that in its popular form, the vast majority of contemporary outdoor photography is hopelessly uninspired. There are some photographers, however, who do it well.

Awoiska van der Molen comes to mind. Her slow and patient approach to a well-trodden subject matter results in images that are fresh and beautiful, yet often full of an indescribable apprehension. The emotional and spiritual richness in her work allows it to transcend what we normally expect from landscape photography. She spends valuable time in the wilderness and returns home with photos that actually mean something. I'd do this if I could, and maybe I'll get there one day.

At present, I think my best work isn't about the land, but about what we do to the land. This comes from tradition—an inclination likely instilled in me through my admiration for photographers like Robert Adams, whose seminal book, *From the Missouri West* (Aperture, 1980), was made with one ground rule: always show evidence of humankind, however large or small. Adams writes, "It was a precaution in favor of truth that was easy to follow since our violence against the earth has extended even to anonymous arroyos and undifferentiated stands of scrub brush." This statement has only become truer over time, as there's almost no place on Earth where nature exists apart from humanity.

—Bryan Schutmaat

**Purple**

**Putting People in Danger (Except Myself)**

# Q

**Quarantine Boredom**

**Quasi-Deep Thoughts**

**Question Marks on the Covers of Books**

**Quirky Jokey Pictures**

**Quonset Huts**

*Okay. Let's put it right, perhaps it's better. I don't like compromises. Either back to front or right. It's better like that. Maybe another time. Pretend you haven't read all this business about putting a picture back to front. It's nothing. It's not worth it. Go ahead, go ahead. Sorry.*

# R

**Racial Discrimination**

**Railroad Tracks**

**Rainbow**

**Rainbow Pride Walk in Calcutta**

**Rainy Days**

**Ramshackle Houses**

**Random Consumer Detritus Found on the Ground**

**Real Estate**

**Recycled Icons**

Documentary photography has always contended with tension between form and content—the subject (and their agency) versus the visual qualities of the photograph itself. Constricted by the frame, photographs cannot escape the fundamental aesthetic conventions that govern it, and the subjects depicted in it cannot become unstuck from the frame. The danger is when visual tropes are arbitrarily applied to whichever subject in whichever situation, simply because of their effective visual rhetoric.

Documentary photography, and especially its cousin photojournalism, is dominated by these recognizable templates, a form of recycled iconography, casting the world in the same mold over and over again. You know them, perhaps

unconsciously or by some kind of deeply engrained affinity: pietà figures, toys or shoes among the rubble, bodies emerging from the smoke, wailing women, faces half submerged in water, eyebrows peaking over the bottom of the frame, black silhouettes against brightly lit landscapes, hands displaying objects of interest, kids jumping in the water, feet dangling in the top of the frame, a bomb's distant smoke-cloud rising above a city, close-ups of emotionally distressed people, photographs made through car windows or other frames within the frame. When applied, conformist aesthetics overpower the subjects depicted. This is when photographic conventions become self-referential instead of self-reflexive.

For my book *Margins of Excess* (2018), I attempted to make photographs that create an expressive space for the subject yet also reflect on the limitations of this representation. For one thread in the book, I worked with actors in New York City and Los Angeles and used the signifiers of stock photojournalism to create empty containers of the perfect trope. The work referred to the classic examples often seen in the media after a tragic incident, such as a school shooting: close-ups of people embracing each other, portraits of spectators crying and hugging. These types of images are published over and over again with maximum emotional impact, because readers can more comfortably identify with them than with images of the actual transgressive event. In remaking these types of photographs, the actors become professional mourners that seem to weep in our stead, like an ancient Greek chorus.

—Max Pinckers

**Red Carpets in the Wild**

**Redheads Waiting for Food from Food Trucks with Money in Hand at the Golden Hour**

**Redwoods**

**Reenactments**

49. "It's shocking, I know!" (p. 146)

50. ". . . empty containers of the perfect trope." (p. 215)

51. "Like all the people whom I love and spend a lot of time with . . ." (p. 137)

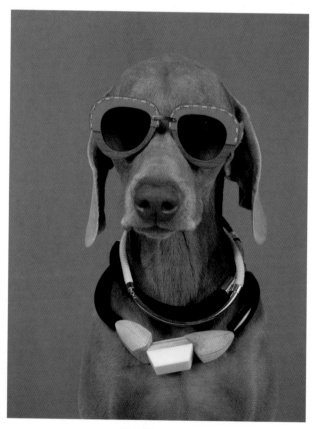

52. "Okay, maybe once or twice." (p. 78)

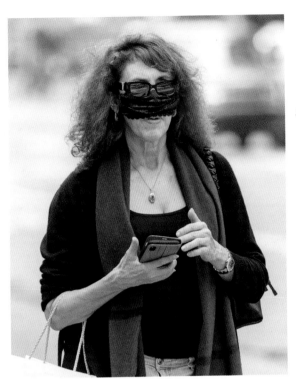

53. "What is a street photo without a damn face in it?" (p. 85)

54. ". . . where nothing is definite or absolute." (p. 36)

55. "Even seemingly futile attempts at something are part of the journey." (p. 262)

56. "A camera flash illuminates a man at work." (p. 284)

57. "It had been a long drive to get there . . ." (p. 132)

58. ". . . unless I really have to." (p. 84)

59. ". . . an opportunity with a willing subject . . ." (p. 48)

60. "Let me say, I am not a hippy."
(p. 87)

61. " . . . de-limbed and left standing as a totem." (p. 81)

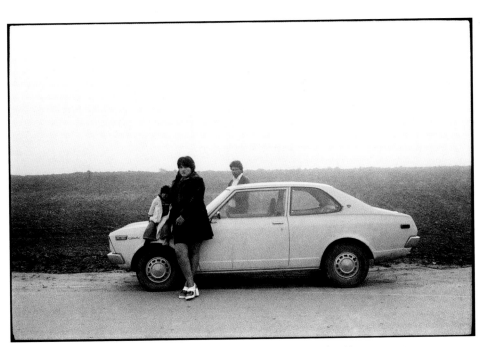

62. " . . . when I implored my students not to make the car picture." (p. 47)

63. "... peeking into my practice in an oblique way ..." (p. 140)

64. "... the definition of insanity?" (p. 44)

65. "... a photograph of numbers, one to twelve ..." (p. 57)

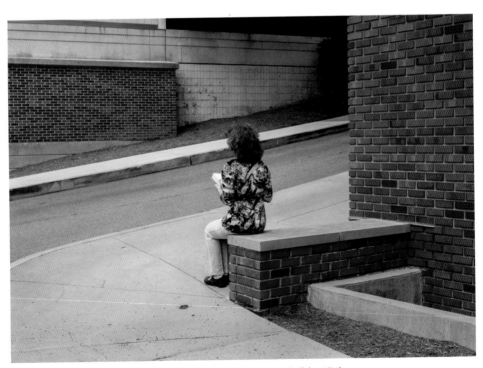

66. "It's difficult to say exactly where any place begins or ends." (p. 174)

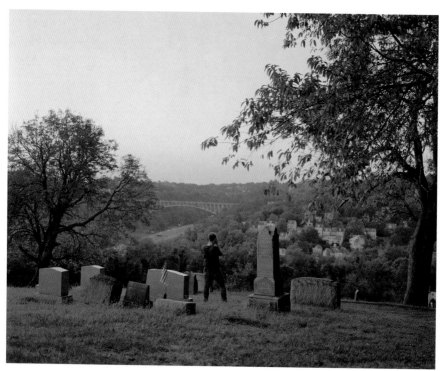

67. "... I realized why Ed was so happy." (p. 53)

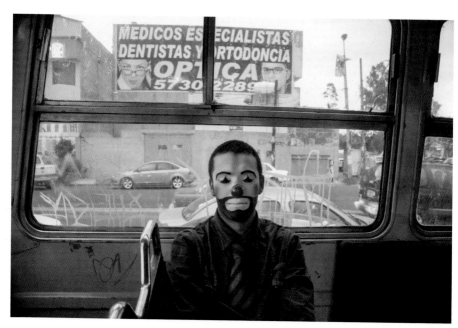

68. "I am part of the floating population . . ." (p. 166)

69. "That night, I had a dream . . ." (p. 60)

70. "I visualize multiple times—deep time, cyclical time, human time—converged and suspended." (p. 169)

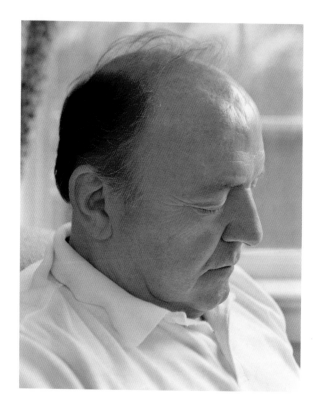

71. "*Phobia* is perhaps too strong of a word . . ." (p. 183)

72. "Our minds are like storage closets with a box for each emotion." (p. 169)

73. "... my adopted hometown every New Year's Day." (p. 191)

74. "... and the whisper is missing a shout." (p. 204)

75. "That unhuman point of view . . ." (p. 191)

76. ". . . when I look up, I feel grounded . . ." (p. 58)

77. "... and then with a heart to boot!" (p. 138)

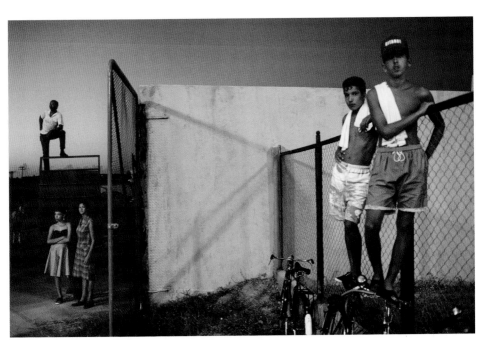

78. "That's when I leave my anxieties behind ..." (p. 260)

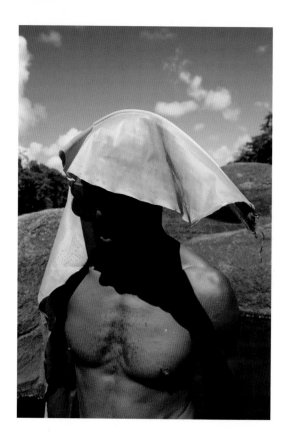

79. "It's more of a social exchange . . ."
    (p. 179)

80. ". . . almost like it is bolted to the architecture of the city." (p. 125)

81. "Murders were rare, they informed me . . ." (p. 71)

82. "Don't think of color." (p. 59)

83. "Okay, we are almost there . . ." (p. 197)

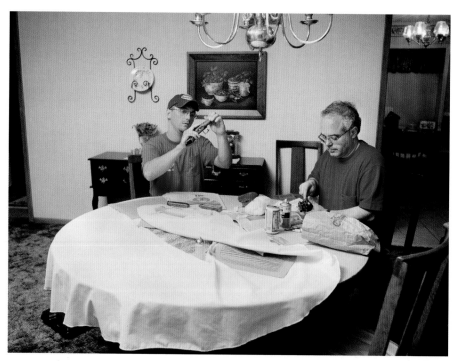

84. "I still naively believed back then (at least to a degree) in the idea of objectivity." (p. 88)

85. ". . . and well-worn white sneakers protruding from the bottom." (p. 155)

86. "I wondered what she was dreaming about." (p. 267)

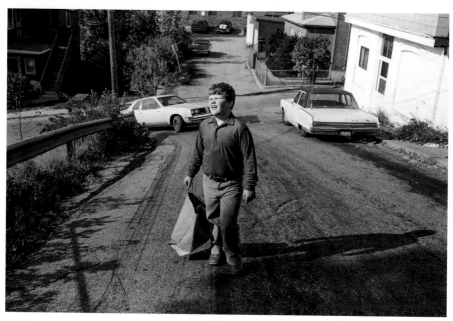

87. ". . . an era when kids could still roam their neighborhoods unsupervised." (p. 55)

88. ". . . an endless parade of faces coming and going,
laughing, touching, crashing into each other." (p. 288)

89. "Once you break a rule, you can break it again." (p. 273)

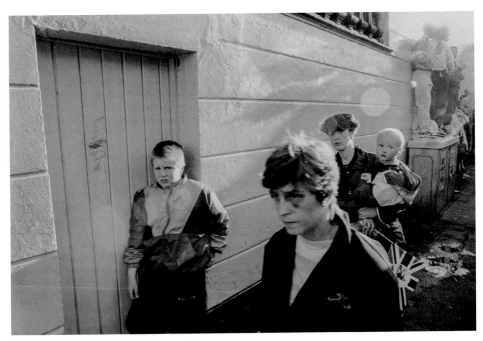

90. ". . . breaking the fourth wall . . ." (p. 177)

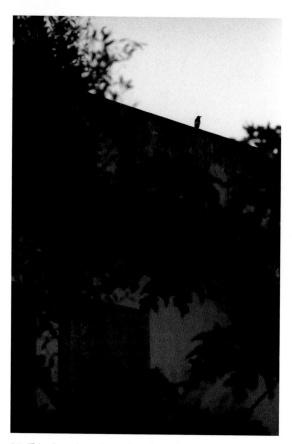

91. "I look at them from the edge of infinity." (p. 41)

92. ". . . perhaps the submission felt safer this way." (p. 65)

93. "Every painter paints himself." (p. 33)

94. "... where the meaning is driven by the subject ..." (p. 175)

95. "I used to hate cats and people who talked about cats . . ." (p. 49)

96. ". . . the Man from Nantucket" (p. 194)

**Reflections**

**Reflections in Mirrors**

**Religious Events**

**Religious Symbols**

**Repetition (Repeatedly Photographing Something Brings It to Life, So Be Careful)**

**Requests**

**Retouching**

**Returning to Reshoot Something**

**Rigidity**

**Rippling Water**

**Road Accidents**

**Roadkill**

As a photo student on aimless walks with friends and peers—more cameras among us than people—we would descend on dead birds and such like vultures. There was a grotesque but undeniable magnetism that we all sensed, like a bad itch. *That's something you take a picture of, even if you have no reason to.* Why were we all gathered around this once-living creature? Is there something inherently more poetic about a dead animal than a living one? Perhaps it was just avant-garde enough in our minds to counter our aunts and uncles and grandparents who assumed that the height of our collective professional and artistic dreams converged at becoming a *National Geographic* wildlife photographer.

While staying at a farmhouse recently with two friends (also photographers), I spotted a beautiful red fox lying still on the tennis court. We had seen the same fox just the day

before, running haphazardly in the daylight and nearly getting hit by a car. We stood around the dead fox, awestruck, observing its parted jaw with bared teeth and lolled tongue. After hoisting the fox into a barrel so we could remove its body from the court and away from the dogs, we quietly hovered for several beats too long. Finally, with mocking annoyance, I said aloud, "We all know we want to take a photo." Like some sort of ritualistic relief, we took our photos—having given ourselves permission without judgment—and could be done with it. I don't think any of us did anything with those photos. I haven't even looked at mine.

I still occasionally photograph dead birds when I find them because sometimes, it feels wrong not to acknowledge what I've seen in some way.

—Emily Patten

## Roadside Kitsch

## Roadside Trash

## Road Trips

Certain photographic tropes are addictive. One of my compulsions is undoubtedly the road trip, especially projects in the mode of lyric self-reflection, where the travel refracts an unsubtle register of existential angst and ennui. These usually involve elegiac landscapes interwoven with unnerving portraits, supplemented with fragmentary architectural details and sculptural detritus. Clearly, this says a lot more about me than anything relevant to contemporary photography—that I am a bit simplistic and romantic?—but I admire the fortitude and perseverance required to make a serious body of work from the real world and understand that it is not just the travel and the shooting, but also the physical and mental processing of images and editing and sequencing.

I receive more submissions in this vein than any other—is everyone aware of my proclivity? I have certainly published

far too many books of this nature, and ironically, they have been some of my most successful and some of my least successful books. This suggests I am blinded by the subject and I'll invariably realize that at least one or two has slipped in to the list, despite the fact that I resolve, every year: "No more. Move on. Grow up."

—Michael Mack

## Rodeos

## Roller-Skating Nuns

## Romani People

## Romantic Landscapes

## Roses

I do not want to be seen as a fragile and romantic person/woman in my work, so I just cannot take pictures of roses. And that's that. The funny thing is that I absolutely love the smell of roses and wear that perfume a lot, but I try not to take any photos of them. Roses are so loaded with meaning; a picture of a rose is never neutral. They symbolize love and romance, passion and luxury, in cliché ways, and have even come to represent cliché itself. Roses also encapsulate most of the stereotypes for femininity from a masculine point of view: the passive-aggressive energy in the visible beauty versus the hidden spines, that idea of beauty that can hurt you, the trap of sensuality, the metaphor of blooming, the scent of a woman. A photo of a rose taken by a woman has a different meaning.

I do have a picture of one that I like precisely because of the loaded meaning. It is a double exposure of a rose with the entrance of a hospital in Congo where Dr. Denis Mukwege—the 2018 Nobel Peace Prize–winning gynecologist—treats thousands of women who are victims of rape, used as a weapon of war. The rose was a visual shortcut that added

complexity and layers to the narrative. I used the image at the beginning of the sequence to put things in context and leave no doubt about the topic. It might be the only picture of a rose I have ever taken.

—Cristina de Middel

## Rot

It's hard to photograph a verb. Rot is a process, not a thing. Growing up in Vermont, compost was brown delirium. It was a spirit world—a melee of death and new life. Outhouse holes were portals to other dimensions. All that collapsed, dead, wasted, excreted, and discarded life was luminous to me. Julia Kristeva describes the abject as a thing that "draws [us] toward the place where meaning collapses." With our long-standing fantasies about progress, we don't grow up learning to celebrate rot. It took me years to figure out how I wanted to make work in relation to decomposition. I have found, in rot, a way to participate in radiance.

—Corin Hewitt

## Rotting Fruits & Vegetables

## Rubber Band as Infinity Symbol

## Ruins (Old & New)

## Rules

No matter how much you plan an editorial assignment— creating shot lists, sending references back and forth, making endless phone calls to prep both photographers and subjects— everything can turn out the opposite of what you envisioned. And that is okay. The congressional hearing runs late. A surfer's elusive big wave never comes. The government shuts down and you can't access a national park to photograph a glacier that is disappearing overnight. There is a fine line between

constructive input and overdirection. It's been engrained in me that overplanning will lead to the photographs of my dreams. But I'm often reminded that I should convey the tone and emotion of the piece, and then leave room for the artist to discover. In a deadline-driven field, we often forget that we need to allow for discovery.

In 2019, we were preparing a *California Sunday Magazine* cover story on Paradise, California, where the state's worst wildfire had taken place. It was four months after the fires, and I commissioned Kristine Potter and Matthew Genitempo to photograph the five chapters of a long piece written by Mark Arax. We were curious about what forms of regrowth Kristine might find in the rubble. I came up with lists of ideas based on the news photographs I had seen—green grass growing out of the charred ground, burnt cars, lonely chimneys. Kristine listened but followed her own intuition and came back with photographs full of unexpected magic. The image that made it on the cover was one of a deer that had suddenly walked into her frame, the land around it still blackened but with signs of new growth. She found the deer while wandering, after setting aside preconceived ideas. The photographs that we ended up publishing were those born from moments of wonder and luck.

—Jacqueline Bates

**Rural Debris**

**Rural Mailboxes**

**Rust-Belt Porn**

# S

Sad/Funny Upholstered "Life-Forms"

Sad-Looking People for Sad Magazine Articles

Sailboat Alone on the Sea

Sand Castles

Sand Dunes

Sans Title

SantaCon

Sarcasm

Satellite TV Dishes

Saying "Cheese!"

Scars

Scenic Highways

Schadenfreude

The Sea

The Sea in Black & White during a Tempest

Seasonal Death of Flowers in the Garden (or Even Flower Shops)

Seaweed on the Beach at Sunset

## Secrets

When I lift up a rock that has been unmoved for years, under
   it is a whole ecology.
Secrets survive to be discovered.
Giving away a secret is a fracture of trust, a secret must
   remain a secret.
When you are alone, you need them.
I always misspell the word *secret*.
I'm becoming superstitious about what I draw toward me.
Recurring images are secrets coming to life.
These are the photos I tell myself not to take.
Some are visible in plain sight and some disguised as
   accidents, stray misfits.
With time and gentle disentangling, some end up being
   images ringing with resonances.
Secrets are looking for freedom and friendship.
How will I know if I did not photograph them?
My secret could be your secret.
In losing some mystery it may reveal what is essential.

—Priyadarshini Ravichandran

## Seductive Images

## Seedy Bars

## Seesaws

## Self-Conscious Self-Portraits

## Self-Help Vibe

## Selfies

## Selfies in Front of Places I Visit

## Selfies Just to Finish the Film I Am Using

## Self-Policing

I am fond of photographers' chastising notes to self. It tells me they are reflective people. Don't be too arty. Don't take shortcuts. Avoid the obvious. Pursue the art. Be as efficient as possible. Be as obvious as possible. They never add up.

And yet, self-policing presumes too many things. It presumes you think you know exactly what you're doing. It presumes that a "bad" decision or a "wrong" image won't lead you to a good or right image, if you keep pushing. In psychoanalysis, the imperative is to stop policing yourself, to say the first thing that comes into your head without being embarrassed, and to see where it might lead.

The artist and writer Victor Burgin once recalled that students would come into tutorials saying things like: "Don't get me wrong, I like the theory I am learning, and I like the critical thinking, but I can't take pictures anymore. I'm always asking myself if my images are correct, if they are acceptable, if they are what I should be doing. Has it been done before? Is it a cliché? Am I repeating myself?" What was Burgin's constant reply? "Shoot first, ask questions later." I'm inclined to agree.

Self-policing may be the most disabling thing a photographer can do. This isn't to say that photographers should allow themselves to do things they know aren't good, or keep on mindlessly when their work is going nowhere. But when does the question of self-policing actually come up? When does it raise itself as an issue, as a conscious dilemma for a photographer? It tends to come up in moments of doubt or uncertainty. And in those moments, the best thing a photographer can do is tell the inner police to leave, so that the photography might continue.

"Shoot first, ask questions later." In photography, there is image capture, and then comes the review of what has been done, the postproduction, printing, editing, sequencing, and so on. This is the "later," when the questions can be asked.

And even at those stages, if there are moments of doubt, just do it. You can always undo it.

—David Campany

## Self-Portrait Crying

## Self-Portrait in Costume

## Self-Portrait in the Mirror Holding a Camera

## Self-Righteousness

## Sensuality

## Sentimentality

## Sewer Grates

## Sexist Imagery

## Sex Workers at Work

## Sexy Underwear

## Shadow Puppets

## Shadows & the Like

## A Shoe Left behind after a Disastrous Event

What is it about shoes that's so popular: a photo of a high heel, a symbol of Eros, and a torn, dirty one of Thanatos? A photograph of a single shoe in a scene of disorder caused by wars, natural disasters, or urban violence is one of those stereotypical images in photojournalism and documentary practice. The representation of fragments of personal belongings as a metaphor for their owners' disappearance has been a common conceptual trope among artists, photographers, and filmmakers, but I have a feeling that the misplaced shoe is mostly reserved for photography. For me, a picture presented

in the right place in a sequence of photographs or in company of other objects or a text is much more powerful. And rather than focusing on a single object, the image of a perfectly organized and neat interior without any human presence, as if the inhabitants suddenly evaporated, is more uncanny. It's the expressive power and the notion of universality that we expect from a single photographic image that is problematic. The image of a shoe is a perfect example.

—Hannah Darabi

**Shoes Hanging from Overhead Lines**

**Shortcuts**

**Show Business**

**Showing Disrespect**

**Shrubbery**

**Shtick**

**Sick Loved Ones**

**Signage**

**Signposts**

**Signs & Symbols**

Signs and symbols with strong, universal identities can manipulate our visual perceptions. For example, when an image contains something known to us, like a national flag, a religious symbol, or a famous landmark, it can lead us to fast, standardized, and simplified interpretations. Such elements in an image can act as shadows, blocking the viewer's access to other, more personal visual layers. They interrupt, and even sometimes derail a narrative.

—Yorgos Yatromanolakis

Silhouettes

Simplistic Views of the Human Condition

Sinkholes Full of Cars

Skateboarders Doing Tricks

Skeleton in the Desert

Skid Marks on the Pavement

Skid Row

Skinny Models

Skulls

The Sky, Looking Dramatic & Beautiful

Skyscrapers

Skywriting

Slaughterhouses

Small-Business Signs

Small-Town America

Smoke Bombs

Smugly Provocative Bodies of Work

Snake Handlers in Church

Snapshots

I don't think I have no-gos on what's in front of the lens. But I can't take the photographs I want unless I'm looking through ground glass and everything is upside down. I've been using the same large-format camera since 1995. I modified it to

work with a digital back as the technology was shifting in that direction. I sometimes try to be more impulsive and less structured, but it doesn't seem to work.

—Taryn Simon

## Snark

## Snowflakes

## Snowpeople

## So-called Art That Requires Explanation

## Socialist Realism

## Someone Talking on a Cell Phone beneath a Billboard of Someone Talking on a Cell Phone

I don't tell photographers what they should or should not photograph; that would be misguided at best, and supercilious and potentially destructive at worst. But in my opinion, there is nothing clever about photographing someone in the midst of some public humiliation, whether great or small. If someone has tripped on a cracked sidewalk and is about to hit the pavement, or has been the recipient of a load of pigeon poo dropped down on their head, or is talking on their phone oblivious to the fact that they are standing beneath a giant billboard of someone talking on a phone, please do not make a picture and try to pass that off as illuminating some important truth about who they are or how they are. Public humiliations of this sort are no more revealing of someone's nature than if the subject had suddenly been hit by lightning: they might look silly with their hair singed and sticking straight up, but they did not bring the lightning strike on themselves, and it says nothing about them, other than the fact that they were in the wrong place at the wrong time. To my mind, their pain and embarrassment should not be your clever photograph.

—Sasha Wolf

**Something Circular in the Center of the Frame**

**Something Exceptionally Simple**

**Something I Don't Want to Remember**

**Something I Hate**

> A mentor once told me that if I'm feeling stuck and need a bit of inspiration, I should try to shoot something that I hate—something gross, untasty, a concept that I loathe. I come back to this exercise often, but I can never really bring myself to shoot something that I hate, even when I try. By the end, I'm repelled back to shooting something that I'm obsessed with—a food, a product, a shape or texture. One thing that I really hate in particular are carrots! Oftentimes when I'm stuck, I'll start thinking of fun ways to shoot them before the cycle repeats itself and I end up shooting something that I love. Ironically, I ended up being commissioned to shoot an entire campaign centered around carrots, and those images happen to be some of my favorites.
>
> —Jessica Pettway

**Song & Dance**

**Souls of People**

**Spanish Moss**

**A Sparkle in the Water**

**Speed**

> I was at a museum show restaging an iconic exhibition from the 1990s when it occurred to me. I could look outside the relative present tense and let my photographs wait a few decades. I paused at a series of black-and-white images that depicted New York City streets at a modest scale: 11-by-14-inch prints, in white mattes, and thin silver frames.

Sometimes, the pictures showed inside buildings. Maybe the photographer worked in an office. The pictures included cars, which were boxy—models still in use, but not the latest trend. I was reminded of my own impulse to wait for a car to leave the frame when I compose a picture, because I long for my photos to be unmarked by the now.

Around the time of this realization, I was put off by cameras that immediately rendered images. I also found little motivation to learn the skills of digital darkrooms. So I became a photographer who resides in words. But I still, on occasion, had the desire to take pictures with my 35 mm rangefinder camera. To remove the burden of printing, I started to shoot on slide film. Meanwhile, I made pictures with my camera phone and learned to post these knockoff pictures before I forgot they even existed. But for my analogue process, I slowed the image down after the split second of the shutter does its work.

I arrived at a circulation defined by an intimate and often imperceptible pace. A new picture in this context could be shot five or ten years before showing it to someone. The subjects of my pictures do not rely on mystery: storefronts, trash, friends, family, plants. I edit the mounted slides by holding them up to the window light. I accumulate a selection for a Kodak slide-projector carousel, dropping the images into a carousel, upside down and backward. If I am at home, with someone who expresses interest, I do a slideshow.

—Ariel Goldberg

## Spiders & Webs

Formal considerations aside, I try not to think about my pictures when I'm taking them. If I thought too much, I wouldn't take any pictures at all, so I keep my shooting loose and intuitive. Critical thinking comes later, in the editing process. Even without imposing restrictions, I make the same types of picture over and over again. The keywords and

phrases in my picture collection include many well-known stars of low-hanging fruit—icicles, waterfalls, abandoned umbrellas, couples from behind, spiders and webs, fog and other atmospherics, the photographer's shadow, scenic highways and country roads, shooting into the sun, other people's porches, cats, flashed flora at night, windows and reflections. The list goes on. These pictures seem to satisfy a desire for repetition, pattern, and connection—and an impulse to accumulate.

They're not bad pictures. On the contrary, many of them are good, but they easily slip into the category of uselessness due to their redundancy. Why are they so easy to take, yet so difficult to use? While editing, I often find myself spiraling down into a pit of despair. Why do I keep shooting these subjects, just to file them away into a network of stacks, boxes, hard drives, collections, and ratings—to perhaps never emerge from their resting places? Am I just a cog in the program, entangled in the rituals of making pictures without any clear intention?

I continue to collect my fruit. Most will never enter the arena of "the work." Those that do never fully escape their humble beginnings. But over time, some eventually emerge from dormancy and reveal their significance. There's no better feeling than when that happens.

—Melissa Catanese

## Spitting on the Surface of a Photograph

Please do not spit on the surface of the photograph to see the "change." Trust me, I have tried.

—Zeynep Kayan

## Spoon-Feeding the Audience

## Sporting Events

## Squirrels

**Stacks of Anything: Pipes, Balls, Boxes**

**Stages**

**Stages or Toilets at a Gig**

**Stairways to Nowhere**

**Stalactites Lit with Colorful Lights**

**Stalagmites Also**

**Star Filter**

**Statuary**

**Steam Coming from underneath City Streets**

**Stereotypes**

As a photographer who sometimes collaborates with French newspapers and magazines, I have had to confront the fact that some French photo editors seem unaware that they are contributing to a deliberate, oppressive narrative created more than a hundred years ago. I'm referring to the colonial history of countries where my work will be shown. Algeria, for instance, has suffered 130 years of French occupation, and during that period, French authorities have used every colonial trick in existence to advance their narrative. One of their main tactics has been reshaping the representation of locals, those they define as "Arabs" or "Kabyle," and sometimes reductively as "Muslims," combining two identities into one label. Visual media, especially, were used to enforce images of Algerians that underscored the idea of French and European superiority. Over time, I've learned what visual elements make an image into a colonial or an Orientalist picture. For example, if I photograph a veiled woman, I know I need to be careful. Oftentimes, images of veiled women are used to portray them as submissive, without knowing or trying to understand

the people wearing the veils. Therefore, I avoid photographing veiled women in situations that could easily reinforce such stereotypes. It is not easy to do, but it is my responsibility to reclaim the narrative that has been imposed on us. Even if it means I have to censor myself in certain situations.

—Abdo Shanan

## Stigmatizing Images of Black & Brown People

## Still Life

## St. Louis Arch

## Stoner Art

## Strange Men Who Ask Me to Take Their Photos on the Street

## Strangers

Taking pictures of people is such an intense exchange. When I first started taking photographs with any kind of focus, it was on people. People riding skateboards, people standing in the sun in the street, people taking naps on benches in public, people covered in spray paint, people whom I knew and people whom I didn't. I moved to San Francisco to go to art school in 1995, the Halloween parade was still happening in the Castro then, and the whole street was full of the most amazing people in costumes; some were fully nude. I photographed a string of hippies holding hands and dancing down the street. Their leader, wearing a Native American headdress and a kind of wizard cloak, got in my face about taking their pictures. I can't remember what he said, but what stuck with me was how intimate the interaction suddenly became. It didn't make me stop photographing people, but I think of this interaction whenever I think about photographing strangers.

—Will Rogan

## Stray Dogs

**Street Children Smiling at the Camera**

**Street Children Taking Drugs**

**Street Performers**

**Street Photography**

Toward the end of my undergraduate education, I abandoned street shooting, or even anything at all documentary in nature, interested instead in how the photograph could stray from being literal, pushing the photo to do other things. Or maybe I was just too shy to take photos on the street. I had not yet learned to never say *never*.

Some years later, Kathy Acker wanted photographs to accompany her text *New York City in 1979*. I traversed the streets of Midtown Manhattan, with my camera around my neck and with her text in mind. More than thirty years later, these images are among my favorites.

A decade or so afterward, I began to question my decision to stay in the studio. I was in a city as uniquely diverse as New York. *What was I thinking staying in the studio?* This time, I took my 4-by-5 camera outdoors, set it up, turned my back, and recorded the line of people waiting to get into a federal building. The work was difficult for me to make but, decades later, I find it still full of surprises and history.

With the ubiquity of smartphones, the question has become not what not to shoot, but rather what not to share. Or maybe that was always the question.

—Anne Turyn

**Street Photos of Glamorous Women**

**Street Signs**

**Strong Convictions**

**Stuffed Animals, Plush Toys**

## Stupid Sunglasses

If the person is wearing wraparound sunglasses (think Guy Fieri), I will not shoot them. Doesn't matter if the craziest thing you have ever seen is going on in the photograph, I won't shoot it. Can't.

—Deanna Templeton

## Subjects That Might Mistake My Interest in Them as Sexual

"This pervert is down here taking pictures of everyone! This guy's a pervert!" the gentleman in the business suit screamed down the subway platform after I took his picture. I don't believe he yelled it because he actually thought I was trying to sexually objectify him (though I did find his suit, blue eyes, and jaw beautiful). He said it because it was the most incendiary thing he could think of to shout on a train platform packed full of strangers. And he was right to think that I would deeply fear that interpretation. I tend to avoid candid pictures of subjects that might mistake my interest in them as sexual. That's not to say that I'm not interested in sexuality as a subject matter; in fact that is very far from the truth. My fear lies in being perceived by the subject as having taken a sexual interest in *them*. Consciously or subconsciously, I find this psychological territory too charged for a photograph that takes place in public and extremely quickly.

I avoid these situations not only because I don't want people to think I'm objectifying them in that way, but also because that perception is in stark contrast to why I'm motivated to make art in the first place. In a world where seemingly every human undertaking is overtly, or adjacently, motivated by sex, reproduction, and stability, I'd like to think that I am motivated by genuine curiosity in who we are and why we exist.

—Matthew Beck

**Subways**

**Succulents**

**The Sun**

**Sun Flares**

**Sunrise across the River/Sea**

**Sunsets**

Ever since I embraced working in intense, vibrant color in the late 1970s, I've had a deep ambivalence about photographing sunsets. While their otherworldly glow often seduces the eye, I find that another part of me viscerally resists their clichéd beauty. I remember showing Josef Koudelka an early color photograph of mine from Jamaica of a group of men in trees silhouetted against a brilliant orange sky at a Bob Marley concert. "Too sugar," he said in his blunt Czech way. And he was right—but it wasn't just that it was too sweet, it was too easy.

But every once in a while, I discover something that qualifies and complicates the one-note refrain of the setting sun: a mercury vapor lamp casting its greenish hues across baseball spectators in Cuba with a burning red sky behind, or the cold blue tones of a quay in Greece contrasting with the pinkish notes along the horizon. That's when I leave my anxieties behind, and give myself permission to photograph the complex music of certain sunsets.

—Alex Webb

**Super-Contrasty Images without Nuance**

**Superstitions**

**Swans**

We all make rules that shape, determine, and influence what we photograph and how we take pictures. These rules are

learned and gathered together through practice and through observing and reflecting on the work of others.

One of my rules is that when working with a plate camera, I don't play around with the horizon; it goes straight through the middle of the horizontal frame, and the challenge of the picture is to work out a balanced relationship between the two equal halves of the photograph. I found early on that if I started moving the horizon around, the pictorial approach that developed overwhelmed the photograph. I never used wide-angle lenses, as they draw too much attention to the device of a picture.

In terms of content, things I learned not to photograph: bright sunlight in the English landscape (all the impossible greens); populated landscapes (the character of an individual draws attention away from the scene); highly manicured landscapes (pictures of others' designs); elegance (roses and swans).

A swan is the most extravagantly elegant creature and, when I did photograph them when I was young, the pictures that resulted never rose beyond a poor portrayal of the bird. I came to regard them as treacherous subject matter.

Gradually, I have broken all these rules and feel better for it. Whether the work has improved, I don't know, but each time I discard a rule, I feel a little more liberated.

Sometimes, it became necessary to lower the horizon in order to show the full sculptural presence of a rockfall. One day, I accidentally acquired an extremely wide-angle lens for the 8-by-10 camera; all the pictures from my book *The River Winter* (2012) came from that. And while out walking one winter evening four years ago, I came across a group of swans who performed as a corps de ballet along the river, and have since made four bodies of work featuring this group of birds.

I still find bright sunlight hard though, with color, in such a green land. But swans and flowers now take up much of my time.

—Jem Southam

## Symmetry

## Tabletop Assemblages

I was often told to avoid shooting still lifes or tabletop assemblages because they have been done so thoroughly and so well in the tradition of photography. The other reason provided was that it is hard for this type of work to raise questions beyond formal and aesthetic concerns. To be honest, I still do not really know what any of that meant. Early on, when I started photography, I did photograph some still lifes on tabletops. I made some rudimentary clay forms and had them act out scenes on my study table.

Now that I am older, I am of the opinion that we should be free to photograph whatever it is we are drawn to at each period in life. Even seemingly futile attempts at something are part of the journey. There should be a special place in art for projects that went nowhere and amounted to nothing.

—Sean Lee

## Taking a Snap for the Purpose of Memory

## Tamara's Knees

## Tangles of Wires

## Tarps over Cars

## Taste

A somewhat British institution, *Desert Island Discs* has been on BBC Radio 4 since 1942. Famous people are interviewed

and invited to share their life stories and to choose eight albums they would bring along with them to a mythical desert island. I listen every week, regardless of where I am in the world. I borrowed the idea when I used to teach, and at the start of each term, asked my students to select eight images they love. It helped to get to know each other, and to learn about our influences and the rather abstract and difficult idea of taste.

For a curator, a certain level of objectivity is essential. I am aware that I should not include works in exhibitions or books simply because I like them. I probably overcompensate: pieces that I would hang on my wall at home have to fight hard to be included in my professional life. As aware as I am of my taste in photography, I am surprised by how frequently it changes, and how tied it is to larger world events and my own experiences. At the moment, I am obsessed with swimming, and consequently, am drawn to fragile things like line drawings and certain types of land art and ephemeral sculpture. In terms of photography, this is manifesting as an interest in pictures of gentle abstraction with an elastic back-and-forth between realism and hallucination. This seems to satisfy my need for freedom, space, solitude, hope, beauty, transience, and persistence, which seem so crucial at the moment. It's no coincidence that these are the exact same feelings I get from being submerged in water. Ultimately, this might be bad news for the artists—artworks that correspond to my personal taste rarely make it into my books and exhibitions.

—Susan Bright

## Tautology

## Taxidermy

## Technology

I try to strip images of all the trappings of the age they were made in. The hint of a headphone wire, the flash of a logo, or

a hand clutching at a phone will stop me from photographing. I love when a photograph is abstract, when its meanings take longer to discover. A keen eye can spot the model of phone or branded T-shirt a mile off. I'm drawn to people who could have walked the streets of any era, the hunched figure who could have traipsed the passageways of the 1920s or the present day.

—Jack Davison

**Teepee Motel**

**Televisions Tuned to a Dead Channel**

**Temples**

**Text on Buildings**

**Text on Clothing**

**That's Not My Picture**

About ten years ago, I had a conversation with a curator here in New Haven. I sat in his mid-nineteenth-century clapboard house, right across the river from my early twentieth-century clapboard house, and we started our conversation on a mid-century modern couch, while waiting for the wood stove to warm the house above the fifty or so degrees it had dropped to while he was at the museum. I already felt ungrounded from all this architectural time travel, as I showed him a stack of new workprints and contacts I was unsure about; I had been feeling a bit in limbo after moving out of the city while simultaneously moving toward working in digital and also toward a new subject matter. Flipping through the stack, he pointed to a photograph I took of a young, male Coast Guard officer, who was looking down and talking on a public pay phone on the boardwalk of the honky-tonk Jersey Shore town of Wildwood. It was a picture that resonated with me for some reason, but I didn't know why or

what to do with it yet. It didn't feel like it had a place. It was different. It was made outside in broad daylight. It featured a figure, and that figure wasn't collaborating with me or even aware of me, as in previous work. It felt like a street photograph, albeit a still one. He pointed to it and decisively said, "That's not your picture." We spent some time talking about what he meant by that, but didn't really get anywhere. I think I understood what he was trying to say, but I also took some offense. It was *mine*.

It made me think a lot about who I outwardly appeared to be as a photographer, who I was expected to be in the photography world, what expectations a viewer might place on me. It also made me think about who I might be referencing too closely in the image, and therefore, not being myself somehow. It can be a hard thing to accept—being told who you are as an artist—and doubly hard to resist the urge not to challenge that. Now that picture remains stuck in my mind, simply because of this exchange. Maybe it is an example to me of trying to go with instinct—or not—or of putting the camera down—or not; or maybe, it's just an example of what to go ahead and shoot, but edit out later. It nags me still, because it's a pathway, a way of considering a move *toward* a certain kind of picture-making, rather than *away*. Perhaps it was a comment that maybe shouldn't have meant much. Maybe it was just that he had seen it before, something I hear myself saying to my students all the time, sort of a cop-out comment when something is just not interesting, or is cliché, or is too simply shown.

This struggle makes me think of being a student, trying to gain footing and find one's voice. In the classroom, though, the conversation has shifted; now, we are not talking quite so much about one-sided authorship in photography. Students are more actively questioning their privilege and are unsure whether they can even ethically take a photo of a stranger on the street without asking for consent, even if intentions are good. I don't entirely know where to stand on the issue,

because I came from the school of street photography and the Arbusian idea that we can *and should* show things that no one would ever see unless we pointed them out. And that *that* has value—the pursuit of expressing humanity in a beautiful and poetic way matters. It matters because it helps us all see how connected we are and how not alone we are. But it has become more and more clear that I can't just send them out into the world with that same sense of naivety and entitlement, blindly encouraging them to attempt to represent another human being. So I firmly place the final decision in their own hands, asking them to consciously create and follow their own moral compasses, with me and their peers and their hand/heart/eye as their guide.

The person in my photograph wasn't aware I was looking at him, watching him, wondering about him, imagining his private conversation happening out in public. Was it with his sweetheart, with his mom? It seems like no harm was done in this case, just a passerby taking note of his cap-topped frame against a distant backdrop of fantasy and amusement. What I *can* know is this: that the photograph was made by me, or a version of me from fifteen years ago. Maybe the man on the phone is a stand-in for myself in a way, trying to connect, out on the streets, with the carnival seen at a distance. So in effect, the picture does connect to my other work, because it still does that thing my other work seems to do: raise the question of what it means to want to escape reality and point out how futile that pursuit can really be.

—Lisa Kereszi

**That Which Could Be Described Better with Words**

**Theme Parks**

**There's a Man Looking at the Woman You're Looking at**

**Thesis Project**

**Things Hanging from Rearview Mirrors**

**Things That Are Red, White, & Blue**

**Things That Are Singularly Out of Place**

**3-D**

**Thrift-Store Items**

**Tigers at the Zoo**

My first long-term story started out being about the conflict between humans and tigers in the Sundarbans in India. The landscape there, though open, feels dense, so the visibility is deceptive. There is no clear sense of where the forest begins or the village ends. One feels the hidden presence of the tiger all around. I never managed to see a tiger even once. "You may not see the tiger often, but the tiger is always watching you," said the villagers. The mysterious presence was stronger than actually seeing a tiger, so I left that presence invisible in my work.

After I had collected a good number of images, I sent them to several photo editors from around the world to see if they were interested in publishing the story. Many responded asking for a photo of a tiger. One of them wrote back suggesting I might go to a nearby zoo and photograph the tiger there. In a rage, I wrote back to him that the only meaning to our existence is the mysterious unknown and that I will never, ever photograph a tiger at a zoo. My work took an entirely new direction after that e-mail, and the word *conflict* was removed from the description of my work.

I stood by that vow for eight years, until one day, I went to a zoo for fun. I had a camera with me, and the vow was flashing in my brain when I came to where the tigers were. There were three white tigresses in a deep pit. Two of them were hidden behind some foliage in a blind spot. One of them was sleeping right below. The entire crowd was hooting and making all possible growls, so they could see her awake and

walking around. I spent about thirty minutes there, while she remained unperturbed by the human growls. I wondered what she was dreaming about. It was impossible to know, and I felt strangely good about that. With no guilt, I took the camera out and made a few images of the tigress having a siesta.

PS: I finally saw a tiger at the Sundarbans a few years later. It was a rainy afternoon, and a lone tigress was swimming in the wide waters of the delta. I eagerly made several photographs of her. They will remain hidden in my archive and shall never be shown as a part of my work.

—Karthik Subramanian

## Time-Bending Pictures

Once we pass through the portal of a photograph, it becomes consigned to a place in memory, and memory is essentially a place where our time—past, present, and future—is held captive. Painful parts of memory often get locked away, too difficult to deal with in the present. Unless the event in focus is not over, has no decisive end, and has become a living thing that can't be framed, dissolved, or disappeared—acting on the body like an overbearing historical weight that moves in culture under the cloak of denial and disavowal, unable to be touched, but nevertheless intensely felt like an ever-present colonial now that pulls the present and future toward its own violent homogenizing black hole. Some have no choice but to feel the past, as well as to see it. The only way I survive in the present is to fully recognize that I do not fully live in this dimension. I have to refuse the work time does on the soul and remind myself that time has to be fought for and, whenever possible, avoided; therefore, I can't help but fear what time really is.

—Mark Sealy

## Timelessness

**Times Square**

**Tire Swings**

**Toilets**

**Tokenism**

**Tombstones with Funny Names**

**Tone-Deaf Content**

**Too Matchy-Matchy**

**Topiary**

**Totem Poles**

**Tough Nuts**

**Touristy Images in Touristy Places**

**Toy Soldiers in Proximity to Male Genitalia**

I started teaching photography almost at the same time that I had the confidence to call myself a photographer. My own growth was slow and characteristically painful, but all the while, I stood in front of classes of students making pronouncements about what one should avoid shooting. Though I never went as far as making an official list, I would go on record about what almost always guaranteed a failed photograph: using a wine glass as a prop; someone conspicuously playing guitar; toy soldiers in proximity to male genitalia (the latter has been a surprising recurrence, a shorthand for unpacking masculinity). In other words, be wary of using a camera as a tool for collecting the obvious, avoid making photographs that point out things that are singularly out of place and overstate their reason for being. A one-liner is a cheap brand of humor with no room for mystery or complexity.

Having spent many years photographing in Eastern

Europe, I have marveled, laughed at, and photographed many misalignments or mistranslations, something particularly noticeable to a Russian who grew up in the West. I have also avoided aligning myself with photographers who travel in search of the exotic, making an effort to be subtle and nonpartisan in my relationship to my subject matter. But with regularity, I make pictures I purport to disdain, that can be accused of riding the wave of kitsch and basking in the outrage of bad taste.

—Sasha Rudensky

**Tractor Trailers**

**Traffic Lights**

**Trains**

**Trash**

**Trash Heaps**

**Travelogue**

**A Tree in Black & White during Winter**

**Trees**

**Trends**

**Trespassing**

**Tripods**

**Tropes**

**Trucks**

There is something about trucks that is irresistible to me. Their size, their powerful appearance, their colors. The idea that they are temporary homes for their drivers when they

feature a bed behind the driver's seat. Trucks form a sort of parallel universe of travelers. What are they transporting? Where did they come from?

There is a big factory near our house, and the entrance to the property is exactly opposite our living-room windows. All day long, large trucks make the turn into the factory. Every time I see that turn, I am impressed. I am also worried. I see accidents happen all the time. The drivers are often tired and they make weird decisions: driving the wrong way, driving backward because they miss the turn, parking on the sidewalk, looking dazed and confused. When things look dangerous, I take out my phone to take a picture or video. It is a reflex to capture the moment, to gather evidence, to have something to show to the factory owners: "Look! This is so dangerous; do something about it!" But I never send the pictures. I only take them, so slowly a collection of evidence photos is growing and becoming something else.

I take them as a mother, a worried citizen, an amateur, but at the same time, they are exactly the type of functional photographs that attract me when I find them in old books and magazines—their unintended beauty, the stuff I would cut out and save for a project. Maybe one day, they will become part of my work, but for now, I keep them stored on my computer, waiting to be used as evidence.

—Ruth van Beek

## Truth & Accuracy

The gray area where truth and accuracy rub up against one another should be a central consideration for people working in journalism. A photograph can be "true" in the sense that it is a direct representation of a single moment in time, and free of Photoshop or other types of manipulation, but that doesn't mean that it is a faithful, accurate, and comprehensive representation of the subject at hand. An image of one

moment can obscure the real state of affairs.

The George Floyd protests are a good example. Although there were violent moments in the weeks after Floyd's murder, the protests were largely peaceful. Despite this, many news outlets ran photographs of burning buildings or altercations alongside articles about otherwise calm demonstrations. Those violent photographs hardly made for an accurate representation of the movement.

As I see it, truth is a nebulous amoeba of a concept. Its borders shift constantly, and it can be subjective or circumstantial. Accuracy, instead, is about reality and precision. There's immense responsibility in the field of journalism both for image-makers and editors. Both represent positions of power, and their choices can reverberate in unanticipated ways. A photograph or photo edit, if published, will impact popular opinion, and one has the responsibility of considering it from as many angles as possible, anticipating a myriad of interpretations, and interrogating biases and blind spots. Although many people will view your work with a healthy dose of skepticism, more people will consume it as "truth." It's a serious charge.

Photographers have a responsibility to reflect reality rather than encourage hyped or sensationalized material, because it's too easy for photographs to skew reality and mislead viewers into assumptions or impressions that are either wrong or harmful to the public good.

Moreover, once they're out in the world, photographs are vulnerable—they can be picked up, spun around, and recontextualized to fit an alternate agenda.

The danger is that both editors and photographers are attracted to the dramatic, sensational, and unusual—such as moments of stillness amid action, or a moment of action in an otherwise serene scene. Our eyes are trained to recognize these instants, but we have to temper that hunger with an awareness of reality. When I think about moments in which I censor myself, this is what I think about: I question when

I feel myself pulled toward the most visually compelling image over a photograph that more accurately represents the situation at hand. I take that energy, potential, and strange yearning and put it somewhere else.

—Coralie Kraft

## Tubs

I don't photograph tubs, but will do oceans. I've always had a rule not to photograph queer and trans people on beds, because we are so often hypersexualized. I've broken the bed rule several times; when I thought the night was finished, when wrapping up, chatting, I photographed roommates and bunk beds and life that goes on. It reminds me not to stop seeing, even when I think I'm done. Once you break a rule, you can break it again.

Then there was one summer when it rained almost every day. I gave myself permission to make the quiet-rainy-Tuesday picture of queerness in Hong Kong—visualizing the every-day was okay too. We're "allowed" those kinds of moments, and pictures too. I also made photographs in the thick of the protests in Hong Kong in 2019 and immediately decided not to share that work. As the weeks progressed, I put my camera down altogether while out in the streets.

The conceptual framework of my work is community and care. I had another rule to only photograph people I like and love. Years ago, I broke that rule too. I photographed a colonizer—a literal colonizer, a former lieutenant colonel in the British Army in Hong Kong. He canceled on me at first. And on his cancellation (4-by-5 gear is heavy, by the way!), I bought an orchid and had it delivered to him. He invited me over soon after, and I made photographs of him with his Asian partner. There was an unease in the way he held his partner. It looked more like possession than love; he held him like he owned him. I thought I had needed a picture that achieved an emotional register other than tenderness, that I

needed that tension. But it felt too hard to look at. It was like a ringing pain. Ultimately, I took that picture out of the edit for my book, *narrow distances* (2018). I couldn't give the colonizer space that we had collectively worked so hard to build.

—Ka-Man Tse

**Tubular Openings**

**Tumbleweed on a City Street**

**Twee**

**Twins**

# U

**Underwater Sea Life**

**Underwear Packaging in a Store or on the Sidewalk**

**Unfiltered Stream of Consciousness**

**Unintended Affectation**

**Up-Close Mirror Reflections**

**Upset People**

**Used Car–Lot Flags**

**Using Outdated Film**

**Using the Same Wig**

In the past decade, I have developed a fascination with collecting antique wigs. With time, my fascination has grown into love and my love into obsession. Wigs became practical for shooting self-portraits; they gave me the freedom to be any subject I could imagine.

I started taking my wigs everywhere with me. I would even find myself squeezing some into my tote bag for day trips— "just in case." It took me a while to admit it to myself, but I developed a special relationship with a few wigs, and with one in particular, which became my main alter ego. I found myself putting most of my wigs into my checked luggage and taking my favorite in my carry-on, in case my bags were lost during travel. It became a kind of first-class, second-class scenario.

But my favoritism came with a problem. I usually avoid stories that are linear, or about a particular subject. Having the same wig appear over and over unwittingly created a sense of connection across different photos. Now, every time I am going to shoot, I tell myself, "Please not today, not that one." Sometimes, I get over it and control my impulse. Other times, I leave it at home so that I won't be tempted. But more often than I might admit, I fall prey to its charms, and it feels so good.

<div align="right">—Tania Franco Klein</div>

# V

## Vagueness Disguised as Ambiguity

## Varanasi

## Vasoline on the Lens

## The Vatican

## Vegetables

As I suggest this anti-topic, I realize I'm being sarcastic—not a good starting point. It's just that I can't see myself intentionally taking a still life of a green pepper, squash, or eggplant. Actually, it turns out, these are considered fruits! The gravitational (and cliché) pull of the great white hunter, Edward Weston, is too overwhelming. Also, still lifes tend to recall strong commercial motives. Although Jan Groover, as another type of role model, created distinctive feminist perspectives using peppers in her Kitchen Still Life series from 1978 to 1979.

In fact, one secondary definition of *vegetable* refers to people with little life or cognitive functioning. Typologies might be good use for edible plants in some academic survey, proof of something scientifically significant. It is just that most vegetables are not major players in the romantic scheme of life unless we are looking at starvation—which we might be.

I remember Lisette Model in her New School class in the late '70s saying that it was best for us to be taken over by subject matter and not vice versa—that one should have a sense of awe. She also said that she could feel one way about

a photograph one day and differently the next. Her words remind us of the great amount of subjectivity that goes into creating meaning on the part of both the maker and receiver.

I tend to be drawn in by a subtle kind of ambiguity or puzzle about our current times. My kind of photograph puts a frame around something unresolved, between two states: frozen in time, and existing for some reason—yet to be intuited—in front of a lens.

—Susan Lipper

## Vertical (35 mm) Pictures

## Victims

## Vintage Carpets

## Vintage Car Repair Shop Signs

## Vintage Props

## Violence

## Violence against Women

## Violent Acts Performed for the Camera

Jumbo, the rebel prison guard, was eager to show off his most prized possession, and we, as journalists, were thrilled to have the rare opportunity to interview a member of the feared pro-Assad militia known as the *shabiha*.

Zakariyya Gazmouz emerged from one of the detention rooms, bloodied and limping, his head hastily shaven and his beard unkempt. As he approached us, the extent of his wounds became apparent, especially on his chest: large tattoos depicting the faces of the ruling Assad family had been sadistically defaced by dozens of cuts made with a razor or some other sharp object. Under the watchful eye of Jumbo, and before we even had a chance to ask, Gazmouz eagerly shared that he self-inflicted those wounds as a gesture of repentance

toward the rebels who had arrested him.

I often think back to this brief encounter, wondering what more there was to Gazmouz's story, and reflect on the fine line between victim and perpetrator that inevitably blurs in a war. The violent act of defacing the tattoos was not done for the camera, but I became complicit in the violent performance that followed.

—Moises Saman

## Vomit

## Voyeurism

## Vulnerable People

## VW Bugs

For *Hamlet*'s garrulous Polonius, the best photographers (I imagine him thinking), like the "best actors," would be skilled in all modes: "tragedy, comedy, history, pastoral, pastoral-comical, historical-pastoral, tragical-historical, tragical-comical-historical-pastoral, scene indivisible, or poem [photograph] unlimited." In any case, that's a broad, shaggy-dog version of the mission I set for myself as a photographer once I picked up a camera. But not *so* broad, I came to realize, that I would ever include a Volkswagen Beetle, or "Bug," anywhere in my pictures.

Why? It's hard to say. It certainly wasn't a reflection of my feelings about the Nazis and the German *Volk* under their thumb, for whom Hitler himself ordered the Beetle to be produced in 1938. And it doesn't suggest what I think about actual beetles or even insects: for me, a ladybug moved to "fly away home" draws one of the sweetest, most delicate arcs I know in nature, a minor-key cousin to that of the humming-bird and the "route of evanescence" that Emily Dickinson took it to be tracking. Which hints at a possible answer to my question, for it's difficult to imagine a more unlikely cousin

in *any* key to the darting, shimmering beauty traced by either bug or bird than the lumpen, earthbound Volkswagen under question here, even one in motion.

As I continue to think about this, though, I have to consider a different idea: that my rejection of this car as a possible photographic subject could well have been prompted by the "Think Small" advertising operation that the Doyle Dane Bernbach agency introduced for VW in 1959. This effort featured ad after ad of an undersized, lemon-shaped automobile snuggled discreetly into the corner of a bright, white magazine page intersected with a few words of black text—a campaign so effective that *Ad Age* later ranked it as the best of the twentieth century. When I arrived in New York in late 1965, the Beetle was a celebrated object, at least in the advertising world that, through photographer friends, I soon came to know tangentially. But this was a world that my "tragical-historical" temperament rejected out of hand: How could I ever be an artist, I asked myself, and photograph an ad campaign? So it's conceivable, and even likely, that my physical distaste for making pictures of the VW was actually a manifestation of my psychic distaste for commercial photography, particularly advertising photography.

Besides, the car *was* a bit dumb-looking, especially when compared to the Porsche-inspired VW Karmann Ghia. And—is it necessary to admit it?—I eventually did make pictures of it. Even good ones.

—Tod Papageorge

## Waiting for the Barbarians

I was on one of the last boats allowed in the Mediterranean to rescue migrants fleeing the coast of Libya. We traveled for two days from Malta. When we got to about twelve kilometers from the shore, within an hour, we picked up six hundred people—one of whom was a one-day-old baby who was handed to me. It took me four hours to find the mother. Now, this is somebody who's prepared to get on a rubber dingy that's built by some Chinese company, because there's a market in Libya for rubber boats, somebody who is prepared to risk their own life and their baby's. Believe me, this is not the way an economic migrant would go about it. All six hundred people had gasoline burns from the water that was splashing about their rubber boats.

There are images (still and moving) from that day that I did not include in the film we were making. They were images of the chaos, of the mass of bodies. I decided to concentrate on single portraits instead, because I felt the image of a tsunami of Black bodies emerging from Africa was all we were seeing in the media. It reminded me of the book *Waiting for the Barbarians* (1980) by J. M. Coetzee, which conjures the same image conjured up since Biblical times— "an image of the Barbarians invading our borders," right?

There were six hundred people, but we focused on one person at a time: individuals, who have their individual narratives—as complex, as interesting, as funny, and as tragic as my grandmother's story of taking a boat from Lithuania to Africa seventy years ago in the opposite direction to escape

the Nazis. I believe if pictures had circulated of hordes of people fleeing in the 1930s, South Africa would have closed its border, as did many countries that refused entry to Jewish and other migrants.

I spent the three-day journey interviewing as many individuals as I could, but there were never more than one or a few people in any of the images. And so I hope what was communicated was a few hundred individual stories, ranging from somebody seeking their fortune to somebody escaping genocide, famine—all of which is exacerbated and escalated by the climate crisis.

—Adam Broomberg

## War

## Wasting Time

I don't photograph that often. I made most of my work in the winter or fall, because I had four children and wanted to be home with them during the summer as they were growing up. It forced me to work quickly when I was shooting, to produce as much as possible in a short period of time, and to not waste time taking assignments that meant nothing to me. It also forced me to do things other than photography, like song-writing, learning to play instruments, editing, and working on more complex book dummies. Professional photographers used to tell me that having a family would slow me down. It made me work harder.

—Larry Towell

## Water

## Waterfalls

I once had a professor whose harshest go-to critique was, "This picture reminds of something similar, but better." I usually regard any image I make as raw material until I've

situated it in a particular framework, as just about any photograph, given the proper context, has the potential to transcend its limitations. I don't consider a photograph to be officially activated until it has survived the edit and been assigned context. I've taken thousands of ill-conceived, poorly executed images that will never see the light of day, but I don't see these as reflections of my abilities as a photographer. Only the exhibited or published photographs count. Many of my worst photographs are those I thought were brilliant when I made them. Many of the best are images I might not have made had I censored myself, for fear of treading into the territory of predictability and cliché.

It might seem hypocritical, then, that along with their first assignment, I give my students a list of things to avoid. This list includes, but is not limited to, waterfalls, party pictures, coastal sunsets, their older siblings' infant children, and sporting events. It's part of an important early lesson about avoiding obvious photographic tropes. But an equally important lesson for more advanced students is how all those subjects can be approached deftly by self-aware photographers who know how to find depth and value beneath a subject's facile appearance. I've spent the past three years photographing waterfalls, coastlines, unspoiled forests, and other well-worn subjects, fully aware of the difficulty of moving past their sentimental potential or mere surface appeal. At this point in my creative life, I embrace this difficulty as a worthy and interesting challenge rather than something to avoid.

—Ron Jude

**Watermelons**

**Water Towers**

**Wax Figures**

**Webcam Images**

**Weddings**

**Weddings of Strangers**

**Weed Smoke Covering the Face**

**What I Already Know**

**What I Think Is Disgusting**

**What We Couldn't Add to Evidence**

Consider a picture made on June 15, 1934. The exact date, and another six-digit number that identifies the photograph, is handwritten on the negative. A camera flash illuminates a man at work. He is wearing a headset connected to a microphone that is harnessed in place around his neck. At the base of the microphone is a triangular plate that presses against his chest and allows the horn of the microphone to be close to his face. Wires trail below. A braid of wiring also falls from the left side of his head. He is holding a tool that appears to be a gauge. His left hand is not only bracing the gauge, but his fingers are pressed together just above the top of the gauge. Perhaps he is guiding the hidden part of the gauge that tests for pressure. Perhaps there is a bolt located just beyond his fingertips that we cannot see. It is aimed at the black smudge next to the number five. The man is working on a surface that floats at a forty-five-degree angle in space. I say "floats," because it resembles the underside of a boat. Below the right hand is a metal ring that looks like a chain ring from a bicycle gear. I can't tell if the ring is part of the gauge or part of the boat, if it even is a boat. The light from the flash trails off at the man's left side and also at the lower right side of his body, so that he is brilliantly lit against the darkness behind him. The man is standing so that his lower body almost faces the camera, but he twists his upper body toward the boat. He is wearing the headset and microphone, harness, and wires, and seems to be seriously examining the gauge. And he is naked. His smooth skin extends from the hairline above his

forehead. We cannot tell where the hair begins, because the head is cropped way above the forehead. It is cropped where one would expect to see hair, so there is no hair. The man's smooth, naked skin extends downward. His thin shoulders and arms, and his chest and torso, are hairless until we get to the bottom edge of the picture. Here there is hair, hair that defines the volume of the man's pubis. And this turns out to be the crux of the photograph. Why is this man nude? Is it to illustrate that a man must discard his clothes to dive underwater to work on a boat's hull? I can almost believe it. But it doesn't look like this photograph was made underwater. The man's interest is directed at the gauge. The viewer's interest veers much lower, toward the bottom edge where the photographer has barely cropped the man's penis. The question remains: why is this man nude?

—Mike Mandel

## What You Saw on Instagram

## When I Am Afraid

I don't have pictures from the moments when I am afraid. Fear prevents me from seeing beyond myself, and it is the opposite state that I am in when I take pictures. When I photograph, I only think of what is in front of me, and it is an extraordinary mechanism to make fear disappear.

—Antonio M. Xoubanova

## When I Am Drunk

## Whirligigs

## Whirlpools

## White Boys

Throughout my childhood, I gave the white boys I went to school with a lot of unnecessary attention. I admired their

clothes, points of access, and ability to be in charge of whatever they wanted. It's not that I no longer have white, male friends in my life, but their stories no longer command my attention.

—Clifford Prince King

## White Cowboys

## Whiteness

Black photographers like myself are often troubled with the expectation of using our artwork to counter all the wicked shit that has pathologized Blackness across all forms of media, especially anti-Black racism inherent to the invention of photography. Of course, creating around one's identity can be prolific and meaningful. It can also quickly become a distraction that, at the core, keeps addressing whiteness, regardless of our approaches. The practice of Black artists engaging with the politics of representation has been highly regarded by the art canon, but I find it to be a trick door, confining our imaginations to the limits of what whiteness wants to consume. So when I am constructing images about Black being, I look to the aesthetic approaches of photographers such as Roy DeCarava. His abstracted figurations of Black life undermine the palatable desires of whiteness, and reveal the beauty of a community despite the technological bias of the camera.

—Shikeith

## White Saviorism

Whether it's a casual, fun selfie, or a more staged set-up, imagery featuring comparatively rich photographers posing among apparently grateful, open faces of poverty makes me flinch.

I am immediately suspicious when I see photography being used to reinforce this type of characterization. Photography hasn't been able to shake its indexing, categorizing nature and at this rate, it doesn't seem like it ever will. Is the intention

to project the selflessness and altruism of the individual, to make sure each and every misguided "good deed" is noted and shared? This type of "saviorism," combined with the "travel photo blog" aesthetic, enters the realm of taboo because of its tone-deaf, fleeting approach. Like the proverbial tree in the forest without an audience, do the wells still get dug, and do the schools still get built if no photograph of the selfless act exists to prove it?

—Mariama Attah

## Wholeness

In defense of fragmentation and of the image that refuses to be held: I am not interested in wholeness. For me, to photograph is to capture fragments—to be in conversation with the impossibility of completeness. An image is activated by breaks and fissures. I look to build images in which something is withheld and the edges reside in an indelible yearning. Photography does not make things whole, but accentuates the fragmentation of life and existence. The nature of the image is incomplete. We give it wholeness.

—Keisha Scarville

## Wide-Angle Lens

## Wide Open Space

## Wigs

## Wildlife near Chernobyl

## Willow Trees

## Windmills

## Window Displays

## Window Reflections

**Windows**

**Windowsill Still Life**

**Wine Glass as Prop**

**Winter**

I photograph almost exclusively in the summer. Summer is
when humanity shakes itself awake and ventures out. I rely
on people for my work—as collaborators, subjects, and guides.
So when the heat forces people outdoors, the possibilities for
pictures feel endless. Looking for leisure, people walk the
streets just to walk, allowing themselves to navigate the world
without any planned thought or pressing need. In the sum-
mer, shirts come off and skin is bared. Crime spikes. Waves
of humidity pour over the landscape, pushing weeds through
concrete.

Summer is a smell: it is the stink of the river in your
nose. It is the overflowing cup. It is the snake in the grass
you didn't see until you stepped on its back. Summer is all
the hidden sounds rising in the night: cicadas screaming and
the bottle rocket's report. Summer is gathering in the dark
damp shadows of the front porch and watching the after-
noon thunderheads roll in out of nowhere to bury the world
in water. Most of all, summer is faces—an endless parade
of faces coming and going, laughing, touching, crashing
into each other. Faces engaged in careless violence and
sloppy embrace. Faces excited to share something of their
life with someone else. All of them slick with sweat, all of
them perfect and irresistible. During the wide open days and
extended evenings of the summer season, people naturally
flow together, and the world shimmers and warps in the
sweltering air like a dream.

If summer extends opportunities to photograph like an
open palm, then the winter closes them like a fist. All the
sensory excess, all the effortlessness, all the energizing joy that

lives outside in the summer vanishes in the winter. The only exceptions are the celebratory indoor gatherings of the holiday season, and afterward, winter life becomes less about the excesses of social ripeness and more about the solitary world of the inner mind. In the winter, people naturally retreat indoors and inside themselves. Perhaps I don't photograph in the winter simply because I hate the way I feel in the winter. I close down, become depressed, and hibernate. As a result, it's harder to motivate, to be comfortable, to get myself out the door and interested. There are also the strictures of day. Natural light dominates my photographs, and when the days are short and the sun gives no warmth, possibilities shrink away. Further, harsh winter weather inhibits movement and travel and few people linger outdoors, instead hurrying along to the cozy confines of their work and homes.

For me, the colder months have always been about the other side of photography: editing, printing, thinking, planning, and trying to make money. Winter is about perseverance and waiting for the better times to come around again. Despite the difficulty of photographing winter, I actually find the winter beautiful. For example: the sky is most beautiful in winter. Winter skies are drawn with unnaturally vivid color. The blues achieve their clearest, bluest expressions. Winter sunsets and sunrises are beyond compare when colors stain the snow, mirroring the sky. One could argue that telling myself not to photograph winter is a limitation of my artistic practice, a blind spot in my work. That may be true. The truth is, what is best for a photographer is what produces their best work, and so far, summer has worked. The winter is something I still have to figure out.

—Curran Hatleberg

**A Wire Hanging from the Ceiling**

**Wisteria on a Stone Building**

**Wistful Glances**

## Without Asking Permission

It is damn near impossible for me to photograph strangers, or people I know, without asking permission. I have to let them know. There needs to be an agreement. My high-school photo teacher, Mr. Hartsfield, would repeatedly share the following cautionary tale, not only because he wanted all of us students to take heed, but also because he would forget that he had already told us: Once, while walking around photographing in downtown Los Angeles, he saw an old lady with a bunch of shopping bags. He decided to photograph her *without asking permission* and sneakily, stealthily, went for it. This old lady immediately knew he had photographed her and in response, chased him down and, according to him, beat him with her shopping bags. So I can't photograph people without some kind of announcement. Old ladies are not afraid to pull up.

—Dannielle Bowman

## Women Gazing Up at the Camera

## Women Lying Down

As a teenager, I remember taping magazine pages to my wall to remind myself of what I wanted to look like. As if by looking frequently enough, I could embody that image. As though I were at risk of forgetting that ideal.

Recently, I searched for the word *nude* in an image archive and spent some time sorting the results. One of the notable subcategories was images of women lying down, often on a bed, and viewed from above. There weren't many men depicted that way. There were also a lot of people from the African continent standing outside, "nude." I swiped past a couple of my own images in the archive. They fit in pretty neatly with the other pictures. This disturbed me.

Not long afterward, I began photographing a group of friends in Water Valley, Mississippi, for my project Knit Club.

I wanted to create a set of pictures in which the category "Women" could exist without requiring its expected counterpart: "Men." Only women were present, myself included.

When I began editing the work, I noticed that I had repeatedly invited the women to lie down on the floor to have their picture taken. I've read my share of feminist and film theory so I am not unaware of the tropes associated with the male gaze. But I also like to work on instinct. So I am asking myself: What does this pattern of looking tell me about myself? Is this a project of resistance or is it one of conformity? I'm not sure I have an answer.

—Carolyn Drake

**Wooden Fence Grain**

**Words**

**World's End**

# X

Xmas Lights

X-Raying Film for Effect

X-Rays of Flowers

X-Rays of People Wearing Jewelry

## Yakuza

In 1999, while I was going to art school in New York, my father in Japan was diagnosed with terminal cancer. As a result, I'd go back to Japan every three months or so to visit him in the hospital. My proud and funny father seemed to be growing weaker with every visit, even though he was doing his best to act cheerful in front of me. As a young photographer, I thought a lot about how to approach taking a picture of my fading father. I did photograph him a few times, but to be honest, I never got what I was looking for. The hospital was near Asakusa, Tokyo, and after these visits, I would roam the streets with my 35 mm camera, usually feeling very sad.

Asakusa is a very old area of Tokyo. I would wander about aimlessly in the more shady areas where the locals hung out, and avoided the more popular tourist spots. I don't know if it's still like this, but at the time, there were still a lot of colorful characters in Asakusa. You could turn a corner and feel like you had walked right into one of Takeshi Kitano's films. Of course, I was scared of interacting with these characters, but I was drawn to them enough that I would sometimes stare, or follow them. I'm sure I probably seemed pretty weird to them as well. Occasionally, I would get the nerve to ask someone on the street if I could photograph them, but most of the time, I was too afraid or it felt too awkward. I had this rule that I should always ask first.

On one of these walks, I happened on a small back road where a group of policemen were hanging out smoking

cigarettes. As I walked by, I saw a man lying on the ground in a fetal position. He was passed out with his eyes closed, facing the blue sky, drool dripping out of his mouth. The police weren't paying him any attention, and a cleaning lady was busy trying to sweep the street around him. It was one of those social-journalism moments. I remember thinking that this was probably not the kind of picture I should take. I knew it wasn't fair to the man on the street, whose life could be at its lowest point, and who was completely unaware of a girl with a camera observing and contemplating. Against my better judgment, I raised my camera and photographed the cleaning lady and the man on the ground. Then, unable to stop myself, I moved in closer to the fetus shape. His body contrasted with the dark asphalt in the bright daylight, and a water puddle reflected shiny light next to him. He looked like he was floating in a dark universe. As I framed my shot, I fantasized about making a contrasty print in the darkroom to accentuate this. I clicked the shutter and all of the sudden, I heard a deep, heavy voice right next to my ear. It said, "Hey, hey Jo-chan."

My heart almost stopped. I slowly turned my head and a bald man with a toothpick sticking out of his mouth was staring right into my eyes. He smelled of strong cologne and cigarette smoke, and a colorful flower shirt was sticking out from under his dark pinstriped suit. His eyes were quietly fixated on my face. My brain just repeated the words, *Shit, shit, shit*. At the same time, I felt that I had to maintain eye contact with him. My heart was pounding, but I was trying not to show it. Then he quietly said, "There's a photograph to take, and there's a photograph not to take. Which one do you think this is?" Before I got a chance to respond, he quickly shifted from his threatening yakuza [gangster] character into a silly comedian and said, "Why don't you take a picture of me? You don't see too many good-looking gents like me around here!" With that, he struck a pose and waited for me to take a picture. So I did. Click. The yakuza

nodded and seemed pleased that my attention had moved from the passed-out man on the street to him.

On the way home that day, I imagined having a drink of cold sake with the yakuza man. I wondered what he would have said about me taking a picture of my dying father in the hospital, plugged into all those tubes and the urinary drainage bag. "There's a photograph to take, and there's a photograph not to take. Which one do you think this is?"

—Kyoko Hamada

**Yard Sales**

**Yellow Cabs**

**Yesterday's News**

**Yetis**

**Yoga**

**Yoga Pants**

**Yucca Plants in Los Angeles**

# Z

Zealotry

Zebras in the Natural History Museum

Zeitgeist

Zeppelins

Zigzagging Shadows on Sunlit Stairs

Zombie Formalism

Zoom Lens

Zoom Screenshot

# Plate List

1. Jeffrey Ladd, *New York City*, 1991
2. Aaron Schuman, *Elinor, Negative and Business Card, New York*, 1996
3. Lisa Kereszi, *Coast Guard Officer on the Phone, Wildwood Boardwalk, Jersey Shore*, 2006
4. Edward Grazda, *Untitled*, 1971; from *On the Bowery*
5. Anne Turyn, *While U Wait*, 1981; from the series New York City in 1979, Shot in 1981
6. Jeff Mermelstein, *New York City*, 1993
7. Mark Cohen, *A Shirt Flashed, Scranton, PA*, August 27, 1983
8. Chris Verene, *Grace Braun*, 1997; from the series The Self-Esteem Salon
9. Bruno Morais, *Midnight at the Crossroads*, 2016
10. George Georgiou, *Mardi Gras Parade, Morgan City, Louisiana*, 2016
11. Erica Deeman, *Untitled 2 (Self-Portrait During COVID 19 Quarantine)*, 2020
12. Shane Lavalette, *Untitled*, 2016; from the series Still (Noon)
13. Tim Carpenter, *Untitled*, 2013
14. Nadav Kander, *Untitled II, London*, 2020
15. Federico Clavarino, *Untitled*, 2016; from the series The Castle
16. Elinor Carucci, *Dave Grohl and His Mother*, 2006
17. Photographer unknown, found photograph from the collection of Todd Hido
18. Jem Southam, *Untitled*, 2019; from the series a bend in the river
19. Fryd Frydendahl, *This Is for Someone You Care About*, 2018
20. Alejandro Cartagena, *We Are Things #136*, 2020
21. Matthew Leifheit, *Logan*, 2017
22. Sasha Rudensky, *Open Gates*, 2012
23. Danna Singer, *Mackenzie*, 2019
24. Stanley Wolukau-Wanambwa, *1/2 Charity Street*, 2014
25. Rebecca Norris Webb, *Suanne*, 2019
26. Kyoko Hamada, *Yakuza*, 1999
27. Paul Kooiker, 2014; from the series Nude Animal Cigar
28. Adama Delphine Fawundu, *Chabaa Thai Cuisine Bathroom, San Francisco, CA*, 2018
29. Deanna Templeton, *Man Rides Bike, Huntington Beach, CA*, 2014
30. Gus Powell, *Brooklyn Bridge*, March 13, 2020
31. Sheung Yiu, *Untitled (Hair)*, 2016
32. Simon Gush, *Iseeyou*, 2013
33. Nelson Chan, *Mom's Side of the Bed, New Jersey*, 2010
34. Michael Ashkin, *Untitled*, 2017
35. Cig Harvey, *Trey (Waiting)*, 2012
36. Robin Maddock, *2018*
37. Fabiola Menchelli, *Plexo*, 2020
38. Matthew Beck, *Untitled*, 2017
39. Michael Schmelling, *Door*, 2002; from the series Shut Up Truth
40. Lacey Lennon, *Up the Hill*, 2019
41. Sinna Nasseri, *Untitled*, 2019
42. Cristina de Middel, *Untitled*, 2018; from the series The Body as a Battlefield
43. Rafal Milach, We are the Revolution. No more being nice to violent guys, annual feminist demonstration organized in connection with International Women's Day, Warsaw, 2019
44. Ricardo Cases, *El Blanco*, 2016
45. Asger Carlsen, *Untitled*, 2020
46. Larry Sultan, *Paris on My Parents' Bed*, 2007
47. Tod Papageorge, *El Cerrito, California*, 1975
48. Whitney Hubbs, *Untitled*, 2020
49. Oscar Apfel, *A Prince of Her Soul*, 1917
50. Max Pinckers, *Performance #1, Los Angeles*, 2018; from the series Margins of Excess
51. Katrin Koenning, *Untitled*, 2019
52. William Wegman, *Mondo Bizarro*, 2015

# Contributor Bios

**Valentina Abenavoli** is an independent editor, educator, book designer, and visual artist. Her research is aimed at questioning interpretation and association of meanings in visual narratives. Her artistic practice combines photography, video, and text—often reappropriated and decontextualized. In 2012, she cofounded AKINA Books, an independent publishing house producing challenging photobooks by emerging photographers. She has led intensive workshops worldwide on bookmaking. As an artist, she has published two books, *Anaesthesia* (2016) and *The Harvest* (2017), part of an ongoing trilogy investigating the subjects of empathy and evil. A third book, tentatively titled *Resistance*, is currently in the making.

**Manal Abu-Shaheen** is a Lebanese American photographer based between Beirut and the Bronx. Her solo exhibitions include *2d Skin*, Soloway, Brooklyn (2019); *Theater of Dreams*, Bernstein Gallery, Princeton University, New Jersey (2018); and *Beta World City*, LORD LUDD, Philadelphia (2017). She has received fellowships from the Jerome Foundation, New York Foundation for the Arts, Aaron Siskind Foundation, and A.I.R. Gallery, and has participated in residencies as part of the Lower Manhattan Cultural Council Workspace program and AIM at the Bronx Museum. Abu-Shaheen received an MFA in photography from the Yale School of Art, New Haven, Connecticut. She teaches at the City College of New York.

**Vince Aletti** is a critic and curator based in New York. He was the art editor and photography critic at the *Village Voice* for nearly twenty years, until 2005, when he began contributing photography exhibition reviews to the *New Yorker*. He left there in 2016 to work on *Issues: A History of Photography in Fashion Magazines* (2019). He was the cocurator of *Avedon Fashion 1944–2000* at the International Center of Photography, New York, in 2009, and the coauthor of the exhibition catalogue. That same year saw the publication of *The Disco Files 1973–78*, a compilation of Aletti's weekly Record World columns.

**Michael Ashkin** was born in New Jersey and studied Middle Eastern languages before becoming an artist. His work has been shown at the Whitney Biennial, New York; Museum of Modern Art's *Greater New York*; Documenta, Kassel, Germany; and Vienna Secession. His work in photography, sculpture, installation, video, text, performance, and painting generally deals with issues of perception regarding the landscape and the built environment. He has published four photography books: *Garden State* (2000), *Long Branch* (2014), *Horizont* (2018), and *were it not for* (2019). He teaches at Cornell University, Ithaca, New York.

**Mathieu Asselin** lives in Arles, France. He began his career working on film productions in Caracas, Venezuela, but shaped his photography practice in the United States. His work mainly consists of long-term investigative documentary projects. His latest book, *Monsanto: A Photographic Investigation* (2017), received international acclaim, winning the 2016 Fotobookfestival Kassel Dummy Award and 2017 Paris Photo–Aperture Foundation First PhotoBook Award, and was shortlisted for the 2018 Deutsche Börse Photography Foundation Prize. Asselin has exhibited work at Les Rencontres de la Photographie d'Arles, France; Photographers' Gallery, London; Fotomuseum Antwerp, Belgium; and the European Parliament, Strasbourg, France; among other venues.

**Mariama Attah** is a photography curator, writer, and lecturer with a particular interest in overlooked visual histories, and how photography and visual culture can be used to amplify underrepresented voices. Attah is curator of Open Eye Gallery, Liverpool. Her previous roles include assistant editor of *FOAM*, and curator at Photoworks, where she was responsible for developing and curating programs and events (including the Brighton Photo Biennial) and was commissioning and managing editor of *Photoworks Annual*.

**Roger Ballen** is a photographer, born in the US and based in Johannesburg, South Africa. He has published over twenty-five books, most recently *Roger the Rat* (2020) and *Ballenesque* (2017), a major retrospective of his collected works. Ballen's images are in many international museum collections.

**Lisa Barnard**'s photographic practice discusses real events, utilizing traditional documentary techniques with more contemporary and conceptually rigorous forms of representation. Barnard connects her interests in aesthetics, current photographic debates around materiality, and the existing political climate. She is associate professor at the University of South Wales, Pontypridd, and program leader of the MA in documentary photography program. Among her publications are: *Chateau Despair* (2012), supported by the Arts Council; and *Hyenas of the Battlefield, Machines in the Garden* (2015), supported by the Albert Renger-Patzsch Award. Barnard's latest work, *The Canary and the Hammer*, was published in September 2019 and funded by the Getty Images Prestige Grant.

**Jacqueline Bates** is photography director of the *California Sunday Magazine*, which won the National Magazine Award for excellence in photography two years in a row, in 2016 and 2017, and of *Pop-Up Magazine*. Previously, she was senior photo editor of *W Magazine* and worked in the photo departments of *ELLE*, *Interview*, and *Wired*. Bates holds an MFA in photography from the School of Visual Arts, and her work has been exhibited internationally.

**Endia Beal** is a North Carolina–based artist, internationally known for her photographic narratives and video testimonies that examine the personal stories of Black women working within the corporate space. Beal has been featured in the *New York Times*, *National Geographic*, *Time*, and the *Atlantic*. Her work has been exhibited in institutions, including the Nasher Museum of Art at Duke University, Durham, North Carolina, and Aperture Gallery, New York. Beal holds a BFA in art history and studio art from the University of North Carolina at Chapel Hill, and an MFA from Yale University, New Haven, Connecticut.

**Matthew Beck** is a Virginia-born photographer and filmmaker living and working in New York City. His work tends to revolve around themes of consciousness, impermanence, and exploring the deep relationship between science and art. His first book, *EVENT*, was published in 2020.

**Ruth van Beek**'s work originates in her ever-growing archive of images. Mainly taken from old books, they are her tools, source material, and context. By physically intervening in the pictures through folding, cutting, and by adding pieces of painted paper, she rearranges and manipulates the images to reveal the universes within. Her work has been shown internationally

and she has published numerous artist books, including *The Arrangement* (2013), which was shortlisted for the Paris Photo–Aperture Foundation PhotoBook of the Year Award in 2014, and *How to Do the Flowers* (2018). Her new book, *Eldorado*, made in collaboration with Willem van Zoetendaal, was released in 2020.

**Ute Behrend** is a photographer who teaches at various schools and universities in Germany. She has published four books to date: *The Last Year of Childhood* (2011), *Zimmerpflanzen* (2008), *Märchen/Fairy Tales* (2005), and *Girls, Some Boys and Other Cookies* (1996).

**Rebecca Bengal** is a writer of fiction and nonfiction who often collaborates with visual artists. Her short stories and essays have appeared most recently in books by Carolyn Drake and Paul Graham, and in Justine Kurland's *Girl Pictures* (Aperture, 2020). She is a frequent contributor to *Aperture*, the *New York Times*, *Guardian*, and *Criterion Collection*, among many other publications. Originally from western North Carolina, she lives in Brooklyn.

**September Dawn Bottoms** (who was, in fact, born on a September dawn) is a self-taught photographer from Oklahoma. She focuses on women's and social issues, and also endeavors to explore her family through photography to better understand the effects of sexual trauma and mental illness. She gravitates toward projects that blossom from a connection with certain characters and figures out how their stories fit into a larger context. In June 2020, she joined the *New York Times* as a photography fellow. She now splits her time between Tulsa and Los Angeles.

**Dannielle Bowman** received a BFA from the Cooper Union and an MFA from the Yale School of Art, New Haven, Connecticut. Bowman has participated in residencies at Baxter St at the Camera Club of New York; Center for Photography at Woodstock, New York; and PICTURE BERLIN. From 2019 to 2020, she was a contributor to the *New York Times Magazine*'s 1619 Project. Her work has been published by *Aperture* magazine and elsewhere. Bowman is recipient of the 2020 Aperture Portfolio Prize and a 2020 PHmuseum Women Photographers Grant. She lives and works in New York.

**Andre Bradley** lives and works in Philadelphia. His work explores race and trauma through writing, photography, and curatorial practice. Bradley received an MFA from Ithaca College, the Maryland Institute College of Art, and the Rhode Island School of Design. His book *Dark Archives* (2015) was shortlisted for the Photo-Text Book Award at Les Rencontres d'Arles, France, and the Paris Photo–Aperture Foundation First PhotoBook Award, both in 2016. Bradley has been a fellow at the Arc Baltimore, Image Text Ithaca, Hampshire College, and Philadelphia Photo Arts Center.

**Frish Brandt** is partner and president of Fraenkel Gallery, San Francisco. Opened in 1979, the gallery has witnessed the evolution of photography from nonart to high art and represents work from the nineteenth to the twenty-first centuries. Over the years, the gallery has increasingly played with the ever-blurring lines of what photography is by incorporating artists working in other mediums and mounting exhibitions along the lines of *Not Exactly Photographs* (2003) and *The Unphotographable* (2013). In addition to her work at the gallery, Brandt serves on the board of San Francisco Art and Film for Teens, and is active at the San Francisco Museum of Modern Art as the longest-serving member of the Director's Circle committee. She also has a secret life as a "letter" midwife, working with people in palliative care and hospice.

**Susan Bright** is a curator based in London. She returned to the UK in 2020, after many years based in New York and Paris. She has curated exhibitions at Tate Britain, the National Portrait Gallery, and Photographers' Gallery, London; and the Museum of Contemporary Photography, Chicago, among other institutions. In 2019, she was guest curator for PHotoEspaña, Madrid, and is cocurator of f/stop 9: Festival für Fotografie Leipzig 2021, Germany. She has authored seven books, including *Feast for the Eyes: The Story of Food in Photography* (Aperture, 2017); the exhibition of this project has toured six venues worldwide. Bright holds a PhD in curating from Goldsmiths, University of London.

**Adam Broomberg** is an artist and educator living and working in Berlin. He is a professor at Hochschule für bildende Künste in Hamburg.

**David Campany** is a writer on photography. His books include *On Photographs* (2020), *Walker Evans: The Magazine Work* (2014), *Jeff Wall: Picture for Women* (2011), *Photography and Cinema* (2008), and *Art and Photography* (2003). Campany is managing director of programs at the International Center of Photography, New York.

**Asger Carlsen** uses photography as a means of creating sculptural work. After digitally photographing the body in various poses in his studio, he edits and transforms the shape and composition of the figure to the point of abstraction. The final images convey a sense of grace and elegance, while simultaneously provoking a visceral reaction. Carlsen was born in Denmark in 1973 and moved to New York in 2007, where he continues to live and work. He has had solo shows at the Museum of Contemporary Art of Rome; FOAM, Amsterdam; and the 9th Berlin Biennale. His work has been featured in the *New Yorker* and *Frieze*, among other publications.

**Tim Carpenter** is a photographer and writer who works in Brooklyn and central Illinois. He is a cofounder of TIS books, an independent photobook publisher.

**Alejandro Cartagena** is a Mexican artist and photographer. His work looks at landscape, portraits, and the archive as a way to question social, economic, and political structures embedded in cities and their peoples. Cartagena has published several books, including *Suburbia Mexicana* (2008), *Carpoolers* (2015), *Before the War* (2015), *Santa Barbara Return Jobs back to US* (2016), *A Guide to Infrastructure and Corruption* (2017), *We Love Our Employees* (2019), and *Santa Barbara Save US* (2020). His work is in the collections of the San Francisco Museum of Modern Art; Museum of Fine Arts, Houston; and Museum of Contemporary Photography, Chicago, among others.

**Elinor Carucci** was born in Jerusalem. Her work has been included in many solo and group exhibitions worldwide, and has appeared in publications internationally. Her work is in the collections of the Museum of Modern Art, New York; Jewish Museum, New York; and Brooklyn Museum, among others. She has been awarded an ICP Infinity Award, Guggenheim Fellowship, and New York Foundation for the Arts Fellowship.

Carucci has published four monographs to date: *Closer* (2002), *Diary of a Dancer* (2005), *Mother* (2013), and *Midlife* (2019). She teaches at the graduate program of photography at the School of Visual Arts and is represented by Edwynn Houk Gallery, New York.

**Ricardo Cases** was born in Orihuela, Alicante, Spain. He holds a BA in information science from the Universidad del País Vasco, Bilbao, Spain. In 2006, he joined the Blank Paper photography collective. He has published six books: *Estudio elemental del Levante* (2020), *Sol* (2017), *El porqué de las naranjas* (2017), *Paloma al Aire* (2017), *La Caza del Lobo Congelado* (2013), and *Belleza de barrio* (2008).

**Melissa Catanese** works from an inventory of images, both personal and anonymous, to build elliptical narratives that drift away from simple typology into something more intuitive and openly poetic. She recently exhibited at Silver Eye Center for Photography, Pittsburgh, and her books include *Dive Dark Dream Slow* (2012), *Dangerous Women* (2013), *Hells Hollow Fallen Monarch* (2015), and *Voyagers* (2018). She is founder of Spaces Corners, an artist-run photography bookshop and project space in Pittsburgh.

**Bruno Ceschel** is founder and director of Self Publish, Be Happy, and visiting lecturer at École cantonale d'art de Lausanne. He founded Self Publish, Be Happy in 2010, and has since organized events at Tate Modern, London; Kunsthal Charlottenborg, Copenhagen; MoMA PS1, New York; and the National Gallery of Victoria, Melbourne, Australia. He has published books by Lucas Blalock, Carmen Winant, and Lorenzo Vitturi, among others. Ceschel gives lectures and workshops internationally, and also consults for leading companies interested in contemporary photography.

**Nelson Chan** was born in New Jersey to immigrant parents from ▉▉▉▉▉▉▉▉▉▉▉, and has spent his life between the US and ▉▉▉▉▉▉. Having grown up on two continents with unique cultures, his immigrant experience has influenced the majority of his work. Nelson holds a BFA from the Rhode Island School of Design and an MFA from the Hartford Art School. He is a cofounder of TIS books; from 2016 to 2019, he was production manager of Aperture Foundation, and he is now based in the San Francisco Bay Area, where he is an assistant professor of photography at the California College of the Arts.

**Federico Clavarino** is a photographer and teacher. He studied creative writing at Alessandro Baricco's Scuola Holden in Turin, Italy, and documentary photography at Fosi Vegue's Blank Paper School in Madrid. He holds a master of research degree from the Royal College of Art, London. Clavarino's works revolve around issues of power, history, and representation. He has published six books: *Ukraina Pasport* (2011), *Italia o Italia* (2014), *The Castle* (2016), *La Vertigine* (2017), *Hereafter* (2019), and *Alvalade* (2019). His works have been exhibited internationally at festivals, including PHotoEspaña, Madrid, and Les Rencontres d'Arles, France, as well as in galleries and museums such as CaixaForum Madrid/Barcelona and the Museum of Contemporary Art of Rome. He taught at Blank Paper School from 2012 to 2017 and currently gives lectures and workshops internationally.

**Jessica Cline** serves as supervising librarian for the New York Public Library's Picture Collection.

**Mark Cohen** has been taking pictures since high school and has published *Grim Street* (2005), *True Color* (2007), *Dark Knees* (2014), and *Frame: A Retrospective* (2015). His work is in many collections and museums, and he is currently photographing in Philadelphia. He received Guggenheim Fellowships in 1971 and 1976.

**Matthew Connors** is an artist and a professor in the Photography Department at the Massachusetts College of Art and Design, Boston. His work has been exhibited and published widely. A graduate of the University of Chicago and Yale School of Art, New Haven, Connecticut, he has received a few awards and occasional acclaim. He is based in New York City.

**Charlotte Cotton** is a curator and writer. She has held positions including head of the Wallis Annenberg Department of Photography at the Los Angeles County Museum of Art, and curator of photographs at the Victoria and Albert Museum, London. She is author of *The Photograph as Contemporary Art* (2004), recently revised and in its fourth edition. Three of her curatorial projects have been published as books by Aperture: *Words Without Pictures* (2010); *Photography Is Magic* (2015); and *Public, Private, Secret: On Photography and the Configuration of Self* (2018).

**Sara Cwynar** currently lives and works in Brooklyn. Her work in photography, video, and bookmaking involves a constant archiving and re-presentation of collected visual materials. Her book *Glass Life* (Aperture, 2021) brings together her multilayered portraits and stills from the films *Soft Film* (2016), *Rose Gold* (2017), and *Red Film* (2018). Cwynar has exhibited her work at MoMA PS1, New York; Malmö Konsthall, Sweden; and Fondazione Prada, Milan, and her works are in the permanent collections of the Museum of Modern Art, New York; Museum für Moderne Kunst, Frankfurt; and Art Gallery of Ontario, Toronto. She is a former staff graphic designer at the *New York Times Magazine*.

**Hannah Darabi** is an Iranian artist based in Paris. Her country of origin remains the subject of most of her photographic work. In order to reveal the complex political situation of Iran, she creates series in which her photographs interact with other materials, such as texts, archival images, and objects. The artist book occupies a privileged place among the forms of representation that she explores. Her books are part of public and private collections, and her recent publication *Enghelab Street, a Revolution through Books: Iran 1979–1983* (2019) has received numerous awards.

**Tim Davis** is an artist, writer, and musician who lives in Tivoli, New York, and teaches photography at Bard College. His latest photographic project is *I'm Looking Through You* (Aperture, 2021). The Frances Young Tang Teaching Museum and Art Gallery at Skidmore College showed a large survey of his recent work in photography, video, sound, sculpture, and performance entitled *Tim Davis—When We Are Dancing (I Get Ideas)* in 2019. The catalogue was published in 2020.

**Jack Davison** is a London-based photographer. He studied English literature at the University of Warwick, Coventry, UK, but he spent most of the time experimenting with cameras. Since the age of fourteen, he has continuously photographed those around him. He works for numerous publications, including the *New York Times Magazine*, *M Le magazine du Monde*, *Luncheon*, *Double Magazine*, and *British Vogue*.

**Erica Deeman** holds a degree in public relations from Leeds Beckett University and a BFA in photography from Academy of Art University, San Francisco. She is currently an art practice MFA candidate at the University of California, Berkeley. Deeman has exhibited widely, and her work is in the permanent collections of the Berkeley Art Museum and Pacific Film Archive; Museum of Contemporary Photography, Chicago; Museum of Photographic Arts, San Diego; New Orleans Museum of Art; Pérez Art Museum, Miami; and Pier 24 Photography, San Francisco.

**Carolyn Drake** is a visual artist based in California, whose work seeks to interrogate dominant historical narratives and reimagine them. Her practice embraces collaboration and has, in recent years, melded photography with sewing, collage, and sculpture, following an impulse to play with and pervert the photographic gaze. She is recipient of many awards, including a Guggenheim Fellowship, Anamorphosis Prize, and Peter S. Reed Foundation grant. Drake's books include *Two Rivers* (2013), *Wild Pigeon* (2014), *Internat* (2017), and *Knit Club* (2020). She is a member of Magnum Photos.

**Doug DuBois**'s photographs are in the collections of the Museum of Modern Art in New York, San Francisco Museum of Modern Art, J. Paul Getty Museum in Los Angeles, and the Los Angeles County Museum of Art. He has received fellowships from the Guggenheim Foundation, MacDowell Colony, and National Endowment for the Arts. DuBois has exhibited at the J. Paul Getty Museum; Museum of Modern Art; Irish Museum of Modern Art, Dublin; and Museum of Contemporary Art of Rome. He has published two monographs, *All the Days and Nights* (Aperture, 2009) and *My Last Day at Seventeen* (Aperture, 2015). His work for magazines has appeared in the *New York Times Magazine*, *Time*, *Details*, *GQ*, and the *New Yorker*. DuBois teaches in the college of visual and performing arts at Syracuse University.

**Jess T. Dugan** is an artist whose work explores issues of identity through photographic portraiture. Their work has been widely exhibited and is in the permanent collections of over thirty-five museums throughout the United States. Dugan's monographs include *To Survive on This Shore: Photographs and Interviews with Transgender and Gender Nonconforming Older Adults* (2018) and *Every Breath We Drew* (2015). They are recipient of a Pollock-Krasner Foundation Grant and an ICP Infinity Award, and were selected by the Obama White House as an LGBT Artist Champion of Change. Dugan is represented by the Catherine Edelman Gallery, Chicago.

**Ike Edeani** is a Nigerian photographer, born in Enugu, who works on editorial, commercial, and self-generated projects. He moved to the United States at sixteen, receiving a master of architecture degree and working in design before pursuing photography. His clients include the *New York Times*, the *New Yorker*, *Time*, Google, Nike, and Netflix.

**Charlie Engman** is an artist based in New York City. His work has been exhibited internationally, in venues such as Lisson Gallery, London; FOAM, Amsterdam; Manchester Art Gallery, UK; Scrap Metal Gallery, Toronto; and Lishui Biennial, China. He also works extensively in commercial and fashion contexts with clients such as Prada, Vivienne Westwood, Stella McCartney, Hermès, *Vogue*, *Dazed*, and Collina Strada. Engman published his first monograph, *MOM*, in 2020.

**Roe Ethridge** was born in Miami. He is a photographer living and working in Brooklyn.

**Cary Fagan** is a Houston-based artist, who started out as a photographer and filmmaker. Over the years, Fagan's explorations into notions of time, memory, and how we form connections with one another have segued into other artistic mediums. A curiosity about the anthropomorphic characteristics of chairs led Fagan to what he calls "chair sculpting." These experimental sculptures resulted in a residency at Arts Itoya, Takeo, Japan (2019); exhibition at Numeroventi, Florence (2019); and takeover of the Museum of Fine Arts, Houston's Instagram page (2020). In June 2020, "Chairs Are People" became a registered trademark. In 2018, Fagan created *timeless.goods*, a series of fine-art jigsaw puzzles, through which he encourages people to #disconnect from the intensity of the digital world.

**Adama Delphine Fawundu** is a photo-based artist born in Brooklyn to parents from Sierra Leone and Equatorial Guinea, West Africa. She received her MFA from Columbia University. Fawundu is a coauthor of the critically acclaimed book *MFON: Women Photographers of the African Diaspora* (2017). Her most recent publication is a handbound, quarterly, limited-edition journal titled *hala: an unexpected gift*.

**Larry Fink** is a fine-art and editorial photographer. He has won two Guggenheim Fellowships and two National Endowment for the Arts grants, and has shown work at New York's Museum of Modern Art and Whitney Museum of American Art, among countless other institutions. Fink, in his words, was "born to photograph." He had no schooling, he's been to jail, and he's taught at Yale. He has been teaching for fifty years and is presently a professor at Bard College, Annandale-on-Hudson, New York. His pictures are informed by music, painting, farmwork, bodily functions, and critical love.

**Joel W. Fisher** received a BA in English from the University of New Hampshire, Durham, and an MFA from the Rhode Island School of Design, Providence. From 2006 to 2007, he worked and studied at the Hochschule für Grafik und Buchkunst in Leipzig, Germany, on a Fulbright Fellowship. He was a visiting assistant professor at the Rochester Institute of Technology, New York, and an area head of photography at the City College of New York. Fisher is currently associate professor of art and chair of the Department of Art and Art History at Lewis & Clark College, Portland, Oregon.

**Lucas Foglia** grew up on a small family farm in New York and currently lives in San Francisco. His photographs examine the intersections between humans and wild spaces. He recently published his third book, *Human Nature* (2017). Foglia exhibits prints internationally, photographs for magazines, and collaborates with nonprofit advocacy organizations.

**Anna Fox** is a British photographer and professor of photography at the University for the Creative Arts, Farnham, UK. Working in color, Fox first gained attention for *Work Stations: Office Life in London* (1988), a study of office culture in Margaret Thatcher's Britain. She was shortlisted for the 2010 Deutsche Börse Photography Prize. Fox is currently working on the award-winning research project Fast Forward: Women in Photography.

**Jermaine Francis** is a London-based photographer who works between portraiture, documentary, and editorial. Born in the West Midlands, UK, he holds a BA in photographic studies from the University of Derby. Francis has contributed to publications, including *i-D*, the *Face*, *10 Magazine*, *Self Service*, *Beauty Papers*, and *Telegraph Magazine*. He has exhibited at the National Portrait Gallery, London; International Center of Photography, New York; and *Invisible* exhibition, London. Francis's work was included in the book *Fashion Photography Next* (2014). In 2020, he published a book of his lockdown project, *Something That Seems So Familiar Becomes Distant*.

**Tania Franco Klein** studied architecture in Mexico before pursuing a master's degree in photography at the University of the Arts London. Her practice focuses on social behavior and contemporary practices such as consumption, media overstimulation, and the psychological sequels of the pursuit of the ideals of the American dream. Her work has been awarded by Aperture, Sony, and Photo London, and has been reviewed and featured by *Artforum*, CNN, *Los Angeles Times*, the *Paris Review*, and the *Guardian*. She has been commissioned by the *New York Times*, the *New Yorker*, *FT Weekend*, *New York* magazine, and Dior, among others. Her work is currently represented by ROSEGALLERY, Santa Monica.

**Justin French** is a photographer based in London and New York. He directs his lens toward people who are often overlooked, making their presence inherently political. He captures modern images with a nostalgic eye.

**Fryd Frydendahl** is a photographer who divides her time between New York and Denmark. Represented by V1 Gallery, Copenhagen, she was born on the West Coast of Denmark in 1984. She graduated from Fatamorgana, Copenhagen, in 2006; and from the International Center of Photography School, New York, in 2009. Frydendahl has published several books, and her work has been exhibited widely. Two series from her book *Nephews* (2017) were selected for inclusion in the permanent collections of Statens Museum for Kunst and the National Museum of Photography, Copenhagen. Frydendahl most recently published the book *Never Run Faster Than Your Guardian Angel Can Fly* (2020). She is currently acting principal at Fatamorgana School of Photography, Copenhagen.

**Jason Fulford** (editor) is a photographer and cofounder of J&L Books. He is a Guggenheim Fellow and a frequent lecturer at universities. Monographs of his work include *Raising Frogs for $$$* (2006), *The Mushroom Collector* (2010), and *Picture Summer on Kodak Film* (2020). He is coeditor with Gregory Halpern of *The Photographer's Playbook* (Aperture, 2014), coauthor with Tamara Shopsin of *This Equals That* (Aperture, 2014), and guest editor of *Der Greif,* Issue 11 (2018).

**Peter Funch** currently lives and works in Paris, after living for thirteen years in New York. He graduated as a photojournalist from the Danish School of Journalism, Aarhus, in 1999, and he combines social commentary with a cinematic style. Funch works internationally on exhibitions and books, and with editorial and advertising clients alike, combining technical excellence with a touch of Nordic calmness and dry humor. Recent exhibitions include *42nd and Vanderbilt* (2018) at Eighteen Gallery, Copenhagen; *A History of Photography: Daguerreotype to Digital* (2018) at the Victoria and Albert Museum, London; 2018 Triennial of Photography Hamburg, Germany; and Photography Biennale 2018, Brandts, Denmark.

**George Georgiou** was born in London. His work is mainly focused on the complexities of the individual in relation to community and urban public space. He has produced three monographs, *Fault Lines/Turkey/East/West* (2010), *Last Stop* (2015), and *Americans Parade* (2019), which was shortlisted for the 2019 Paris Photo–Aperture Foundation PhotoBook Awards. His work has been exhibited in galleries and museums internationally and was included in the *New Photography 2011* exhibition at the Museum of Modern Art, New York. Institutions and private collectors, including MoMA, New York, and the Elton John collection, have collected Georgiou's work. Awards include the *British Journal of Photography* project prize 2010, World Press Photo prizes in 2003 and 2005, and Pictures of the Year International first prize in 2004.

**Gauri Gill** is a Delhi-based photographer. She has exhibited in India and internationally, including at the Venice Biennale; MoMA PS1, New York; Documenta 14, Athens and Kassel; Kochi-Muziris Biennale, India; Smithsonian Institution, Washington, DC; Wiener Library, London; and Art Gallery of Ontario, Toronto. Her work is in the collections of prominent institutions worldwide, and in 2011, she was awarded the Grange Prize, Canada's foremost award for photography. Gill's various ongoing projects highlight her sustained belief in collaboration and "active listening," and in using photography as a memory practice. Gill's work addresses the caste, Indian identity markers of class and community as determinants of mobility and social behavior; in her work, there is empathy, surprise, and a human concern over issues of survival.

**Ariel Goldberg**'s publications include *The Estrangement Principle* (2016) and *The Photographer* (2015). Their writing has appeared in *Afterimage, e-flux, Artforum,* and *Art in America.* Goldberg currently teaches at the City College of New York; Bard College, Annandale-on-Hudson, New York; and Parsons School of Design at The New School, New York. They have been a curator at the Poetry Project, New York; Leslie-Lohman Museum of Art, New York; and Jewish History Museum, Tucson, Arizona.

**Jim Goldberg**'s innovative use of image and text make him a landmark photographer of our times. His long-term projects include Rich and Poor (1977–85), Raised by Wolves (1985–95), and Open See (2003–11), for which he was awarded the Henri Cartier-Bresson Award and the Deutsche Börse Photography Foundation Prize in 2011. Goldberg's work is in numerous private and public collections, including of the Museum of Modern Art, and Whitney Museum of American Art, New York; San Francisco Museum of Modern Art; J. Paul Getty Museum, Los Angeles; and National Gallery of Art, Washington, DC. Goldberg is professor emeritus at California College of the Arts, and a member of Magnum Photos. He is represented by Casemore Kirkeby, San Francisco.

**Andres Gonzalez**'s work synthesizes in-depth research with the poetics of photography to reveal truths behind overlooked narratives in the American landscape. He has published two books: *Some(W)Here* (2012) and *American Origami* (2019), which won the Light Work Photobook Award. He has received recognition from the Pulitzer Center and the Alexia Foundation, and is a Fulbright Fellow. He lives in Vallejo, California.

**John Gossage**, since the age of fourteen, has devoted his life to photography and the music of Charles Edward Anderson Berry.

**Daniel Gordon** holds a BA from Bard College and an MFA from the Yale School of Art. He is the author of *Houseplants* (Aperture, 2020); *Spaces, Faces, Tables and Legs* (2018); *Intermissions* (2017); *Still Life with Onions and Mackerel* (2014); *Still Lifes, Portraits & Parts* (2013); *Flowers and Shadows* (2011); and *Flying Pictures* (2009). His work has been exhibited widely, including at FOAM, Amsterdam; Houston Center for Photography; J. Paul Getty Museum, Los Angeles; Pier 24 Photography, San Francisco; and MoMA PS1, and the Museum of Modern Art, New York. His work is held in the collections of the Museum of Modern Art and Guggenheim Museum, New York; Pier 24 Photography; FOAM; and Lisser Art Museum, Lisse, the Netherlands.

**Elena Goukassian** is Aperture's copy editor and the person who added all the extra commas to everyone's texts in this book. She also writes occasional freelance articles on art forgery, graphic novels, and the Cold War era for publications like *Artsy,* the *Nation,* and the *Los Angeles Review of Books.*

**Edward Grazda** was born in Queens in 1947. He graduated with a BFA from the Rhode Island School of Design, Providence, in 1969. His books include *Afghanistan Diary 1992-2000* (2000), *New York Masjid / Mosques of New York* (2002), *A Last Glance: Trading Posts of the Four Corners* (2015), *Mean Streets: NYC 1970-1985* (2017), and *On the Bowery: NYC 1971* (2019). Grazda's work is in the collections of the Museum of Modern Art, and Metropolitan Museum of Art, New York; New York Public Library; and San Francisco Museum of Modern Art. He has taught at Harvard University, Cambridge, Massachusetts; School of the Museum of Fine Arts, Boston; and International Center of Photography, New York. He lives in Chilmark, Massachusetts.

**Naima Green** is an artist and educator working in photography, performance, and text. Her work has been

featured in numerous exhibitions, including at Fotografiska New York; Smart Museum of Art, Chicago; MASS MoCA, North Adams, Massachusetts; International Center of Photography, New York; Houston Center for Photography; Bronx Museum; and BRIC, Brooklyn. Her works are in the collections of the Museum of Modern Art Library, International Center of Photography Library, Barnard College Library, and Teachers College, Columbia University, New York; National Gallery of Art, Washington, DC; and Decker Library at the Maryland Institute College of Art, Baltimore. She earned an MFA in photography from ICP-Bard, where she was awarded the Director's Fellowship (2016–17); an MA from Teachers College; and a BA from Barnard College.

**Hans Gremmen** is a graphic designer based in Amsterdam, who works in the fields of photography, architecture, and the fine arts. He has designed over three hundred books and won various awards for his experimental designs, including a gold medal in the Best Book Design from All over the World competition. In 2008, Gremmen founded the publishing house Fw:Books, with a focus on photography-related projects and books. Together with Roma Publications and Premiss, he recently started ENTER ENTER, a space for books and projects that explore the boundaries of the book, in the center of Amsterdam.

**Guido Guidi** lives and works in Cesena, Italy. His work, spanning more than forty years, has focused on rural and suburban landscapes in Italy and Europe. Guidi's photographs have been exhibited extensively, including at Fotomuseum Winterthur, Switzerland; the Venice Biennale; Canadian Centre for Architecture, Montreal; Guggenheim Museum, New York; and Centre Pompidou, Paris. He has published numerous books, including *Guardando A Est* (2015); *Veramente* (2014); *Preganziol, 1983* (2013); *A New Map of Italy* (2011); and *Due fotografi per il Teatro Bonci* (1983). Since 1986, Guidi has taught photography at various Italian universities, and since 2001, he has been a visiting professor at Iuav University of Venice.

**Soham Gupta** is an artist based in Calcutta, India, who works between the realms of documentary photography, art, and the written word. He responds to themes of loneliness and isolation, abuse and pain, scarred pasts and uncertain futures, sexual tensions and existential dilemmas. In 2018, Gupta was selected by the *British Journal of Photography* as one of sixteen emerging photographers to watch. In the same year, his book *Angst* (2018) was shortlisted for the Photo-Text Book Award at Les Rencontres d'Arles, France, and for the Paris Photo–Aperture Foundation First PhotoBook Award. In 2019, he participated in the Venice Biennale.

**Simon Gush** is an artist living in Johannesburg. His work examines labor, subjectivity, and land. He completed a postgraduate certificate at the Hoger Instituut voor Schone Kunsten, Ghent, Belgium; and an MA in sociology at the University of the Witwatersrand, Johannesburg. Gush's work has been exhibited at the Museo Universitario Arte Contemporáneo, Mexico City; Göteborgs Konsthall, Sweden; MAXXI, Rome; Walther Collection, Neu-Ulm, Germany; Biennale für aktuelle Fotografie, Mannheim, Germany; Dakar Biennale, Senegal; and Bamako Biennale, Mali. His films have been screened at the National Gallery of Art, Washington, DC; Institute of Contemporary Arts, and Tate Modern, London; Museum of Fine Arts, Boston; Haus der Kulturen der Welt, Berlin; Palais de Tokyo, Paris; and in a number of film festivals.

**David Guttenfelder** is a photojournalist and National Geographic Explorer focusing on geopolitical conflict, conservation, and culture. In 2011, he helped open a bureau in Pyongyang for the Associated Press, the first Western news agency to have an office in North Korea. He is an eight-time World Press Photo award-winner and a seven-time finalist for the Pulitzer Prize, as well as the recipient of several Overseas Press Club of America awards. In 2013, he received the ICP Infinity Award for photojournalism. Pictures of the Year International and the National Press Photographers Association have named him photojournalist of the year. In 2016, a photograph of his made in North Korea was named among *Time*'s "100 Most Influential Photographs Ever Taken."

**Kyoko Hamada** is a still-life and fine-art photographer based in Brooklyn. She grew up in Japan, until her father's job relocated the family to Wheeling, West Virginia, when she was fifteen years old. Hamada studied fine art and photography at Pratt Institute, Brooklyn. Her book, *I Used to Be You*, was published in 2016. She is a regular contributor to various magazines, including the *New Yorker* and *T* magazine.

**Léonie Hampton** is part of the collective Still/Moving, which aims to create social and environmental change through questioning established modes of thinking and behavior. Hampton teaches documentary photography at University of the Arts London. She won the 2009 KLM Paul Huf Award and 2008 "F" Award for concerned photography. In 2011, Hampton released her first book, *In the Shadow of Things*, which was nominated for the Deutsche Börse Photography Prize. In 2020, Royal Albert Memorial Museum and Art Gallery, Exeter, UK, commissioned Hampton to make a new body of work, *A Language of Seeds*. Hampton is currently working on two Arts Council England–funded film projects, *Islands of Women* and *Speedwell*.

**Sharon Harper** received an MFA in photography and related media from the School of Visual Arts, New York. Her work explores technology and perception. It is in permanent collections at the Museum of Modern Art, Whitney Museum of American Art, Metropolitan Museum of Art, and New York Public Library, New York; Museum of Fine Arts, Houston; Harvard Art Museums, Cambridge, Massachusetts; Nelson-Atkins Museum of Art, Kansas City, Missouri; and Portland Art Museum, Oregon, among other institutions. She is recipient of a Guggenheim Fellowship in photography, and is professor of visual art in the Department of Art, Film, and Visual Studies at Harvard University.

**Lyle Ashton Harris** has cultivated a diverse artistic practice, ranging from photography and collage to installation and performance art. His work explores intersections between the personal and the political, examining the impact of ethnicity, gender, and desire on the contemporary social and cultural dynamic. Harris is represented in the permanent collections of renowned institutions worldwide and has been widely exhibited internationally, including in *Photography's Last Century* (2020) at the Metropolitan Museum of Art, and in *Basquiat's "Defacement": The Untold Story* (2019) and *Implicit Tensions: Mapplethorpe Now* (2019) at the Guggenheim Museum, New York. His monograph *Today I Shall Judge Nothing That Occurs* was published in 2017 by Aperture.

**Cig Harvey** is an artist who uses images and language to explore sensory experiences and elevate the everyday. She is author of four monographs: *You Look at Me Like an Emergency* (2012), *Gardening at Night* (2015), *You an Orchestra You a Bomb* (2017), and *Blue Violet* (2021). Harvey's photographs and artist books are held in the permanent collections of numerous museums and institutions, including the Museum of Fine Arts, Houston; George Eastman Museum, Rochester, New York; Museum of Fine Arts, Boston; and Ogunquit Museum of American Art, Maine. In 2018, Harvey was named a Prix Virginia laureate; in 2021, she was recipient of the Maine in America Award, Farnsworth Art Museum, Rockland.

**Curran Hatleberg** received his MFA from Yale University, New Haven, Connecticut, in 2010. His work has been exhibited internationally, including recent shows at the Whitney Museum of American Art, New York; MASS MoCA, North Adams, Massachusetts; Higher Pictures Generation, Brooklyn; and Fraenkel Gallery, San Francisco. He is a recipient of numerous awards, including the Aaron Siskind Foundation Individual Photographer's Fellowship and Richard Benson Prize for excellence in photography. Hatleberg's work is held in various museum collections, including at the Whitney Museum of American Art, New York; San Francisco Museum of Modern Art; KADIST; and Yale University Art Gallery. He is the author of two monographs, *Lost Coast* (2016) and *Peanut's Dream* (2021).

**Ron Haviv** is an award-winning photojournalist, Emmy Award–nominated filmmaker, and cofounder of the photo agency VII. He is dedicated to documenting conflict and raising awareness about human rights issues around the globe. In the last three decades, Haviv has covered more than twenty-five conflicts and worked in over one hundred countries. He has published four critically acclaimed monographs, and his work is in the collections of numerous museums. Haviv's photography has had singular impact. His work in the Balkans was used as evidence to indict and convict war criminals at the international tribunal in The Hague; and President George H. W. Bush cited Haviv's photographs of paramilitary violence in Panama as one of the reasons for the 1989 American intervention.

**Rei Hayama** was born in Kanagawa, Japan, where she currently resides. Her works are developed through film, video, sound, and writings. Based on the practical experiences around natural environmental issues, her works revolve around nature and all other living things that have been lost or neglected from an anthropocentric point of view, and bring forward the invisible layers of our natural reality into the human imagination. Her first solo exhibition was held at Empty Gallery (2018–19). Recent exhibitions include *Notes for Tomorrow* by Independent Curators International (2020–25), the Busan Biennale (2020), and *Open Possibilities* (2019–20).

**S\*an D. Henry-Smith** is an artist and writer working primarily in poetry, photography, and performance, engaging Black experimentalisms and collaborative practices. They have received awards and fellowships from the Fulbright Program, and Poetry Project, Poets House, and Antenna/Paper Machine, New York. Henry-Smith has read, performed, and exhibited at Basilica Soundscape, Hudson, New York; Issue Project Room, Brooklyn; Brooklyn Museum; Studio Museum in Harlem, and elsewhere. As mouthfeel, they coauthored *Consider the Tongue* (2019), alongside Imani Elizabeth Jackson, which explores histories of aquatic labor and Black food through cooking, poetry, and ephemeral practices. Henry-Smith is also the author of two chapbooks; their first full-length collection, *Wild Peach*, was released in fall 2020.

**Corin Hewitt**'s installations, performances, sculptures, photographs, and videos investigate relationships within architecture and domestic life. He received his BA from Oberlin College, Ohio, and his MFA from Bard College, Annandale-on-Hudson, New York. He is associate professor and graduate director of sculpture and extended media at Virginia Commonwealth University, Richmond. Hewitt has held solo exhibitions at the Whitney Museum of American Art, New York; Museum of Contemporary Art Cleveland; and Atlanta Contemporary Arts Center, among other venues. He is recipient of a 2014–15 Rome Prize, 2011 Guggenheim Fellowship, and 2010 Joan Mitchell Fellowship. In 2015, Mousse Publishing released Hewitt's monograph, *Seven Performances*, featuring six years of work.

**Todd Hido** wanders endlessly, taking lengthy road trips in search of imagery that connects with his own memories. His photographs are held in many private and public collections, including the J. Paul Getty Museum, Los Angeles; San Francisco Museum of Modern Art; and Whitney Museum of American Art, and Museum of Modern Art, New York. Pier 24 Photography, San Francisco, holds the archive of all his published works. He has published more than a dozen books, including *House Hunting* (2001), *Excerpts from Silver Meadows* (2013), and *Bright Black World* (2018). His Aperture titles include *Todd Hido on Landscapes, Interiors, and the Nude* (2014) and *Intimate Distance* (2016). Hido has created a notable photobook collection over the last twenty-five years, which was featured in *Bibliostyle: How We Live at Home with Books* (2019).

**Whitney Hubbs** is a photographer who obsesses about giving it up to become a drawer or a musician, but in reality, she likes taking pictures too much. Hubbs changes her photographic mind a lot, meaning her subject matter varies because she doesn't want to get bored. Hubbs was raised and educated in California but currently lives and teaches in Western New York.

**Hyo Gyoung Jeon** lives and works in Seoul. After establishing an exhibition-making organization, Even the Neck, in Mok-dong, Seoul, in 2011, with a few local artists, she has been working as a curator, editor, writer, and translator. Jeon cotranslated *Self-organised* (2013) into Korean with Gahee Park and Eunbi Jo in 2016. She recently curated exhibitions including *One-A-Day* (2018), *Heecheon Kim: Deep in the Forking Tanks* (2019), and *Mire Lee: Carriers* (2020), and coedited Koki Tanaka's book *Reflective Notes (Recent Writings)* (2020). She is a curator at Art Sonje Center, Seoul.

**Jim Jocoy** moved to the San Francisco Bay Area as a teenager in 1968. He is mostly a self-taught photographer, who documented the first wave of punk rock in San Francisco starting in 1976. *We're Desperate: The Punk Rock Photography of Jim Jocoy* (2002) and *Order of Appearance* (2017) are his photography books of images from that period. He lives in Oakland, California.

**Ron Jude**'s photographs have been exhibited widely in places such as the J. Paul Getty Museum, Los Angeles; Museum of Contemporary Photography, Chicago; and Photographers' Gallery, London. He is the author of eleven monographs and has lectured extensively about his work. Jude was named a 2019 Guggenheim Fellow and recently released his fourth book, *12 Hz* (2020). He is currently developing a traveling exhibition of *12 Hz* with the Barry Lopez Foundation for fall of 2021. He is represented by Gallery Luisotti in Santa Monica, California, and Robert Morat Galerie, Berlin. Jude is a professor of art at the University of Oregon, Eugene.

**Nadav Kander** lives and works in London. His past projects include *Yangtze, The Long River*, winner of the Prix Pictet in 2009; *God's Country*, photographs in the US; *Dust*, an exploration of Cold War radioactive ruins; *Bodies: 6 Women, 1 Man*, photo-sculptures of the human; and Obama's People, a portrait series commissioned by the *New York Times Magazine*. His ongoing series Dark Line–The Thames Estuary is a personal reflection on the landscape of the River Thames at its point of connection with the sea through atmospheric images of its slow-moving dark waters and seemingly infinite horizons.

**Ed Kashi** is a photojournalist, filmmaker, and educator. A member of VII photo agency, Kashi is recognized for his complex imagery and compelling renderings of the human condition. He has produced nine books, and is a pioneer and innovator of multimedia. Kashi's award-winning work has been published and exhibited worldwide.

**Nina Katchadourian** is a multidisciplinary artist based in Brooklyn and Berlin. She is represented by Catharine Clark Gallery in San Francisco, and Pace Gallery in New York. Katchadourian is on the faculty of the New York University Gallatin School of Individualized Study. Stickies the cat is based in Berlin and established an online art school for children that was active through spring and summer of 2020. Although not accredited, Stickies Art School was featured in the Metropolitan Museum of Art's *Bulletin* in fall 2020.

**Rinko Kawauchi** was born in 1972 in Shiga, Japan. She released three photobooks in 2001, two of which, *Utatane* and *Hanabi*, won her the 27th Ihei Kimura Photography Award. Kawauchi is a celebrated photographer with numerous honors and awards under her belt. Her works have been exhibited internationally and gained critical acclaim. Her solo exhibitions have been hosted by venues, including Foundation Cartier pour l'art contemporain, Paris; Tokyo Photographic Art Museum; and Contemporary Art Museum Kumamoto, Japan. Kawauchi has published several books, including *Halo* (Aperture, 2017) and *as it is* (2020).

**Zeynep Kayan**'s practice focuses on exploring the repetitious structural setup of variations she creates using photography, video, and sound pieces in relation to portraiture and performance. Through experimentation and chance, she articulates a personal vocabulary of the "self" and the "human condition." Using the image itself as material, Kayan defines her works as experiments in the construction of an image through means of deconstruction, the result of her actions of going back to her own archive, (re)creating the "new" from the "old." Kayan received her MA in fine arts from the Utrecht Graduate School of Visual Art and Design, the Netherlands. She is cofounder of the independent art space Torun in Ankara, Turkey.

**Lisa Kereszi** is a photographer and educator. She has published five photobooks, including *Fun and Games* (2009) and *Joe's Junk Yard* (2012). Her work is in the collections of New York's Whitney Museum of American Art, Metropolitan Museum of Art, and Brooklyn Museum, and has appeared in the *New Yorker*, *Harper's*, and the *New York Times Magazine*. She studied at Bard College, Annandale-on-Hudson, New York, and then at the Yale School of Art, New Haven, Connecticut, where she has taught since 2004 and is currently director of undergraduate studies in art.

**Tommy Kha** received his MFA from Yale University, New Haven, Connecticut. He is a 2021 FOAM Talent; finalist for the 2021–22 Jerome Hill Artist Fellowship, Spring 2020 Hopper Prize, 2020 New York Artadia Award, and 2019 Hyères Photography Grand Prix; and a 2016 En Foco Photography Fellowship recipient. He is a former artist-in-residence at Light Work, Syracuse, New York; Camera Club of New York; and International Curatorial and Studio Program, Brooklyn. Kha likes to think he takes after his great-aunt, who "read too many books and went crazy." He is based between New York City and Memphis.

**Clifford Prince King** is an artist and photographer living and working in Los Angeles. King documents his intimate relationships in traditional and routine settings that speak to his experiences as a queer Black man. In these instances, King's work begins to morph into an offering of memory; it is how he honors and celebrates the reality of layered personhood—soft moments of refuge and uninhibited intimacy that are unapologetically honest.

**Mark Klett** is a photographer interested in the intersection of cultures, landscapes, and time. His background includes working as a geologist before turning to photography. Klett has received fellowships from the Guggenheim Foundation, National Endowment for the Arts, and Japan-US Friendship Commission. Klett's work has been exhibited and published in the United States and internationally for over thirty years, and his work is held in over eighty museum collections worldwide. He is the author/coauthor of eighteen books. Klett lives in Tempe, Arizona, where he is regents' professor of art at Arizona State University.

**Katrin Koenning** is a German photographer based in Naarm on Wurundjeri land (Melbourne, Australia). Her work has been exhibited and published widely in Australia and internationally. Koenning also teaches photo-thinking. She is represented in Australia by ReadingRoom, Melbourne.

**Paul Kooiker** lives and works in Amsterdam. He studied at the Royal Academy of Art in The Hague, and at the Rijksakademie van Beeldende Kunsten in Amsterdam. He was the winner of the Prix de Rome in 1996 and the A. Roland Holst Prize in 2009. He has held solo shows in many museums and galleries, including FOAM, Amsterdam; Gemeentemuseum, The Hague; and Museum Boijmans Van Beuningen, Rotterdam. His work has been shown in group exhibitions in numerous institutions, including the Venice Biennale; Maison Européenne de la Photographie, Paris; He Xiangning Art Museum, Shenzhen, China; Museum of Contemporary Art, Vigo, Spain; Moscow Museum of Modern Art; and Maison Rouge, Paris. He has published more than fifteen monographs of his work.

**Coralie Kraft** is a writer and visuals editor based in New York City. As photo editor at the *New Yorker*, she commissions original photography for the weekly print magazine. Her writing on photography and visual media has appeared in the *New Yorker* and *New York Times*, and on NPR.

**Anouk Kruithof** is a Dutch visual artist, whose interdisciplinary approach encompasses photography, sculpture, installation, collage, artist books, video, text, performance, and (social) interventions. She lives and works between Brussels, the Netherlands, and her wooden house in Botopasi, Suriname. She has exhibited internationally, including at the Museum of Modern Art, New York; Stedelijk Museum Amsterdam; FOAM, Amsterdam; Centro de la Imagen, Mexico City; Nederlands Fotomuseum, Rotterdam; Tate Modern, London; and Kunst Haus Wien, Vienna. Her works are included in public collections at the San Francisco Museum of Modern Art; Museum Folkwang, Essen, Germany; Stedelijk Museum Amsterdam; Fotomuseum Winterthur, Switzerland; and FOAM.

**Justine Kurland** received a BFA from the School of Visual Arts and an MFA from Yale University. Her work is in the public collections of the Whitney Museum of American Art, Guggenheim Museum, and International Center of Photography, New York, among other institutions. She has published two monographs with Aperture, *Highway Kind* (2016) and *Girl Pictures* (2020).

**Jeffrey Ladd** is an American photographer born in Elkins Park, Pennsylvania. His work has been exhibited at the Art Institute of Chicago; Oklahoma City Museum of Art; International Center of Photography, New York; and Museum of the City of New York, among others. Ladd was one of the founders of the publishing company Errata Editions. His photobook *The Awful German Language* was published in 2020.

**David La Spina** is a photographer based in Brooklyn. He completed a BFA at the Rochester Institute of Technology, and an MFA in photography at the Yale School of Art, New Haven, Connecticut. He operates the small photo agency Esto and, with Michael Vahrenwald, runs the imprint ROMAN NVMERALS. La Spina is a contributing photographer and

editor at the *New York Times* and has had solo exhibitions at Motel and Primetime in Brooklyn, and at the Architectural Foundation of Cincinnati.

**Shane Lavalette** is an American photographer and the author of four photobooks: *One Sun, One Shadow* (2016); *Still (Noon)* (2018); *LOST, Syracuse* (2019); and *New Monuments* (2019). Lavalette's photographs have been shown internationally and are included in various public and private collections. His work has been featured by the *New York Times*, *Time*, NPR, CNN, *Telegraph*, *FOAM*, among others. Lavalette is represented by Robert Morat Galerie in Berlin, and We Folk agency in London and New York.

**Dionne Lee** is a visual artist working in photography, collage, and video, exploring ideas of power and agency in relation to the American landscape. She has exhibited work at the Museum of Modern Art, Aperture Gallery, and International Center of Photography, New York; and throughout the San Francisco Bay Area, including at Aggregate Space Gallery, and Interface Gallery, Oakland, and at the San Francisco Arts Commission. Lee lives and works on the unceded territories of the Ohlone and Chochenyo peoples.

**Sean Lee** was born in 1985 and grew up in Singapore. Lee's photographs have been exhibited in a number of institutions and festivals, most notably, the Saatchi Gallery in London and the Chobi Mela photo festival in Bangladesh. Much of Lee's work can be found at the Singapore Art Museum. Lee's first book, *Shauna*, was released in September 2014. It was collected by the Museum of Modern Art Library, New York.

**Matthew Leifheit** is gay.

**Lacey Lennon** is an artist working in photography, performance, and video art. In 2018, Lennon earned an MFA from the Yale School of Art photography program, where she was awarded an H. Lee Hirsche Memorial Prize and Alice Kimball English Traveling Fellowship. Selections of her work have been featured in *Artforum* and shown in exhibitions at David Zwirner, New York, and the Museum of Contemporary Photography, Chicago. Lennon has given artist lectures at Princeton University and Pratt Institute, New York. She is an assistant professor of art at California State University, Long Beach, and lives in Mid-City, Los Angeles.

**Susan Lipper** is mostly known as a bookmaker, particularly for her trilogy comprising *Grapevine* (1994), *trip* (1999), and *Domesticated Land* (2018), which follows her female persona's thirty-year pilgrimage east to west across the United States. She lives and works in New York City, and received an MFA from Yale University, New Haven, Connecticut, in 1983, and a Guggenheim Fellowship in 2015.

**Sharon Lockhart** considers her subjects primarily through the media of film, video installation, and photography, often working on a long-term basis with communities to devise her research-based, collaborative work. Selected solo exhibitions have been hosted by the Contemporary Art Centre, Vilnius, Lithuania (2019); Fondazione Fotografia Modena, Italy (2018); Kunstmuseum Luzern, Switzerland (2015); Bonniers Konsthall, Stockholm (2014); Ujazdowski Castle Centre for Contemporary Art, Warsaw (2013); Los Angeles County Museum of Art (2012); Kunstverein, Hamburg, Germany (2008); Walker Art Center, Minneapolis (2006); and Museum of Contemporary Art Chicago (2001). Her work has been included in the biennials of Liverpool (2014), Shanghai (2014), Sydney (2006), and the Whitney, New York (2004, 2000, 1997). She was selected to represent Poland at the 57th Venice Biennale. She lives and works in Los Angeles.

**Simon Lovermann** is an artist, musician, and cultural entrepreneur. He is the founder and artistic director of the internationally renowned and awarded organization for contemporary photography Der Greif. He is also cofounder and chief security officer of Picter, a software company building visual collaboration tools. His research and practice circle around topics such as a shifting perception of authorship, recontextualization of images, appropriation, and artistic approaches to photographic archives, as well as remix and sampling as forms of art.

**Michael Mack** is founder of the London-based publishing house MACK.

**Robin Maddock** was born in England and grew up in Singapore. After studying archaeology in Wales, he received an MA in photography under Olivier Richon. In 2009, he published *Our Kids Are Going to Hell*, about drug raids in London, which includes an introduction by Iain Sinclair. *God Forgotten Face*, a book about his family hometown of Plymouth, followed in 2011. Then came *III* (2015), shot in California and starring a ping-pong ball and a pint of milk. His third book on England is overdue. The first two are included in *The Photobook: A History Volume III* by Martin Parr and Gerry Badger (2014).

**Sonia Madrigal** lives and works in Ciudad Nezahualcóyotl, Mexico. Her work explores different visual narratives to reflect, personally and collectively, on the body, violence, and territory, focusing mainly on the area east of Mexico City. She has participated in exhibitions in Mexico, Chile, Brazil, Peru, Argentina, Uruguay, France, Italy, Canada, Spain, and the United States, and has published her work in *Harper's*, *Aperture*, and the *Guardian*.

**Chris Maggio** is a photographer living in New York City with 8.4 million of his closest friends.

**Amak Mahmoodian** was born in Shiraz, Iran, and lives in Bristol, UK. Her work questions notions of identity and home, bridging a space between the personal and political. She explores the effects of exile and distance on memory, dreams, and daily life. Working with images, poems, and archives, she looks for lyrical realities framed in photographs.

**Catharine Maloney** is a photographer and art teacher. In 2014, she was chosen for *FOAM*'s Talent Issue. Her book *Teleplay, Part 1* was published in 2015.

**Mike Mandel** moved from Los Angeles to the Bay Area in 1973 to study photography at San Francisco Art Institute. In 1971, he published *Myself: Timed Exposures*, a book of humorous pictures of himself inserted into commonplace situations and environments, often with strangers. Employing deadpan, low-tech, and serial strategies, he soon became known for his conceptual photographs of subjects ranging from baseball to California car culture. During his time at San Francisco Art Institute, Mandel met fellow artist Larry Sultan, with whom he collaborated on *Evidence* (1975–77), a sequence of found photographs from government and corporate archives.

**Michael Marcelle** was born in New Jersey. He received a BA from Bard College, Annandale-on-Hudson, New York, and holds an MFA in photography from Yale University, New Haven, Connecticut. His work has been exhibited at Pioneer Works, Interstate Projects, Aperture Gallery, and Transmitter in New York, among other venues. His work has been featured in the *New Yorker*, *Vogue*, *Vice*, *W Magazine*, *Juxtapoz*, and *Fader*. His first book, *Kokomo*, was published in 2017.

**Roxana Marcoci** is senior curator of photography at the Museum of Modern Art, New York, where she has curated major exhibitions. She holds a PhD in art history, theory,

and criticism from the Institute of Fine Arts at New York University. She chairs the Central and Eastern European section of MoMA's C-MAP (Contemporary and Modern Art Perspectives in a global world) and serves as critic in the graduate program at Yale University, New Haven, Connecticut. Marcoci is a contributor to *Aperture*, *Art in America*, *Art Journal*, *Document Journal*, and *Mousse*. She coauthored *Photography at MoMA* (2017), a three-volume history of photography, and is currently preparing a Wolfgang Tillmans retrospective.

**Mark McKnight** is an artist whose work has been exhibited internationally and written about in *Interview*, the *New Yorker*, *GQ*, *Aperture*, *Art in America*, and *BOMB*, among other publications. McKnight is recipient of the 2019 Aperture Portfolio Prize, 2020 Light Work Photobook Award, and a 2020 Rema Hort Mann Foundation Emerging Artist Grant. His work is in the collections of the Henry Art Gallery, Seattle, and Los Angeles County Museum of Art. His first monograph, *Heaven Is a Prison*, was published in 2020. McKnight is an assistant professor at the University of New Mexico.

**Elisa Medde** edits, curates, and writes about photography. With a background in art history, iconology, and photographic studies, her research reflects on the relationship between image, communication, and power structures. She has been a nominator for the MACK First Book Award, Prix Elysée, Leica Oskar Barnack Award, and MAST Foundation for Photography Grant, among others. Medde has chaired numerous juries and written for *FOAM*, *Something We Africans Got*, *Vogue Italia*, *L'Uomo Vogue*, *YET* magazine, and other publications. She is editor-in-chief of *FOAM*.

**Raymond Meeks** has been recognized for his books and pictures centered on memory and place. He lives and works in the Hudson Valley, New York. His book *Halfstory Halflife* (2018) was a finalist for the Paris Photo–Aperture Foundation PhotoBook Awards. His most recent book, *Ciprian Honey Cathedral*, was published in 2020. Meeks is recipient of a 2020 Guggenheim Fellowship.

**Sarah Meister** has been at the Museum of Modern Art for twenty-five years, most recently as curator in the Department of Photography. In May 2021, she will be the new executive director of Aperture Foundation. Her recent exhibition *Fotoclubismo: Brazilian Modernist Photography and the Foto-Cine Clube Bandeirante, 1946–1964* opened at MoMA in spring 2021—it included no photos of little girls with bows in their hair. Her other recent exhibitions and publications consider the works of Luigi Ghirri, Frances Benjamin Johnston, Dorothea Lange, and Gordon Parks.

**Fabiola Menchelli** was born in Mexico City. Her work explores photography as a poetic space through the language of abstraction. She received a BFA from Victoria University, Melbourne, Australia and an MFA from Massachusetts College of Art and Design, Boston. In 2011, she received a Fulbright Fellowship; and in 2014, she received the Acquisition Prize at the 16th Biennale of Photography at Centro de la Imagen, Mexico City. She has been awarded residencies at the Skowhegan School of Painting and Sculpture, Bemis Center for Contemporary Arts, Casa Wabi, Casa NaNo, and Unlisted Projects. Menchelli is currently part of the Sistema Nacional de Creadores del Arte FONCA. She is the founder of Círculo de Crítica de Obra, a fully funded critique program for Latin American artists working with photography.

**Jeff Mermelstein**, the son of Holocaust survivors, was born in 1957 in New Brunswick, New Jersey. He moved to New York City in 1978 for a one-year internship in photography at the International Center of Photography; he has been on the faculty there since 1987. Mermelstein's photographs are part of the permanent collections of many museums and institutions, including the Whitney Museum of American Art, International Center of Photography, Museum of the City of New York, and New York Public Library; Art Institute of Chicago; Museum of Fine Arts, Houston; and George Eastman Museum, Rochester, New York. His monographs include *Sidewalk* (1999), *No Title Here* (2003), *Twirl/Run* (2009), *Arena* (2019), *Hardened* (2019), and *#nyc* (2020).

**Joel Meyerowitz** is an award-winning photographer whose work has appeared in over 350 exhibitions in museums and galleries around the world. He is a two-time Guggenheim Fellow, a recipient of both National Endowment for the Arts and National Endowment for the Humanities awards, and a recipient of the Deutscher Fotobuchpreis. He has published over thirty books, including Aperture titles *Legacy* (2009), *Cape Light* (2015), *Seeing Things* (2016), and *Provincetown* (2019). He lives in Italy.

**Duane Michals** is a New York–based photographer known for his work with series, multiple exposures, and text. He made his first significant creative strides in the field of photography in the 1960s. Over the past five decades, Michals's work has been exhibited at venues, including the Museum of Modern Art, Morgan Library and Museum, and International Center of Photography, New York; Odakyu Museum, Tokyo; Thessaloniki Museum of Photography, Greece; and Scavi Scaligeri, Verona, Italy. Michals has won a number of awards, including a CAPS grant, National Endowment for the Arts fellowship, ICP Infinity Award, PHotoEspaña international award, and an honorary doctorate of fine arts from Montserrat College of Art, Beverly, Massachusetts. Michals's work belongs to numerous permanent museum collections worldwide, and he has published a dozen books.

**Darin Mickey** is a photographer and musician based in New York City. His work has been exhibited in both solo and group exhibitions in New York, Detroit, Cleveland, Seattle, Atlanta, Copenhagen, Sydney, and Tokyo. He is the author of *Death Takes a Holiday* (2016) and *Stuff I Gotta Remember Not to Forget* (2007). His images have appeared in the *New York Times Magazine*, the *New Yorker*, *Vice*, the *Washington Post Magazine*, *Aperture*, *FOAM*, and *DoubleTake*, among others. He is chair of the creative practices program at the International Center of Photography.

**Cristina de Middel** is a Spanish photographer whose work investigates photography's ambiguous relationship to truth. Blending documentary and conceptual photographic practices, she plays with reconstructions and archetypes that blur the border between reality and fiction. After a ten-year career as a photojournalist and humanitarian photographer, de Middel produced the critically acclaimed series *The Afronauts* in 2012, exploring the history of a failed space program in Zambia in the 1960s through staged reenactments of obscure narratives. De Middel has published more than a dozen books, exhibited extensively internationally, and received numerous awards—including a 2013 ICP Infinity Award, 2017 Spanish National Award in Photography, and 2020 Leica Oskar Barnak Award. De Middel is an associate member of Magnum Photos; she lives and works between Mexico and Brazil.

**Rafal Milach** is a photographer, visual activist, author, and professor at the Krzysztof Kieślowski Film School in Katowice, Poland. His work focuses on topics related to the former Eastern Bloc, including the clash between nonheroic gestures and ostensibly neutral spaces, set against a political background of current events. The oppressive nature of the areas Milach investigates is reflected in architecture, objects, and social structures.

**Karen Miranda-Rivadeneira** grew up along the shores and mountains of Ecuador. Her work focuses on memory,

**309**

geopoetics, and storytelling through collaborative processes and personal narratives. Intersectional theories and earth-based healing also inform her practice. Her work has been exhibited widely, including at the National Portrait Gallery, Washington, DC, and the Queens Museum, New York. She has participated in the Musée du Quai Branly biennial and was awarded their photography residency fellowship in 2017. She is a master mentor in the Women Photograph mentorship program; recipient of the We, Women photo award; and artist-in-residence at BRIClab, Brooklyn.

**Richard Misrach** is a photographer whose work is held in the collections of over fifty major institutions, including the Museum of Modern Art, Whitney Museum of American Art, and Metropolitan Museum of Art, New York; and the National Gallery of Art, Washington, DC. He is the recipient of numerous awards, including a Guggenheim Fellowship. His numerous books include the Aperture titles *Destroy This Memory* (2010), *Golden Gate* (2012), *Petrochemical America* (with Kate Orff, 2012), *The Mysterious Opacity of Other Beings* (2015), *Border Cantos* (with Guillermo Galindo, 2016), and *Richard Misrach on Landscape and Meaning* (2021).

**Paul Moakley** is editor at large for special projects at *Time*. He covers national news and issues such as Person of the Year, and produced the *Opioid Diaries*. Previously, he was senior photo editor at *Newsweek* and photo editor of *PDN* (*Photo District News*). He lives at the Alice Austen House on Staten Island, New York, as caretaker and curator of the museum.

**Andrea Modica**'s photographs have been exhibited internationally, and her work is in many prominent collections, including the Museum of Modern Art; Metropolitan Museum of Art; and Whitney Museum of American Art, New York. She holds an MFA from Yale University, and is a Guggenheim Fellow and Fulbright Scholar. Her work has been featured in many publications, including the *New York Times Magazine*, the *New Yorker*, and *Vanity Fair*. Her twelve monographs, including *January 1* (2018) and *Treadwell* (1996), have been met with critical acclaim. Modica teaches at Drexel University in Philadelphia.

**Bruno Morais** is a Brazilian photographer and founder of the Colectivo Pandilla. He began his career in photography documenting folkloric festivals in Brazil as he was finishing a degree in physical education at Universidade Federal do Rio de Janeiro. He received his training as a photography teacher at the Escola de Fotógrafos Populares and joined the agency Imagens do Povo in 2010. His work focuses on exploring the multiple possibilities that an image presents in storytelling through both individual and collaborative practices. His work has been exhibited at Galeria 535 at the Observatório de Favelas in Maré, as well as at international festivals, including FotoRio, Paraty em Foco, LagosPhoto, and Encontros da Imagem. He lives and works between Brazil and Mexico.

**Stefanie Moshammer** is a lens-based artist from Vienna. She is the author of *Vegas and She* (2014), *Land of Black Milk* (2017), and *Not just your face honey* (2018). Her work has been exhibited internationally, at FOAM, Amsterdam; Red Hook Labs, Brooklyn; C/O Berlin; Museum of Applied Arts, Vienna; Photo London at Somerset House; and Fotografiska New York. Her work has been published in *i-D*, *Wallpaper*, *Dazed*, *Vogue*, *Zeit Magazin*, *New York* magazine, *Purple*, and elsewhere.

**Nicholas Muellner** is a Los Angeles–based artist and writer, and founding codirector of the Image Text MFA and Press at Ithaca College, New York. His books include *Lacuna Park: Essays and Other Adventures in Photography* (2019), *In Most Tides an Island* (2017), and *The Amnesia Pavilions* (2011). His

work has been widely published, exhibited, and recognized by Guggenheim, MacDowell, and Yaddo Fellowships.

**Rory Mulligan** holds an MFA in photography from Yale University, New Haven, Connecticut, and is visiting assistant professor of art at Drew University, Madison, New Jersey. Mulligan's work has been exhibited internationally and is included in the permanent collections of the Philadelphia Museum of Art, and Light Work, Syracuse, New York. Mulligan's work has been published by J&L Books, *Blind Spot*, *MATTE*, *Soft Copy*, and the *New York Times Magazine*, among many others. He has lectured at Sarah Lawrence College, Bronxville, New York; Yale University; Princeton University; School of the Art Institute of Chicago; and International Center of Photography, New York, among other institutions.

In his prolific, seventy-year career, **Bruno Munari** became known for various contributions to art, industrial design, film, architecture, art theory, and technology—including an early model of the portable slide-projector. He liked to (falsely) claim that his name meant "to make something out of nothing" in Japanese. Munari's principles and beliefs were built upon his early involvement in the Futurist movement, which he joined at the age of nineteen using the pseudonym "Bum." During the 1930s, Munari began to move toward Constructivism, particularly with his kinetic sculptures—*Useless Machines* (begun 1933)—meant to transform or complicate their surrounding environments. After World War II, Munari also developed radical innovation in graphics, typography, and book publishing. He died in Milan in 1998.

**Ricardo Nagaoka** is a Japanese Latino artist, born and raised in Paraguay and a grandson of Japanese immigrants. He emigrated to Canada with his family and eventually landed in the United States to study at the Rhode Island School of Design. Growing up in between, Nagaoka pushes to question our positions in society and how we see others. His work explores our collective constructs of home, history, and selfhood. His work has been published by the *New York Times*, *Le Monde*, and the *British Journal of Photography*, and has been shown nationally. He lives and works in Portland, Oregon.

**Laurel Nakadate** is a photographer, filmmaker, and video artist. Her first feature film, *Stay the Same and Never Change* (2009), premiered at the Sundance Film Festival and went on to be featured in New Directors/New Films festival. Her second film, *The Wolf Knife* (2010), premiered at the Los Angeles Film Festival, and was nominated for a Gotham Independent Film Award and an Independent Spirit Award. Her ten-year survey show, *Only the Lonely*, premiered at MoMA PS1 in 2011. Her work is in many collections, including at the Museum of Modern Art, New York; Whitney Museum of American Art, New York; Yale University Art Gallery, New Haven, Connecticut; and the Saatchi Collection, London.

**Sinna Nasseri** is a photographer from California. After attending law school in New York City, he worked as an attorney in Midtown Manhattan for several years, before deciding to devote himself entirely to photography. Nasseri spent 2020 traveling around the United States, photographing political gatherings and regular life in the shadow of the presidential election. His work has been published by *Time*, the *New York Times*, *Vogue*, the *New Yorker*, *BuzzFeed News*, and *L'Obs*.

**Jason Nocito** is a photographer who lives and works in New York City.

**Michael Northrup** began a lifelong commitment to photography in 1970, when Jack Welpott and Judy Dater took him

on as an apprentice. They introduced him to Frederick Sommer, Minor White, Cherie Hiser, and Barbara Crane, all of whom he proceeded to study and work with. All this before his MFA at the School of the Art Institute of Chicago! This rich experience has, for some reason, led him to a great appreciation of "the ironic"—that tension between humor and tragedy. He thinks of his images as "serious humor."

**Musa N. Nxumalo** was born in 1986 in Soweto, Johannesburg, South Africa. Since his introduction to photography at the Market Photo Workshop, Johannesburg, alongside Sabelo Mlangeni and Thabiso Sekgala, Nxumalo has been documenting life as he knows and discovers it. His work focuses on alternative youth culture within the Black communities of South Africa, specifically lived experiences and how alternative culture is weaponized as an attitude that helps people to lead their preferred lives. His ongoing project The Anthology of Youth encapsulates photographs, personal notes, and articles compiled through exhibition texts, such as reviews and critical feedback.

**Olu Oguibe** is an artist and art historian. He's published several books on the history and politics of images, including *The Culture Game* (2004).

**Coco Olakunle** is an autodidact Dutch Nigerian photographer based in Amsterdam. She celebrates the beauty and diversity of young people in subcultures around the globe. For Olakunle, the camera is a way to engage humanity and peacefully open the doors of inclusivity and full-spectrum representation. Her work is people-focused and challenges people to rethink their own social frameworks. With her background in human geography, she explores the blurred lines between fashion and documentary photography. Her current focus is Black hair and the place it has when it comes to representation, storytelling, and shared experiences.

**Eva O'Leary** received her BFA from California College of the Arts in 2012, and her MFA from the Yale School of Art in 2016. She was recipient of the Outset I Unseen Exhibition Fund in 2019, Hyères Photography Grand Prix in 2018, and Vontobel Contemporary Photography Prize in 2017; and was named a FOAM Talent in 2014. Her work has been exhibited internationally, including at the CAFA Art Museum, Beijing; FOAM, Amsterdam; Villa Noailles, Hyères, France; Atelier Néerlandais, Paris; and Hesse Flatow, New York. Her work has been featured in various publications, including *Artforum*, *1000 Words*, and the *New Yorker*.

**Taiyo Onorato** and **Nico Krebs** studied photography at the Zurich University of the Arts. They have worked together since 2003. They have participated in numerous solo and group exhibitions throughout Europe and the United States, and published several books, among them *The Great Unreal* (2009); *As Long as It Photographs, It Must Be a Camera* (2011); *Light of Other Days* (2013); and *Continental Drift* (2017).

**Erin O'Toole** is the Baker Street Foundation Associate Curator of Photography at the San Francisco Museum of Modern Art, where she has worked since 2007. Recent exhibitions she has organized include *Off the Wall: Liz Deschenes, Oliver Chanarin, Sarah Sze, Dayanita Singh and Lieko Shiga* (2021); *Thought Pieces: 1970s Photographs of Lew Thomas, Donna-Lee Phillips, and Hal Fischer* (2020); *April Dawn Alison* (2019); *New Work: Erin Shirreff* (2019); and *Anthony Hernandez* (2016). She is editor of *Thought Pieces: 1970s Photographs of Lew Thomas, Donna-Lee Phillips, and Hal Fischer* (2020); *April Dawn Alison* (2019); and *Anthony Hernandez* (2016); as well as a contributing author to *The Photographic Object, 1970* (2016); *Janet Delaney: South of Market* (2013); and *Garry Winogrand* (2013); among other titles.

**Arthur Ou** is an artist and writer based in New York City. He is an associate professor of photography in the School of Art, Media, and Technology at Parsons School of Design at The New School. His work has been featured in publications, including the *New York Times*, *Aperture*, *Blind Spot*, *Art on Paper*, and *Art in America*, and in the book *The Photograph as Contemporary Art* (2004). His writing has been published in Afterall.org, *Aperture*, *Bidoun*, *Fantom*, *FOAM*, *Words Without Pictures*, and *X-Tra*.

**Ed Panar** is a photographer and bookmaker who has published several photobooks, including *In the Vicinity* (2018), *Animals That Saw Me: Volume One* (2011) and *Volume Two* (2016), *Salad Days* (2012), *Same Difference* (2010), and *Golden Palms* (2007). His photographs and books have been exhibited at venues, including the Museum of Contemporary Photography, Chicago; Cleveland Museum of Art; and Pier 24 Photography, San Francisco. Panar is cofounder of the project space and bookshop Spaces Corners, and currently lives and works in Pittsburgh.

**Tod Papageorge** began to photograph in 1962. In the 1970s, he received two Guggenheim Fellowships and National Endowment for the Arts Fellowship Grants and, in 1979, was named Walker Evans Professor of Photography at the Yale School of Art, where until his retirement in 2013, he also held the position of director of graduate studies in photography. In 2009, Papageorge was a resident at the American Academy in Rome and in 2012, was awarded the Lucie Award for documentary photography. Aperture published his monograph *American Sports, 1970* in 2008 and *Core Curriculum*, a collection of his writings on photography, in 2011.

**Ahndraya Parlato** was born in Kailua, Hawaii. She has a BA in photography from Bard College and an MFA from California College of the Arts. Her forthcoming book, *Who Is Changed and Who Is Dead*, will be released in June 2021. Her first monograph, *A Spectacle and Nothing Strange* was published in 2016, and her collaboration with Gregory Halpern, *East of the Sun, West of the Moon*, was published in 2014.

**Emily Patten** is a Brooklyn-based photographer and publishing assistant for Aperture's book program. She received her BFA from Rochester Institute of Technology, New York, in 2019. As a queer, Korean American adoptee, she seeks to investigate, make space for, and celebrate those at the intersection of unique and complex identities.

**Jessica Pettway** loves to play with color, shapes, and texture in highly gratifying ways, composing vibrant still lifes that burst with emotion and a sense of occasion, even when promoting something as everyday as a beverage. *Looney Tunes* and *Tom and Jerry* are major influences in her work. She loves the sense of humor and the way they idealize food, highlighting the appeal of a wedge of cheese with nothing more than color and the use of line. Pettway received a BFA in photography and video from the School of Visual Arts, and her clients range from Apple, McCann New York, and Uber to *Wired*, *Bloomberg Businessweek*, and Refinery29.

**Sasha Phyars-Burgess.** Scorpio. Black. Alive.

**John Pilson** is a photographer living and working in Brooklyn. He is currently a senior critic at the Yale School of Art's MFA in photography program, where he has taught since 2001.

**Max Pinckers** is an artist based in Brussels. His work explores the critical, technological, and ideological structures that surround the production and consumption of documentary images. For Pinckers, documentary photography involves more than the representation of an external reality; it is a speculative

process that approaches reality and truth as plural, malleable notions open to articulation in different ways. His installations and books are exhibited internationally, and he has received an Edward Steichen Award Luxembourg and Leica Oskar Barnack Award, among others. Pinckers is cofounder of the independent publishing house Lyre Press and the School of Speculative Documentary. He is currently a doctoral researcher and lecturer in the arts at the Royal Academy of Fine Arts, Ghent, Belgium.

**Bettina Pittaluga** I'm a French Uruguayan photographer, living in Paris. I like to think that I photograph beauty. I find beauty in authenticity: of an emotion, an instant, the other, what is most real. I studied sociology and also worked as a reporter. It is therefore second nature for me to compose with what is already present and existent. I am focused on giving a voice and visibility to those who are not or too little represented. It is very important to me to do everything to deconstruct this hegemony; I am committed to invoking all these fights until they are won.

**Mimi Plumb** was born and raised in the San Francisco Bay Area, and received her MFA in photography from San Francisco Art Institute in 1986. Plumb's first book, *Landfall* (2018), is a collection of her images from the 1980s, a dreamlike vision of American dystopia encapsulating the anxieties of a world spinning out of balance. Her second book, *The White Sky* (2020), is a memoir of her childhood growing up in suburbia. Plumb's photographs are in numerous museum collections, including at the San Francisco Museum of Modern Art; Los Angeles County Museum of Art; Pier 24 Photography, San Francisco; and the Museum of Fine Arts, Boston.

**Julie Poly** was born in Stakhanov, Ukraine, and is now based in Kiev. Inspired by Boris Mikhailov's projects and her education at Kharkiv School of Photography, she took her first pictures at the Kinnyi market in Kharkiv. Today, Poly is known internationally as a fashion photographer. Her practice merges her previous experiences in documentary and staged photography. She interprets cultural and visual codes typical of Ukrainian everyday life, focusing on eroticism, fashion, and beauty. Her work is inspired by trivial things, everyday events, stories from the lives of her friends, and her own experiences.

**Gus Powell** attended Oberlin College, where he majored in comparative religion. He is the author of *The Company of Strangers* (2003), *The Lonely Ones* (2015), *Family Car Trouble* (2019), and *Brooklyn Brief* (2019). Powell's photographs have been exhibited at the Art Institute of Chicago; Museum of Fine Arts, Houston; Museum of the City of New York; and FOAM, Amsterdam. He resides in Brooklyn and teaches in the graduate program at the School of Visual Arts, New York.

**Sean Pressley** is an American photographer from Charleston, South Carolina, living and working in Brooklyn. He often uses portraiture to chronicle his community, as well as staged recreations of scenes from memory or imagination to explore intricacies and complex honesties in seemingly everyday moments, emotions, and routines.

Raised in Fort Collins, Colorado, **Hannah Price** is a photographic artist and filmmaker primarily interested in documenting relationships, race politics, perception, and misperception. Price is known for her project *City of Brotherly Love* (2009–12), a series of photographs of men who catcalled her on the streets of Philadelphia. In 2014, Price graduated from the Yale School of Art MFA in photography program and received a Richard Benson Prize for excellence in photography. Price's photos have been exhibited across the United States, and they are part of the permanent collection of the Philadelphia Museum of Art. Price became a Magnum Photos nominee in the summer of 2020. Price lives and works in Philadelphia.

**Daniel Ramos** is an American photographer and artist. Early on in his career, he decided that the people in his life— family, friends, coworkers—would be the subjects of his work. He uses photography as a vehicle to amplify their presence in the world, and recently began moving beyond the single-image convention of picture-making. In March 2020, Ramos completed the International Artist-in-Residence program at Artpace San Antonio, Texas, and he won the Dorothea Lange–Paul Taylor Prize in 2018. Ramos will be an artist-in-residence at Light Work, Syracuse, New York, in June 2021, and is currently at the International Studio and Curatorial Program for the 2020–21 Pollock-Krasner Residency in Brooklyn.

**Laurence Rasti** was born in Switzerland to Iranian parents. The duality of her background leads her to questions both Swiss and Iranian cultural conventions. Her photographs explore themes of identity, gender, and codes of beauty. She received a BA in photography from École cantonale d'art de Lausanne, and holds an MFA from Geneva School of Art and Design. Her book, *There Are No Homosexuals in Iran* (2017), was shortlisted for the Paris Photo–Aperture Foundation PhotoBook Awards and the Author Book Award at Les Rencontres d'Arles, France, as well as listed as one of the best photobooks of 2017 by the *New York Times Magazine*. Her work has been exhibited internationally, including at the Museum of Contemporary Art Chicago; Fotohof, Salzburg, Austria; and Musée de l'Elysée, Lausanne, Switzerland. She lives and works in Geneva.

**Peter Rauch** is a photographer, architect, and lecturer. In his creative practice, he dissects the matter of various buildings and insists on the opposition between a document and construction of an artwork. In his theoretical practice, he deals with the origin of thought, the role of negation in the constitution of an object, and the issue of rupture in the fields of art, science, and politics. He is an assistant professor at the Academy of Fine Arts and Design and in the Photography Department at the Higher School of Applied Sciences in Ljubljana, Slovenia. He coruns the production space Kela in Ljubljana.

**Priyadarshini Ravichandran**'s earliest photographs were of her mother and their dog playing hide-and-seek. In that sequence of photos, her mother unintentionally doubled as the one hiding and also the one closing their dog's eyes with her palms. Nothing felt out of place. In this distortion that photography welcomed, Ravichandran discovered a continuously elastic relationship with the medium.

**Will Rogan** lives and works in West Brookfield, Vermont. As an artist, he identifies as a sculptor and is highly attached to materials, process, magic, and time. Solo exhibitions have been hosted by Altman Siegel Gallery, San Francisco; the Berkeley Art Museum and Pacific Film Archive; San Francisco Museum of Modern Art, in conjunction with the SECA Art Award; Objectif Exhibitions, Antwerp, Belgium; and Misako & Rosen, Tokyo. He cofounded *The Thing Quarterly* with artist Jonn Herschend in 2007, and was an artist-in-residence at Headlands Center for the Arts in 2017. His work has appeared in *Artforum*, *Flash Art*, *Frieze*, *Art in America*, KQED/PBS, *Aperture*, and the *San Francisco Chronicle*, among numerous other media outlets.

**Bobby Rogers** creates work that seamlessly blends his passions for design and ethnography with his long-standing commitment to intellectual rigor and cultural exploration. His work ranges from photography to designed visual eco-systems, which incorporate themes of radical presence, history, and philosophy in order to tell subtle stories of beauty amid precarity. Rogers is the cofounder and executive director of The Bureau, an interdisciplinary art and media studio that produces critical dialogue through robust artistic production.

**Irina Rozovsky** published her third book, *In Plain Air*, in 2021. Her work has been exhibited at the Metropolitan Museum of Art and Museum of Modern Art, New York; and Louisiana Museum of Modern Art, Denmark, among other international venues. She lives in Athens, Georgia, where she and her husband, Mark Steinmetz, run the photography space The Humid. She is currently an MFA thesis advisor for the photography program at the University of Hartford.

**Sasha Rudensky** is a Russian-born photographer whose work has been exhibited widely in the US, Europe, and Asia. Her debut solo show, *Tinsel and Blue*, was exhibited at Sasha Wolf Projects in New York City in 2016. Her work is held in a number of public collections, including at Musée de l'Elysée, Lausanne, Switzerland; the Yale University Art Gallery, New Haven, Connecticut; and Center for Creative Photography, Tucson, Arizona. Rudensky received her MFA from Yale School of Art, and BA from Wesleyan University. Her work has appeared in *Aperture*, *Artforum*, the *New York Times Magazine*, the *Guardian*, *Der Spiegel*, *Times* (UK), and other publications. She is an associate professor of art at Wesleyan University, where she is the head of the photography program, and is represented by Sasha Wolf Projects in New York City.

**Moises Saman** was born in Lima, Peru, into a mixed Spanish and Peruvian family, and grew up in Barcelona. Saman worked as a staff photographer at *Newsday* from 2000 to 2007, where he focused on the fallout of the 9/11 attacks, spending most of his time traveling between Afghanistan, Iraq, and other Middle Eastern countries. Saman has also worked as a regular contributor for the *New York Times*, Human Rights Watch, *Newsweek*, and *Time*, among other international publications. He became a full member of Magnum Photos in 2014. In 2015, he received a Guggenheim Fellowship for his work covering the Arab Spring, culminating in the publication *Discordia* (2016). Saman and his family live in Amman, Jordan.

**Alessandra Sanguinetti** was born in New York and is based in San Francisco and Buenos Aires. She has been a recipient of numerous fellowships and awards, including a Guggenheim Fellowship, Hasselblad Foundation Award, Sundance development grant, Robert Gardner Fellowship in Photography, and Rencontres d'Arles Discovery Award. Her photographs are in various public and private collections, such as the Museum of Modern Art, New York; San Francisco Museum of Modern Art; Museum of Fine Arts, Houston; and Museum of Fine Arts, Boston. Her monographs are *On the Sixth Day* (2005), *The Adventures of Guille and Belinda I* (2010) and *II* (2020), *Le Gendarme sur la Colline* (Aperture, 2017), and *Sorry, Welcome* (2013). She is a member of Magnum Photos.

**Luc Sante** teaches writing and the history of photography at Bard College, Annandale-on-Hudson, New York. His books include *Low Life* (2003), *Evidence* (2006), *Kill All Your Darlings* (2007), *Folk Photography* (2010), and *Maybe the People Would Be the Times* (2020).

Born north of Milan, **Marianna Sanvito** showed a strong passion for the arts in general, and for cinema and painting in particular, from an early age. After graduating from the Academy of Fine Arts, she worked as an art director for many years, before turning to photography. She loves to portray the elegance of mature women, and in her photographs, the strength and depth of the subject's gaze contrasts with the silence and solemnity of the composition. She is constantly searching for balance between opposites, as summed up in a quote by Giovanni Fava about the writer's birthplace: "It must be said that everything that was done in this town had to be done twice and often one against the other, as if there were two souls."

Photographer **Simone Sapienza** graduated with a BA with honors in documentary photography from the University of South Wales, Newport, in 2016. His first photobook, *Charlie Surfs on Lotus Flowers*, was published in 2018. His works have been displayed in festivals and galleries all over the world, and his photographs have been featured in international magazines. In 2015, he cofounded the Gazebook: Sicily Photobook Festival. In 2018, he was an art mediator for Manifesta 12; and since 2019, he has been working for the photography school Spazio Labo' in Bologna. He was a selected artist for FOAM Talent 2020. Sapienza is based in Palermo, where he lives with his three-year-old daughter Marlene.

**Lise Sarfati** is a French photographer and artist. She is known for her photographs of elusive characters, often young, who resist being confined by definitions. Her work is held in major public and private collections, including the Centre Pompidou, Paris; Los Angeles County Museum of Art; San Francisco Museum of Modern Art; Brooklyn Museum; and Philadelphia Museum of Art. Sarfati has been awarded the Prix Niépce (1996) and ICP Infinity Award (1996). Between 1996 and 2011, she was a member of Magnum Photos. She is currently represented by Rose Gallery in Los Angeles.

**Keisha Scarville** is a lens-based and mixed-media artist based in Brooklyn. Her work has been exhibited internationally, including at the Studio Museum in Harlem; Institute of Contemporary Art, Philadelphia; Light Work Museum; Light Work, Syracuse, New York; and Baxter St at the Camera Club of New York. She has participated in artist residencies at the Vermont Studio Center, Light Work, Lower Manhattan Cultural Council Workspace, Stoneleaf Retreat, BRICworkspace, and Skowhegan School of Painting and Sculpture. In addition, her work has appeared in *Vice*, *Small Axe Project*, *Oxford American*, *Hyperallergic*, and the *New York Times*, where her work has also received critical review. She is currently an adjunct faculty member at the International Center of Photography, and Parsons School of Design at The New School, New York.

**Michael Schmelling** is the author of eight photobooks, including *The Plan* (2009), *Atlanta: Hip Hop and the South* (2010), *My Blank Pages* (2015), and *Your Blues* (2018). Schmelling's work from *The Plan* was included in the 2013 International Center of Photography Triennial, *A Different Kind of Order*; his first one-person museum exhibition, *Your Blues*—a commission for the Museum of Contemporary Photography, Chicago—was presented in 2014.

**Kathrin Schönegg** is a writer, editor, and curator of photography at C/O Berlin.

**Aaron Schuman** is a photographer, writer, educator, and curator. He is the author of two monographs, *Slant* (2019) and *Folk* (2016), and has contributed essays and texts to *Aperture Conversations: 1985 to the Present* (Aperture, 2018), *Another Kind of Life: Photography on the Margins* (2018), and *The Photographer's Playbook* (Aperture, 2014), among others. He writes for *Aperture*, *FOAM*, *Frieze*, *Time*, the *British Journal of Photography*, *Hotshoe*, and *Photoworks*; was guest curator for JaipurPhoto 2018, Krakow Photomonth 2014, and FotoFest 2010; and has curated exhibitions for Fotomuseum Antwerp, Houston Center for Photography, the Royal Photographic Society, and elsewhere. Schuman was founding editor of *SeeSaw Magazine* (2004–14), and is founder and program leader of the master in photography program at the University of the West of England, Bristol.

**Bryan Schutmaat** is a photographer based in Austin, Texas, whose work has been widely exhibited and published. He has won numerous awards, including a Guggenheim Fellowship, Aperture Portfolio Prize, and Aaron Siskind Foundation fellowship. Schutmaat's prints are held in many collections, such as those of the Baltimore Museum of Art; Museum of Fine Arts, Boston; Pier 24 Photography, San Francisco; and San Francisco Museum of Modern Art.

**Mark Sealy** is director of Autograph ABP. He has initiated the production of many publications, exhibitions, and residency projects. He has commissioned photographers and filmmakers worldwide, including the critically acclaimed film-work *The Unfinished Conversation* (2012) by John Akomfrah. In 2002, Sealy was part of a team that jointly initiated and developed an £8 million capital building project, Rivington Place, London, which opened in 2007.

**Nigel Shafran** is a British photographer, born in London in 1964, who divides his work into self-motivated projects, commercial commissions, and teaching. Publications include *RuthBook* (1995), *Dad's Office* (1999), *Edited Photographs 1992–2004* (2004), *Flowers for ___* (2008), *Ruth on the Phone* (2012), *Teenage Precinct Shoppers* (2013), *Dark Rooms* (2016), and *The People on the Street* (2018). His work has been shown at Tate Britain, the Victoria and Albert Museum, Photographers' Gallery, and National Portrait Gallery, London; Taka Ishii Gallery, Tokyo; Galeria de Arte do Sesi, São Paulo; Museum für Moderne Kunst, Frankfurt; and Beyond Bridges, Berlin, among other venues.

**Hashem Shakeri** is an artist, photographer, and filmmaker based in Tehran. Through his work, he pursues a psychological investigation of human relationships in the contemporary world. He captures the restlessness, perplexity, and social struggle of the modern capitalist world, in order to record the optical unconsciousness of society and provide a universal narrative formed with personal insight. His work has been exhibited internationally, including at the International Center of Photography, New York; MAXXI, Rome; Arp Museum, Remagen, Germany; FOAM, Amsterdam; and Les Rencontres d'Arles, France. His work has been featured in numerous publications, including the *New Yorker*, *Aperture*, *British Journal of Photography*, *New York Times*, *National Geographic*, and *Le Monde*.

**Abdo Shanan** was born in Oran, Algeria, to a Sudanese father and an Algerian mother. Shanan studied telecommunications engineering at the University of Sirte, Libya, until 2006. In 2012, he undertook an internship at Magnum Photos Paris. In 2015, he cofounded collective220, a collective for Algerian photographers. Shanan won the Contemporary African Photography Prize for his project Dry in 2019—the same year he was selected for the Joop Swart Masterclass by World Press Photo. In 2020, he was recipient of a Premi Mediterrani Albert Camus Incipiens. In the same year, he cocurated the exhibition *Narratives from Algeria* at Photoforum Pasquart in Switzerland.

**Shikeith** is a Pittsburgh-based artist working in installation, sculpture, photography, and film. His work investigates the psychological landscape of Black manhood across space and time.

**Pacifico Silano** is a lens-based artist whose work explores print culture, the circulation of imagery, and LGBTQ identity. Born in Brooklyn, he received his MFA in photography from the School of Visual Arts, New York. His work has been exhibited internationally, including group shows at the Bronx Museum; Tacoma Art Museum; and Oude Kerk, Amsterdam; and solo shows at ClampArt, and Baxter St at the Camera Club of New York. His work is in the permanent collection of the Museum of Modern Art, New York, and his awards include an Aaron Siskind Foundation fellowship, and a New York Foundation for the Arts Fellowship in Photography. In 2013, he was a finalist for the Aperture Portfolio Prize.

**Taryn Simon** is an American multidisciplinary artist who works in photography, text, sculpture, and performance.

**Danna Singer** is a photographer and educator. She received her MFA from the Yale School of Art, and a BFA from Pratt Institute, Brooklyn. Singer's work focuses on the social ramifications of economic inequality. In 2020, she was named a Guggenheim Fellow; and in 2018, she was awarded a residency fellowship at Yaddo and named one of *PDN*'s 30 New and Emerging Photographers to Watch. Her photographs were selected for the Best *New Yorker* Photography of 2019, and the *New York Times* Year in Pictures 2019, and have been featured in numerous publications. Singer is a lecturer at the Yale School of Art.

**Mike Slack** lives and works in Los Angeles. He is a cofounder of The Ice Plant, and his books include *OK OK OK* (2002), *Shrubs of Death* (2014), and *The Transverse Path* (2017).

**Rafael Soldi** is a Peruvian-born, Seattle-based visual artist. His practice centers on how queerness and masculinity intersect with larger topics of our time, such as immigration, memory, and loss. His work has been exhibited, collected, and reviewed internationally. He was a 2019 recipient of the Bogliasco Foundation Fellowship. His first monograph, *Imagined Futures*, was published in 2020. He is cofounder of the Strange Fire Collective.

**Alec Soth** is a photographer born and based in Minneapolis. He has published over twenty-five books, including *Sleeping by the Mississippi* (2004), *NIAGARA* (2006), *Broken Manual* (2010), *Songbook* (2015), and *I Know How Furiously Your Heart Is Beating* (2019). Soth has had over fifty solo exhibitions, including survey shows organized by Jeu de Paume, Paris (2008), Walker Art Center, Minnesota (2010), and Media Space, London (2015). Soth has been the recipient of numerous fellowships and awards, including a Guggenheim Fellowship in 2013. In 2008, Soth created Little Brown Mushroom, a multimedia enterprise focused on visual storytelling. He is represented by Sean Kelly in New York, Weinstein Hammons Gallery in Minneapolis, Fraenkel Gallery in San Francisco, and Loock Galerie in Berlin, and is a member of Magnum Photos.

**Jem Southam** was born in Bristol, England. He studied photography at the London College of Printing and has since lived in southwest England, where he makes most of his work and has taught for over thirty years. His published books include *The Red River* (1989); *The Raft of Carrots* (1992); *Rockfalls, Rivermouths, Ponds* (1999); *Landscape Stories* (2005); *The River Winter* (2012); and *The Moth* (2018).

**Mark Steinmetz** is a photographer who resides in Athens, Georgia. He has published numerous books, including *Greater Atlanta* (2009), *Summertime* (2011), *Paris in My Time* (2013), *Philip and Micheline* (2013), and most recently, *Berlin Pictures* (2020). His work is in the collections of the Museum of Modern Art, Whitney Museum of American Art, and Metropolitan Museum of Art, New York; Art Institute of Chicago; San Francisco Museum of Modern Art, and others. He has taught photography at Harvard University, Yale University, Sarah Lawrence College, Emory University, and the University of Hartford. Steinmetz is recipient of a Guggenheim Fellowship and codirector of The Humid with his wife, Irina Rozovsky.

**Clare Strand** is a British artist working with and against the photographic medium.

314

**Karthik Subramanian** lives and works between the real and the imagined. As a child, Subramanian traveled frequently from his life in the city to his grandparents' in the village, learning to see the world as it moved through the window of a bus or a train. Several years later, when he traveled to photograph the place where the river Ganga joins the Bay of Bengal, the scenes of the shifting land in front of him mixed inseparably with the lingering memories of the landscape through the moving windows. At this slippery edge between water and land began Subramanian's preoccupation with still and moving images, memory and history, the end and the beginning.

**Kelly Sultan** was born and raised in the San Francisco Bay Area, and is a graduate of Mills College, Oakland. A visual artist with a history in education and interior design, she is the director of the estate of her late husband, Larry Sultan, and lives in their home north of San Francisco with her dog, Billie, and an occasional visiting son or two.

**Larry Sultan**'s practice consistently challenged the conventions of documentary photography, and his images reflect an appreciation for the psychological nuances found in the everyday suburban setting of his childhood. Sultan's projects and books include *Pictures from Home* (1992), *The Valley* (2004), and *Homeland* (2006–9). He was coauthor, with Mike Mandel, of *Evidence* (1977). Sultan's work has been published in numerous catalogues, and is collected and exhibited in major institutions worldwide, including the Tate Modern, London; National Gallery of Art, Washington, DC; and Museum of Modern Art, New York. Sultan was professor of art at San Francisco Art Institute (1978–88), and served as distinguished professor of photography at California College of the Arts, San Francisco (1989–2009). Born in Brooklyn, Sultan passed away at his home in Greenbrae, California, in 2009.

**Lisa Sutcliffe** is the Herzfeld Curator of Photography and Media Arts at the Milwaukee Art Museum. Previously, she served as assistant curator of photography at the San Francisco Museum of Art, and Koch Curatorial Fellow at deCordova Sculpture Park and Museum, Lincoln, Massachusetts. She has organized numerous exhibitions, including *Susan Meiselas: Through a Woman's Lens* (2020); *Sara Cwynar: Image Model Muse* (2019); *The San Quentin Project: Nigel Poor and the Men of San Quentin State Prison* (2018); *Penelope Umbrico: Future Perfect* (2016); and *The Provoke Era: Postwar Japanese Photography* (2009).

**Stephanie Syjuco** was born in the Philippines and works in photography, sculpture, and installation, moving between handmade and craft-inspired mediums and digital editing and archive excavation. Recently, she has focused on how photography and image-based processes are implicated in the construction of racialized, exclusionary narratives of history and citizenship. Syjuco is recipient of a Guggenheim Fellowship and has exhibited widely, including at the Museum of Modern Art and Whitney Museum of American Art, New York, and San Francisco Museum of Modern Art. She is an associate professor at the University of California, Berkeley, and resides in Oakland.

**Deanna Templeton** is an American photographer known for her documentary and serial work exploring youth culture and feminine identity. Since the 1990s, Templeton has explored many subjects, from the nude body in her book *The Swimming Pool* (2016), to nighttime street photography in *The Moon Has Lost Her Memory* (2017). Her most recent book, *What She Said* (2021), contrasts her own tumultuous adolescence with that of young women growing up in our current era. Her work has been exhibited in galleries and museums worldwide. Templeton lives and works in Southern California.

**Ed Templeton** is an American artist and photographer whose work reflects human behavior with an emphasis on youth subcultures, religious affectation, and suburban conventions, using a cinéma vérité approach embracing chance encounters. Templeton is a respected cult figure in the subculture of skateboarding, a two-time world champion, and Skateboarding Hall of Fame inductee. He is best known for his photographic books and multimedia exhibitions. His work has been shown in museums worldwide, including the Museum of Contemporary Art, Los Angeles; International Center of Photography, New York; Palais de Tokyo, Paris; Stedelijk Museum voor Actuele Kunst, Belgium; Bonnefanten Museum, Maastricht, the Netherlands; Kunsthalle Wien, Vienna; and Pier 24 Photography, San Francisco.

**Rein Jelle Terpstra** lives and works in Amsterdam. Terpstra investigates the relationships between perception, memory, and photography. His work is held in various collections, including at the San Francisco Museum of Modern Art; Museum of Modern Art Library, New York; Getty Research Institute, Los Angeles; Eye Film Museum, Amsterdam; and Netherlands Photo Museum, Rotterdam. In 2017, Terpstra undertook a Smithsonian Artist Research Fellowship in Washington, DC. His book *Robert F. Kennedy Funeral Train: The People's View* (2018) received the gold medal for the Most Beautiful Book of the World from the international jury of the Stifting Buchkunst in 2019. He teaches fine arts at Minerva Art Academy, Groningen, the Netherlands.

**Dustin Thierry** is a contemporary artist and photographer from Willemstad, Curaçao, whose work is focused on the Afro-Caribbean diaspora in the Netherlands.

Originally from Cincinnati, **Caroline Tompkins** received a BFA in photography from the School of Visual Arts, New York. She has exhibited photographs nationally and internationally, with her work featured in BBC, *Vogue*, and the *New York Times*, among other media outlets. Tompkins has worked as a photo editor at *Bloomberg Businessweek*, and as a professor at the School of Visual Arts. She currently works for editorial and commercial clients and lives in Queens, New York.

**Larry Towell** is a member of Magnum Photos and a freelance photographer and writer. He lives in Ontario, Canada.

**Charles H. Traub** has been a photographer and educator for over fifty years. His work is represented in major museums and collections all around the world. He founded the MFA Photography, Video and Related Media program at the School of Visual Arts in New York City in 1988, and still serves as the chair. Formerly, he directed New York's Light Gallery, and for over twenty-five years, he was president of the Aaron Siskind Foundation. He was awarded an ICP Infinity Award for his work on *Here Is New York: A Democracy of Photographs*. Traub is the editor and author of sixteen books, including eight monographs of his own work. Recent publications include *Lunchtime* (2015), *No Perfect Heroes* (2016), *Taradiddle* (2018), and *Skid Row* (2020). *Tickety-Boo* is forthcoming in 2021.

**Ka-Man Tse** has exhibited her work internationally, including at Para Site, Lumenvisum, WMA Space, Videotage, and Eaton Workshop in Hong Kong; Silver Eye Center for Photography, Pittsburgh; Aperture Gallery; and the Brooklyn Museum. Her awards include an Aperture Portfolio Prize, Aaron Siskind Foundation fellowship, Robert Giard Fellowship, and a research award from the Yale University Fund for Lesbian and Gay Studies. Her curatorial projects include *Daybreak*, cocurated with Matt Jensen at the Leslie-Lohman Museum of Art; and *Unruly Visions*, in partnership with the Hong Kong

International Photo Festival. She teaches at Parsons School of Design at The New School. Her monograph, *narrow distances*, was published by Candor Arts in 2018.

**Anne Turyn** is an artist currently on the faculty of Pratt Institute, Brooklyn. Her work has been included in exhibitions at the Museum of Modern Art, and Metropolitan Museum of Art, New York; Walker Art Center, Minneapolis; Contemporary Arts Museum, Houston; and Denver Art Museum, among others. Turyn's work with text was published as *Missives* (1986), a book of color photographs. She founded and edited the chapbook series *Top Stories*, a prose periodical.

**Brian Ulrich**'s photographs of contemporary consumer culture are held by major museums and private collections, such as the Art Institute of Chicago; Baltimore Museum of Art; Cleveland Museum of Art; George Eastman Museum, Rochester, New York; J. Paul Getty Museum, Los Angeles; Milwaukee Art Museum; Museum of Contemporary Art San Diego; Museum of Contemporary Photography, Chicago; Museum of Fine Arts, Houston; North Carolina Museum of Art, Raleigh; Margulies Collection; Bidwell Collection; and Pilara Foundation Collection. Ulrich was awarded a Guggenheim Fellowship in 2009. His monographs include *Is This Place Great or What* (Aperture /Cleveland Museum of Art, 2011), *Closeout: Retail Relics and Ephemera* (2013), and the forthcoming *The Centurion* (2021).

**Penelope Umbrico** is a photo-based artist whose work explores the production and consumption of photographs. She has exhibited widely, and her work is in the permanent collections of the Carnegie Museum of Art, Pittsburgh; George Eastman Museum, Rochester; Guggenheim Museum, Metropolitan Museum of Art, and Museum of Modern Art, New York; Museum of Contemporary Photography, Chicago; San Francisco Museum of Modern Art; and Victoria and Albert Museum, London, among others. She is the recipient of numerous awards, including a Guggenheim Fellowship. She has held visiting artist and teaching positions, and is currently core faculty at the School of Visual Arts, MFA Photography, Video and Related Media program in New York City. Her monographs have been published with RVB Books and Aperture, who published her first monograph, *Photographs*, in 2011.

**Michael Vahrenwald** is a photographer and cofounder of the publishing imprint ROMAN NVMERALS. Born and raised in Bettendorf, Iowa, he now lives and works in the Bronx.

**Peter van Agtmael** was born in Washington, DC, in 1981. He graduated from Yale University with a BA in history in 2003. Since 2006, his work has largely concentrated on the United States and the post–9/11 wars. He has received a Guggenheim Fellowship, W. Eugene Smith Grant, ICP Infinity Award, Aaron Siskind Foundation fellowship, Lumix Freelens Award, several Pulitzer Center grants, Magnum Foundation Fellowship, and multiple awards from World Press Photo. He is the author of the books *Disco Night Sept 11* (2014), *Buzzing at the Sill* (2017), *Sorry for the War* (2020), and *2020* (2021), which have been recognized in "Book of the Year" lists by the *New York Times Magazine*, *Time*, *Mother Jones*, and others. Van Agtmael is a mentor in the Arab Documentary Photography Program and a member of Magnum Photos.

**Bertien van Manen** is a photographer who has worked on several book projects, including *A Hundred Summers, A Hundred Winters* (1994), photographs taken in the ex-Soviet Union; *East Wind West Wind* (2001), made in China; and *Give Me Your Image* (2006), photographed in Europe and shown in *New Photography* at the Museum of Modern Art, New York, 2005. Other books include *Let's Sit Down before We Go* (2011), *Easter and Oak Trees* (2013), *Beyond Maps and Atlases* (2016), and *I Will Be Wolf* (2017).

These projects resulted in exhibitions all over the world. In 2020, the Stedelijk Museum Amsterdam exhibited a retrospective of van Manen's work. She lives in Amsterdam.

**Chris Verene** is a photographer, performance artist, educator, and musician. He was born in DeKalb, Illinois, and has documented the western Illinois area for over thirty years, chronicling the lives of his family and friends in the small city of Galesburg. Verene has been called a natural storyteller, focusing on the whole intimate truth of human narratives. His monographs include *Chris Verene* (2000), *Camera Club* (2000), and *Family* (2010). Verene is represented in numerous museum collections, including of the Whitney Museum of American Art, and Metropolitan Museum of Art, New York; Walker Art Center, Minneapolis; Getty Center, Los Angeles; Jewish Museum, New York; San Francisco Museum of Modern Art; and Museum of Contemporary Art, Los Angeles. Verene lives and works in New York City, and is represented by Postmasters Gallery. He is associate professor of photography at the College of Staten Island.

**Joseph Vissers.** I was always interested in many different subjects; it was hard to focus on any one. My college degree is in the history of Asia, and I was in the navy for four years. I was hired as a librarian by the New York Public Library and now work for the library's Picture Collection. Looking at images, assigning them subject headings, and adding descriptive information is just as fascinating as helping library users find the images and work with them. I also get to work with smart and interesting coworkers. I'm sixty-two years old and really enjoy what I do.

**Karla Hiraldo Voleau** is a French Dominican artist. She received an MA in photography from École cantonale d'art de Lausanne, Switzerland, in 2018. Her work has been exhibited at Les Rencontres d'Arles, France; Fotomuseum Winterthur, Switzerland; and Biennale de l'image Possible, Belgium. She was named a FOAM Talent and received the Recommended Olympus Fellowship in 2020. Her first photobook, *Hola Mi Amol* (2019), was shortlisted for the Paris Photo–Aperture Foundation First PhotoBook Award in 2019. She works and lives in Lausanne, Switzerland.

**Alex Webb** is best known for his vibrant and complex color photography, often made in Latin America and the Caribbean. He has published seventeen books, including *The Suffering of Light* (Aperture, 2011), a collection of thirty years of his color work and, most recently, *Brooklyn: The City Within* (with his wife and creative partner Rebecca Norris Webb, Aperture, 2019). Webb became a full member of Magnum Photos in 1979. His work has been shown widely, including at the Metropolitan Museum of Art and Whitney Museum of American Art, New York, and at the High Museum of Art, Atlanta. He's received numerous awards, including a Guggenheim Fellowship.

**Rebecca Norris Webb**, originally a poet, often interweaves her words and photographs in her eight books, including her monographs, *My Dakota* (2012) and *Night Calls* (2021), and her collaborative books with photographer Alex Webb, her husband and creative partner, including *Brooklyn: The City Within* (Aperture, 2019). A National Endowment for the Arts grant recipient, Norris Webb has exhibited her work internationally, including at the Museum of Fine Arts, Boston; Cleveland Museum of Art; and Museum of the City of New York.

**William Wegman** has been exhibiting his work both with and without dogs since the '70s.

**Jordan Weitzman** is a photographer and producer of the *Magic Hour* podcast, a conversation series in which he has interviewed over forty photographers and people involved in

the medium. In 2019, he attended the Skowhegan School of Painting and Sculpture. He lives in Montreal.

**John Wilson** is a documentarian based in Queens, New York. Inspired, in part, by a short career working for a private investigator, Wilson spent a decade obsessively documenting street life in New York City. His self-published films on his Vimeo page caught the eye of Nathan Fielder, with whom Wilson soon started a collaboration. His new HBO series, *How To with John Wilson*, can be viewed on HBO Max.

**Vanessa Winship**, born in the United Kingdom, holds a BA (with honors) in cinema, video, and photographic arts from the Polytechnic of Central London, now University of Westminster. Since 1998, she has lived and worked in the Balkans and countries surrounding the Black Sea. In 2005, she joined Agence VU in Paris, and in 2014, she had her first mid-career survey at the Fundación Mapfre Gallery in Madrid. Her first major UK solo survey exhibition, *And Time Folds*, took place at the Barbican Art Gallery, London, in 2018. She is recipient of two World Press Photo awards and a Prix HCB (2011), and author of five monographs.

**Sasha Wolf** represents emerging and mid-career fine-art photographers. Her best-selling book *PhotoWork: Forty Photographers on Process and Practice* was published by Aperture in 2019; and her podcast, *Photowork with Sasha Wolf*, is available on all streaming platforms.

**Denise Wolff** is senior editor at Aperture. Prior to Aperture, she was the commissioning editor for photography at Phaidon Press in London. Among the books she has commissioned and edited are *The Photographer's Playbook: 307 Assignments and Ideas* (2014), edited by Jason Fulford and Gregory Halpern; *Feast for the Eyes: The Story of Food in Photography* (2017) by Susan Bright; *Girl Pictures* (2020) by Justine Kurland; *The Colors We Share* (2021) by Angélica Dass; and *Eyes Open: 23 Photography Projects for Curious Kids* (2021) by Susan Meiselas. Wolff also spearheads Aperture's Photography Workshop Series.

**Stanley Wolukau-Wanambwa** is a photographer, educator, and writer. He has contributed essays to publications by Vanessa Winship, George Georgiou, Rosalind Fox Solomon, Marton Perlaki, and Paul Graham. He has been an artist-in-residence at Light Work, guest edited Aperture's *PhotoBook Review*, and written for *Aperture*, *FOAM*, the Barbican, Photographers' Gallery, and Rutgers University Press. His debut monograph, *One Wall a Web*, was published in 2018 and won the Paris Photo–Aperture Foundation First PhotoBook Award. He has lectured at Yale University, Cornell University, New York University, and The New School.

**Antonio M. Xoubanova** studied photography at Escuela de Arte 10 in Madrid. Upon finishing his studies in 2003, he set up Blank Paper, alongside other photographers with shared interests. He is recipient of several awards and grants. Since 2005, he has conducted workshops and lessons at CASA while working on his personal projects. In 2013, he published *Casa de Campo*; and in 2015, *Un Universo Pequeño*. His work has been exhibited at Les Rencontres d'Arles, France; Le Bal, Paris; and Ángeles Baños Gallery, Spain, among other venues. He is working on an upcoming book, *Graffiti*.

**Guanyu Xu**, born in Beijing, is an artist based in Chicago. He is winner of a Hyères Photography Grand Prix (2020), PHOTOFAIRS Shanghai Exposure Award (2020), Philadelphia Photo Arts Center Contemporary Photography Competition (2019), and Kodak Film Photo Award (2019), and runner-up for the Aperture Portfolio Prize (2019). His works have been exhibited and screened internationally, including at the Museum of Contemporary Art Chicago; New Orleans Museum of Art; Museum of Fine Arts, Houston; Fotomuseum

Winterthur, Switzerland; and 36th Kasseler Dokfest, Germany. His works can be found in public collections, including at the Museum of Fine Arts, Houston; Museum of Contemporary Photography, Chicago; and New Orleans Museum of Art.

**Luo Yang** was born in Liaoning, China, and currently lives in Shanghai. As a photographer, she focuses on women from different generations and backgrounds in contemporary China. In 2012, Ai Weiwei described her as one of the "rising stars of Chinese photography," and included her work in his show *FUCK OFF 2* at the Groninger Museum (2013). She has had solo shows in Berlin, Hong Kong, Bangkok, and Paris, and her work has been widely covered by Western media. She was selected as one of BBC's "100 Women" in 2018, and shortlisted for the C/O Berlin Talent Award in 2019.

**Yorgos Yatromanolakis** lives and works between Athens and Crete. He works on long-term photography projects and experiments with photobook-making, which is key to his artistic practice. He is a cofounder of the artist-run space Zoetrope in Athens and a contributor editor of *Phases Magazine*.

**Sheung Yiu** is a Hong Kong–born, image-centered artist and researcher based in Helsinki. His works concern the increasing complexity of computer-generated imagery (CGI) in contemporary visual culture. He seeks to expand the image discourse by formulating connections between photography theories and new ways of thinking through artistic practices and multidisciplinary research.

**Xiaopeng Yuan** lives and works in Shanghai. He is a photographer, independent publisher, and the founder of self-publishing studio Same Paper. His first photobook, *Campaign Child*, was published in 2019.

**Daniella Zalcman** is a Vietnamese American documentary photographer based between Paris and New York. She is a multiple grantee of the Pulitzer Center on Crisis Reporting; fellow with the International Women's Media Foundation; National Geographic Society grantee; and founder of Women Photograph, a nonprofit working to elevate the voices of women and nonbinary visual journalists. Her work is focused on the legacies of Western colonization, ranging from the rise of homophobia in East Africa to the forced assimilation and education of Indigenous children in North America.

**Giulia Zorzi** is a writer, curator, and owner of Micamera Bookstore, Milan—the first Italian bookstore devoted to photography. Since founding Micamera with Flavio Franzoni in 2003, Zorzi has exhibited the work of photographers from around the world, including Mark Steinmetz, Michael Wolf, Todd Hido, Lucas Foglia, Gregory Halpern, Dana Lixenberg, Gus Powell, Jessica Backhaus, Gerry Johansson, Yamamoto Masao, Paul Kooiker, Melanie Pullen, Philip Jones Griffiths, and Rinko Kawauchi. Through Micamera she organizes workshops, talks, and performances with artists, designers, publishers, and filmmakers. Zorzi also oversees the archive of Fulvio Ventura.

## Acknowledgments

Many thanks to Aperture, Chris Boot, and Denise Wolff for reconsidering this project, after we had abandoned it years ago, convinced that the idea was cursed.

The book would not exist without Denise Wolff, a brilliant editor and reliable sounding board. Her friendship, sense of humor, and sharp criticism were instrumental.

Thank you to Lanah Swindle for your work coordinating with all of the contributors and for your opinions as we gathered this content during the COVID-19 pandemic of 2020.

Thank you to Paula Kupfer for your copyediting skills; to Susan Ciccotti for catching and thinking of everything once we got this into layout (especially Del Greco); to Elena Goukassian for sharpening the book even further; and to Emily Patten for pinch-hitting on the minutiae.

Thank you also to True Sims and Tom Bollier for guiding the printing and logistics, and to Andrea Chlad for your work on the images.

And above all, thank you to all the contributors for sharing your stories.

# Credits

*Photo No-Nos*
*Meditations on What Not to Photograph*
Edited by Jason Fulford
Cover photograms by Jason Fulford

Editor: Denise Wolff
Editorial Assistant: Lanah Swindle
Designer: Jason Fulford
Senior Production Manager: True Sims
Production Manager: Andrea Chlad
Production Consultant: Thomas Bollier
Senior Text Editor: Susan Ciccotti
Copy Editors: Elena Goukassian, Paula Kupfer

Additional staff of the Aperture book program includes:
Chris Boot, Executive Director; Lesley A. Martin,
Creative Director; Taia Kwinter, Publishing Manager;
Emily Patten, Publishing Assistant; Samantha Marlow,
Associate Editor; Brian Berding, Designer; Kellie
McLaughlin, Chief Sales and Marketing Officer;
Richard Gregg, Sales Director, Books

Aperture's programs are made possible, in part, by the
New York State Council on the Arts with the support
of Governor Andrew M. Cuomo and the New York
State Legislature.

First edition, 2021
Printed in China
10 9 8 7 6 5 4 3 2 1

Library of Congress Cataloging-in-Publication Data
available upon request.
ISBN 978-1-59711-499-8

To order Aperture books, or inquire
about gift or group orders, contact:
+1 (212) 946-7154
orders@aperture.org

For information about Aperture
trade distribution worldwide, visit:
aperture.org/distribution

## aperture

Aperture Foundation
548 West 28th Street, 4th Floor
New York, NY 10001
aperture.org

Aperture, a not-for-profit foundation, connects the
photo community and its audiences with the most
inspiring work, the sharpest ideas, and with each
other—in print, in person, and online.